Royal
Style

Luise Wackerl

Royal Style

A History of Aristocratic Fashion Icons

PRESTEL
Munich · London · New York

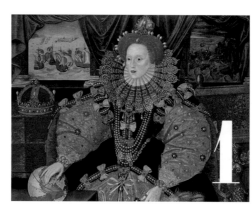

CONTENTS

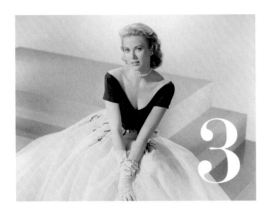

PREFACE

"I couldn't be more Irish but I celebrate Britishness through hats. When I met the Queen, at a design evening at Buckingham Palace, she asked: "What do you do?" "I make hats, ma'am." She said: "Am I the only person who wears a hat these days?" And I said: "Ma'am, you have kept hats alive in the imagination of people all over the world." When you meet the Queen, you are not supposed to ask questions. But I thought: what the hell. So I looked her in the eye and said: "Ma'am, do you enjoy wearing hats?" And she stood back and said: "It is part of the uniform."

Philip Treacy

HIP HIP ROYAL!
Luise Wackerl

They contribute to the economic prosperity of their kingdom, smile radiantly on the covers of the most popular magazines, conquer the international catwalks with their polished elegance, and even inspire Hollywood stars: today young women of the people bask in the glamour of the crown. They have conquered the hearts of crown princes and their fairy-tale aura invites millions of women to indulge in dreams, be it in haute-couture gowns or department-store fashion. Duchess Kate & Co. are the new fashion icons of our time and support a multimillion dollar fashion industry. As members of the middle class they grew up in off-the-rack clothes and with fashion experiments: they know that they can delight millions of women in a fifty-dollar Zara dress; that red, purple, and gold look better before the camera than black; and that they win extra points for recycling their clothes. The new stars of the royal families are icons for every-day – fashion models for real life. Their ascent to the

royal houses is not a pipe dream that bursts – bang! – in the cold light of day. Instead, they show that today any woman can become a princess – as long as there are enough blue-blooded men available on the marriage market.

The best ones are already taken. At the very beginning of the new millennium, for the first time in history the fusty image of the aristocracy got an anti-aging facelift: in 2001 Norway's crown prince married Mette-Marit, a former party girl and single mother; in Spain, Letizia – a former newscaster – will sit on the throne one day; Mary of Denmark used to work in the advertising industry; the crown prince of the Netherlands married the investment banker Máxima; and in Monaco it was the professional swimmer Charlene Wittstock who became a princess. Even Catherine, better known as Kate Middleton, sold cardboard crowns in her family's online shop before becoming a member of the British royal family. Only two royal trendsetters do not

pattern: Crown Princess Victoria of Sweden was born with blue blood, but chose to marry a "male Cinderella" – her former fitness trainer Daniel Westling. And Queen Rania of Jordan is not a European, but in spite of her Arab roots she wears European fashion instead of the veil. Her favorite designer Elie Saab gushed that, "Rania and company are not ordinary women. They don't buy clothes to feel like a princess for a night – they are princesses." And each of them has her own inimitable style – from the charming rebel to the modern Cinderella.

But anyone who thinks that only today's aristocracy sells fashion fairy tales is greatly mistaken. The first blue-blooded trendsetters in history appeared back in the Middle Ages. Clothes embroidered with gold, huge ruffs, sparkling diamonds, and skirts so wide that the fashionistas could scarcely pass through the door – Europe's crowned heads loved superlatives in fashion. Do you know which duke made black "en vogue" – or why the Sun King Louis XIV made the red sole fashionable long before Christian Louboutin? The ladies of yore also appeared more eccentrically dressed than Lady Gaga today: Marie-Antoinette was the Paris Hilton of the Rococo age, and Sisi the first German supermodel. Queen Victoria was madly in love when she became the prime trendsetter for brides; her great-grandson Edward VIII was driven to abdicate from the throne of England by, of all people, an extremely elegant American divorcée. In the middle of the last century the immaculate beauty and elegant style of Grace Kelly brought new glamour to the tiny state of Monaco; in the 1990s Diana liberated herself from the tight corset of the palace through her clothes and conquered people's hearts as a "Princess you could touch." These are just a few examples of the greatest royal trendsetters of all time. Then as now – from Queen Marie Antoinette to Duchess Kate – they all have one thing in common: they are mad about fashion!

A QUICK LOOK AT HISTORY

Their biographies read like real-life melodramas and their looks made them immortal. Ladies and gentlemen, please welcome the greatest trendsetters of the past! While today's royals invite us to emulate their style, Europe's monarchs of the past showed that they were different from the common people by wearing magnificent robes. A glance at history books helps to understand this phenomenon. As a rule of thumb, one could say of costume history that those who held the reins of power in politics or culture also set the tone in fashion. From the Middle Ages to the French Revolution in 1789, the aristocracy had unlimited political power throughout Europe and was thus nearly the only social stratum to set trends. Aristocratic men and women used their outfits to display their status as though on a badge, and enforced strict fashion diktats. This meant that the aristocracy, and nobody but the aristocracy, was allowed to wear particular colors, forms, and fabrics. Costume books often make reference to the term "feudal fashion" in this context. While members of the aristocracy wrapped themselves in precious fabrics and ermine, their servants and the common people had nothing but uniforms and traditional regional costumes. For this reason, lists of the greatest trendsetters of the past are made up mainly of the most powerful ruling families. In the twelfth and thirteenth centuries, French kings – and, by way of exception, knights, too – were the rulers of fashion. While the influence of the latter waned during the fourteenth century, the rulers of France retained their power until the mighty Dukes of Burgundy made a name for themselves with their over-the-top clothing. In the mid-sixteenth century, and into the following century, the Spanish court dictated strict sartorial rules, until the French aristocracy exerted a powerful influence on fashion once again, and wrote the last chapter in the book of courtly fashions.

The date of the French Revolution marks the sudden end of this state of affairs. From this point on, the aristocracy had to share its trendsetter status with the haute bourgeoisie. With the storming of the Bastille, the clothing worn by the aristocracy became a thing of the past, as did the aristocracy's unlimited political control. Of course a few fashion-obsessed rulers, like France's empress Eugénie, would continue to rise to the ranks of style icons, but there can be no doubt about the fact that from 1789 onward, fashion was no longer separating the aristocracy from the common people, but rather, separating men from women. Until that time, men had spruced themselves up more than women had. In the sixteenth century, they had drawn attention to their crotches with cod pieces, a sort of push-up bra for the penis. Later, during the Rococo period, men wore high heels, lace, embroidered fabrics, ribbons, and furs, just like women. But the concept of masculinity, too, acquired an entirely new meaning during the French Revolution. The aspiring middle classes banished all jewelry from men's fashion, which was at the time the emblem of the aristocracy, and transformed this into a practical, gender-neutral, and fairly dull affair.

Nowadays, we are not compelled but choose to follow the latest trends. Fashion is regulated by nothing but its price. It has been a long time since sartorial diktats were issued from the top down in the form of laws. And yet a few dress codes, clothing for particular events and vestiges of aristocratic fashions, survive to this day. A distant forebear of Princess Diana, for example, invented the short Spencer jacket in around 1805 – Lord Spencer is said to have burned the tails of his dress coat when he got too close to a roaring fireplace, so that nothing but a short jacket remained. To tell the entire history of feudal fashion would be beyond the scope of this book. But there are a few outstanding trendsetters, those who with their look have made their mark on history.

Pomp and Circumstance

Courtly Looks from the Twelfth Century Onward

Fashionable Knights and Elegant Ladies
Of Unisex Looks and Red Carpets

The birthplace of haute couture was already considered to be the fashion capital as long ago as the twelfth century: Paris set the tone not only for France, but for the whole of Central and Western Europe. The reason for this is simple: the nobility from every part of the country gathered at the royal court. Although the palace dictated cuts, colors, and fabrics down to the smallest detail, the knights, too, had a big impact on the development of trends. They became acquainted with the superior culture of the Orient and its highly developed textile and clothing production methods during the Crusades. The horizon of the medieval Church was rather narrow at the time. In the big wide world, the knights discovered the most precious of fabrics and most exotic of patterns, and brought them home with them. This meant that they did not simply achieve hero status by winning wars, but also became fashion gurus at court. Every item of clothing had a special significance: gloves, for example, were not only regarded as symbols of power, but also functioned as love tokens in tournaments. The woman took on the role of the "noble lady," becoming the focus of courtly life and setting trends with her floor-length, colorful robes. Over time, she came to have such a strong influence that men dressed increasingly like women. Strictly speaking, clothing did not become fashion – thus placing a stronger emphasis on the wearer's sex – until the fourteenth century. Until then, men often wore the same sleeveless outer garments as women, and let their hair grow to chin length.

Clothing dictates became stricter as knights and the nobility became increasingly intertwined, fusing into a defined feudal stratum. In France and Italy, laws were passed to curb luxury from the thirteenth century onward. In reality, however, their goal was the suppression of the aspiring middle classes and the safeguarding of the sartorial privileges of the nobility. The

longer and narrower the form, the more elegant it was considered, and so clothing took on bizarre shapes. From the mid-fourteenth century, this had an effect on, amongst other things, the dimensions of poulaines; the length of the tip of the shoe was dictated by status, ranging from fifteen centimeters (common people) to seventy-five centimeters (princes). Only the members of the highest echelons of the aristocracy were allowed to wear red, the color of the most expensive of dyes, and ermine fur. These insignia continue to symbolize royalty to this day. As long ago as the Middle Ages, the red carpet (which usually hung on the wall) was rolled out for the most honored guests so that they would not have to step on the bare floor. Nowadays, Hollywood stars, of course, also traipse on red carpets.

Unisex fashion: In the Middle Ages, men copied the styles of their women and wore a differently colored, sleeveless outer garment (surcoat) over their innerwear (below).

While the people wore their hair cut short, noble lords let it grow relatively long. At the time this was considered a symbol of nobility (right).

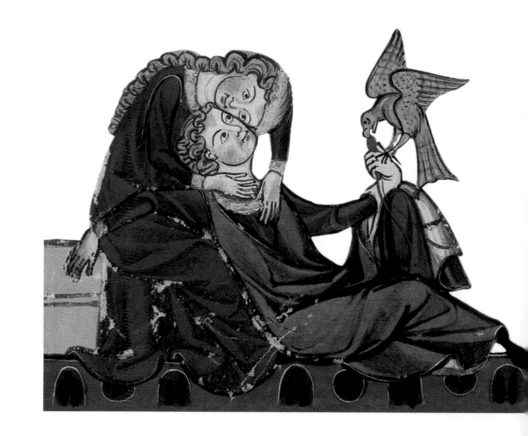

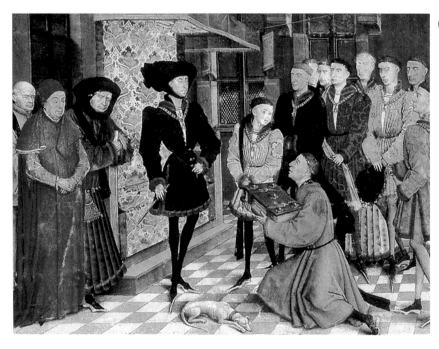

> **Black is modest and arrogant at the same time. Black is lazy and easy – but mysterious.**
> *Yohji Yamamoto*

Top: The Burgundian duke Philip the Good (fourth from left) was the first person in history to wear a "little black dress," and made the non-color fashionable.

Right: From the mid-fourteenth century until the end of the fifteenth century, poulaines became status symbols. The longer the tips of the shoes, the higher their wearer was in the social hierarchy.

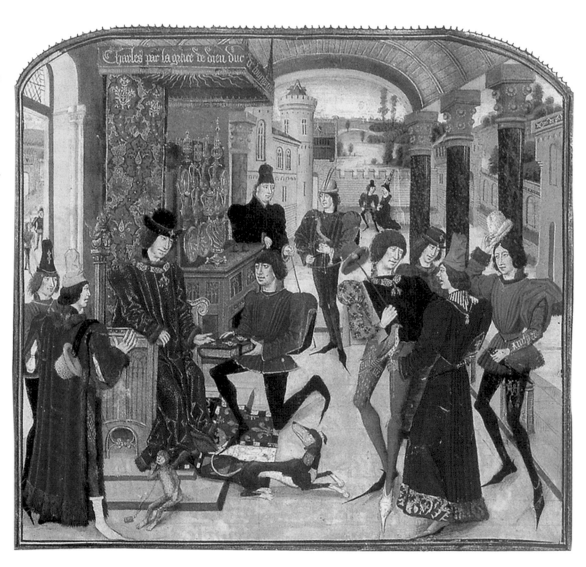

The Dukes of Burgundy
Kings of Elegance

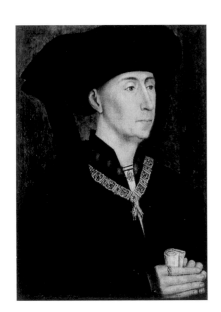

No, this is not about the famous French red wine; this is about fashion. While France was engaged in battle with England during the Hundred Years' War, the dukes of Burgundy ruled international fashion trends. This was no coincidence. During the fifteenth century, their territory was considered the most urbanized area in the world. Trade, crafts, and the textile industry in particular flourished. Just as the bourgeois fashion of the Renaissance slowly began to develop in Italy, the colorful costumes of the Late Middle Ages reached their apogee at the ducal court of Burgundy. Descendants of the French royal family of Valois, the dukes of Burgundy followed Parisian courtly traditions with their sumptuous ceremonial customs.

The degree of kinship with the king was even expressed in the hierarchy of clothing at the Burgundian court – who was allowed to wear satin, silk, ermine, and sable was strictly regulated. The extent of the dukes' wealth is illustrated by the following story. When the Burgundians fled after a battle in 1476, the enemy was able to seize precious booty. The Duke of Burgundy alone had owned a hundred embroidered golden gowns. The Burgundians also had to abandon four hundred silk tents, including the one belonging to the duke, which was lined with satin and decorated with gold and pearls. Even though the rulers of Burgundy never attained the honor of kingship, their splendor outshone that of all rulers of their time.

This makes it all the more surprising that a Burgundian duke was the one to make black fashionable: Philip the Good (1396–1467) popularized the famous non-color around 1450. As the lower classes also increasingly wore colorful clothing, he wanted to distance himself from the aspiring middle classes – and resorted to a "little black dress" with opaque stockings.

At the Burgundian court, aristocrats loved precious fabrics and imaginative headdresses; for a while, turbans and cylindrical felt hats were the height of fashion.

Top: When even the lower classes owned increasingly colorful clothing, Philip the Good wanted to set himself apart and chose black for his ceremonial clothing in about 1450.

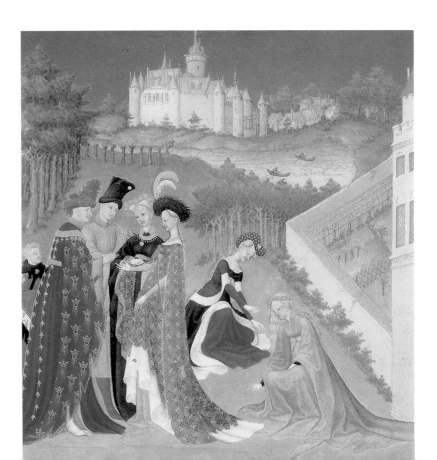

Philip II of Spain
The Greatest Dictator of Fashion of All Time

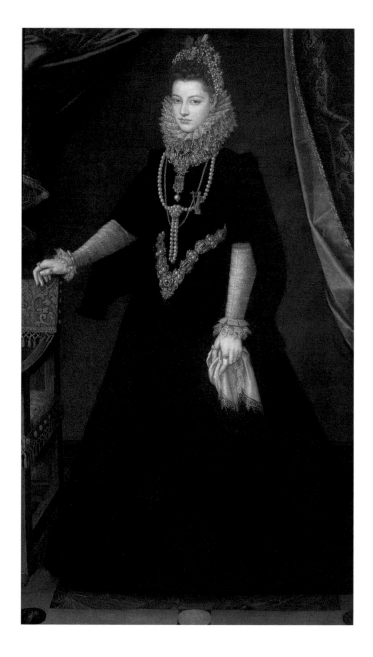

450 years before Letizia shocked conservative monarchists with a white pants suit, the Spanish court was already subject to Europe's strictest etiquette, only much worse than it is now. The following is how it happened. While the fashion-obsessed dukes made rules and regulations governing dress in Burgundy, the Renaissance catapulted the individual into the limelight in Italy, where robes became a form of self-expression. This new style quickly spread across national borders and usurped the place of medieval courtly fashions. Until another Philip surfaced, that is. This one was not a Burgundian duke, however, but a Spanish king. After the discovery of America in 1492 and the founding of countless colonies, Spain became a superpower in the sixteenth century. In terms of fashion, the country also set the tone in Europe.

Philip II (1527–1598) introduced the strictest clothing dictates found until then in European history. Not only did the common people have to sacrifice their political and fashion freedoms; the aristocracy had to make concessions as well. The members of the aristocracy were demoted to the rank of servants of the king, their clothing transformed into court uniforms. Spanish fashion now regulated colors, shapes, and materials even more relentlessly than had been the case during the Middle Ages. The court was dominated by black, and people suffered in order to be fashionable.

Aristocratic women wore a disk-shaped neck ruff that looked as though it separated the head from the body. They flattened their breasts with plates of lead, and even men strapped themselves into whalebone corsets. This is also when the hooped skirt made its first appearance in history. What remains to this day of Spanish court fashion is, by way of exception, not painful, however: galloons, the ornamental silk stripes along the outer seams of suit pants.

The daughter of the King of Spain, Isabella Clara Eugenia (1566–1633), complied with the strict sartorial dictates introduced by her father, Philip II. She wore dark, high-necked clothing and squeezed herself into a whalebone corset. In Spain the hoop skirt was cone shaped and was called »Verdugado«.

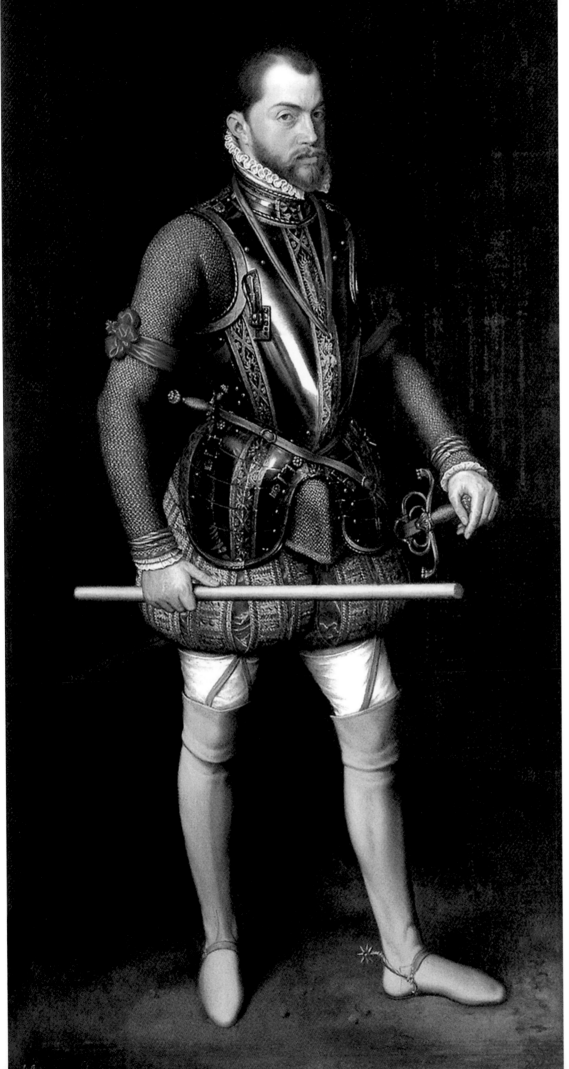

Unrelenting – in fashion as well:
The Spanish king Philip II, wearing
a stiff neck ruff, padded pourpoint,
and balloon trousers typical
of Spain.

Elizabeth I
or, "Don't come too close!"

She should really have been a boy – the red-headed Elizabeth I (1533–1603), a whirlwind of a child with a boyish figure, who cursed like a sailor, and loved crude jokes. She moved from the Tower of London to the throne at the age of twenty-five. But context is necessary to understand this unusual development. Her father Henry VIII (1491–1547) had been the subject of many a scandal in his time: he was married six times and ordered two of his wives to be beheaded. The first, Catherine of Aragon, gave him pleasure in the bedroom but no male heir to the throne. She was pregnant six times, but only one daughter survived: Mary. The king then fell for Catherine's seductive and equally sharp-witted maid Anne Boleyn. He went so far as to challenge the pope's authority for the sake of this unusual love. As the pope was not willing to annul Henry's marriage to Catherine, Henry simply left the Roman Catholic Church, prompting the English Reformation. When his second wife, too, gave birth to only a daughter (Elizabeth), the king was so angry that he ordered the beheading of Anne Boleyn. After Henry's death, Elizabeth's sickly half-brother Edward (the issue of Henry's third marriage) succeeded him, but died when he was still a teenager. And as soon as Mary, a fanatical Catholic, ascended the throne, she used violence to restore the Catholic faith. She made herself even more unpopular through her marriage to the arch-Catholic Spanish king Philip II. She will be remembered by the sobriquet of Bloody Mary. The childless Mary had her half-sister Elizabeth, a Protestant, locked up in the Tower of London until Mary's death.

A golden age began in Elizabeth's reign: the accomplished queen spoke six languages fluently, loved the works of Shakespeare, and was a master of the art of diplomacy. She allowed trade to flourish in an unprecedented manner and encouraged the development of the coal, iron, and textile industries. And yet England remained suspicious of her for many years: this sovereign was, after all, a woman. In order not to show any signs of female weakness, Elizabeth shored up her authority with her robes. She adopted the austere cuts of the Spanish court that were enough to intimidate men, and liked to wear collars of enormous dimensions, demonstrating her unapproachability. Her hooped skirt, too, rose ever higher at the sides and was kept at waist height by an arrangement of supports. It is almost as though she wanted to say: "Don't come too close!" It is no coincidence that Elizabeth was referred to as the Virgin Queen. She was extremely eligible. In order to safeguard her unlimited power, however, she rejected all proposals of marriage. She may have had a few lovers, but she was married to her kingdom.

To avoid looking too stern, the queen did not adopt the black robes worn at the Spanish court. Many of her gowns were made of white fabric decorated with gold appliqué and bows. Elizabeth is said to have owned 6,000 dresses and eighty wigs, and she loved black silk stockings. When a bishop castigated her for her passion for jewels, she snapped back that he had better not raise the subject again if he did not want to ascend to heaven prematurely. Despite her vanity, Elizabeth did not create fashions as such because her look could not actually be imitated. She would not tolerate a queen of style next to her and thus promulgated strict rules governing the clothing of court ladies. She was particularly fond of the towering Stuart collar made of lace, which was named for her second cousin, the Scottish queen Mary Stuart (1542–1587). Fearing for the English throne, the childless Elizabeth had the latter put to death.

"The Virgin Queen": The unmarried Queen Elizabeth I consciously used her gowns to create a distance between herself and others, although their virginal white color and embellishments made them look less austere.

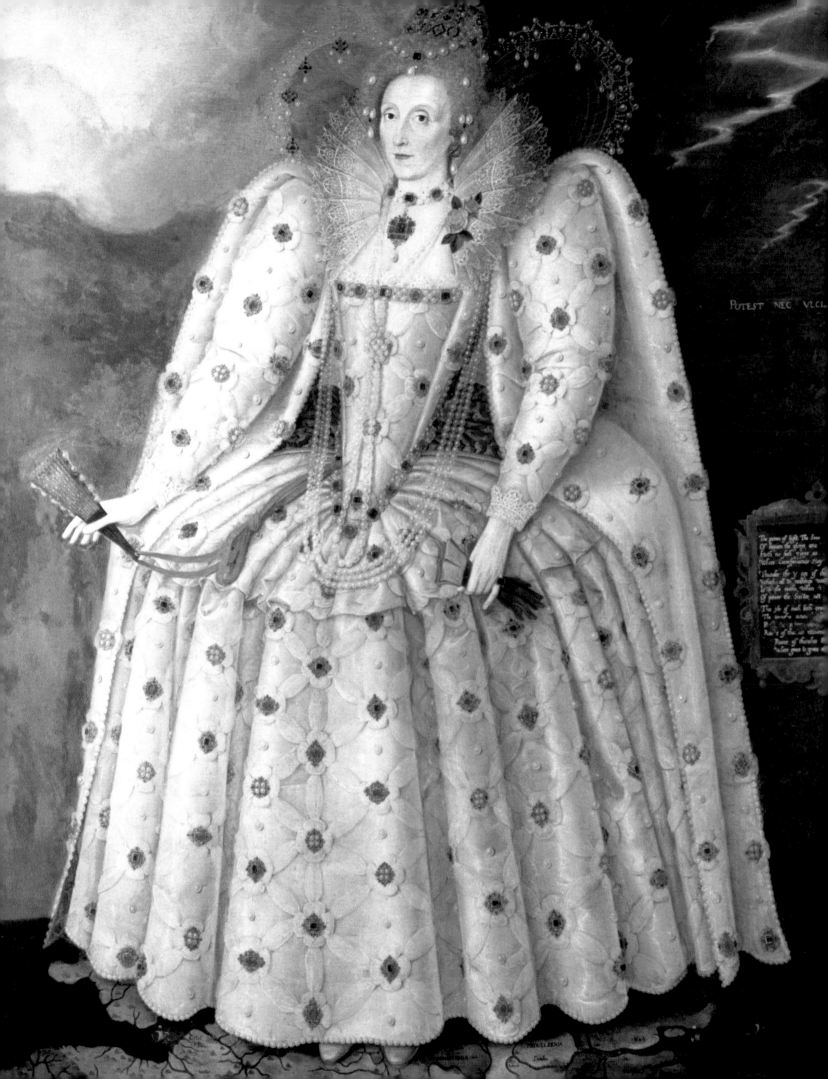

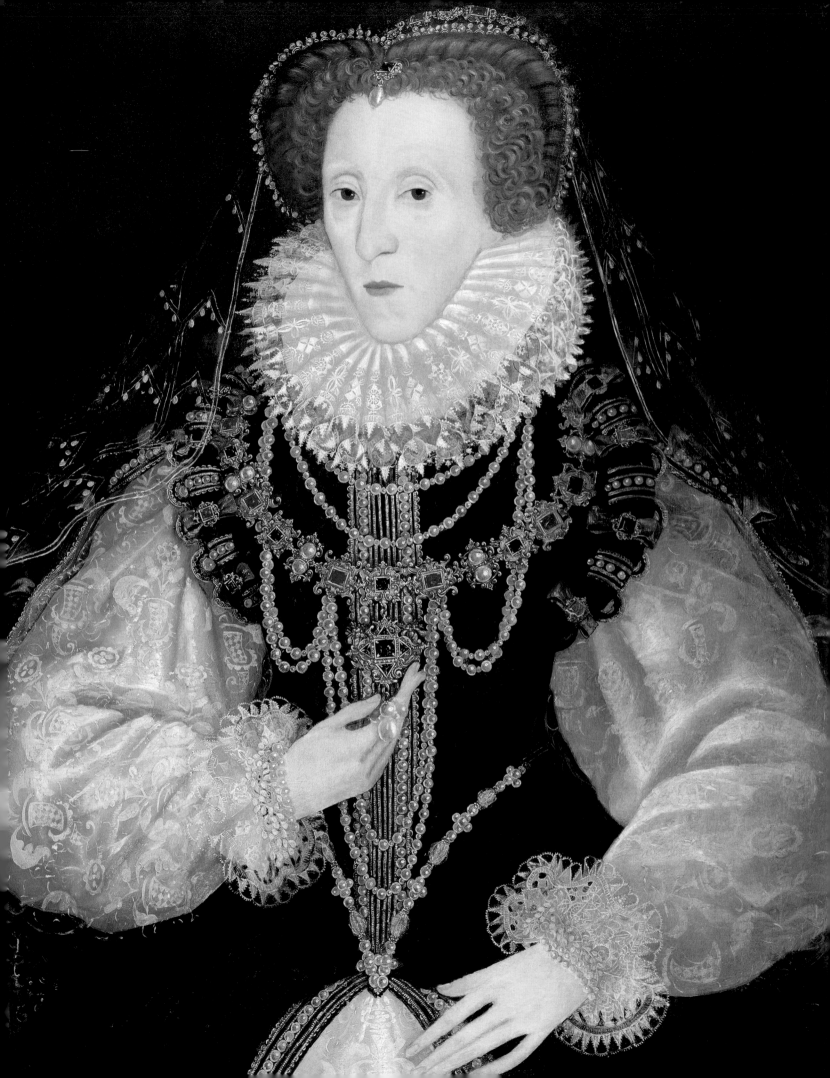

Elizabeth I draped herself with the most valuable jewels and wore starched neck ruffs that symbolized her unapproachability.

Right: The enormous wings attached to her sleeves, which together with the Stuart collar framed her décolleté, were particularly intimidating.

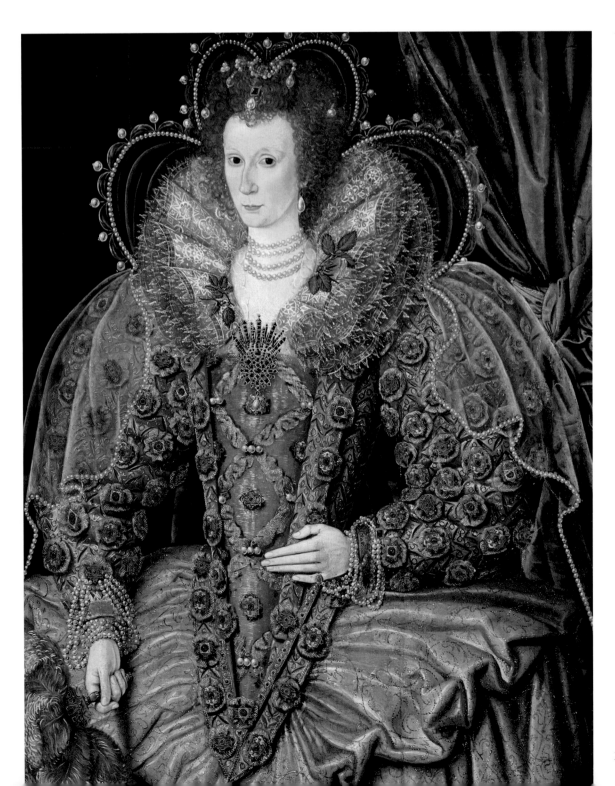

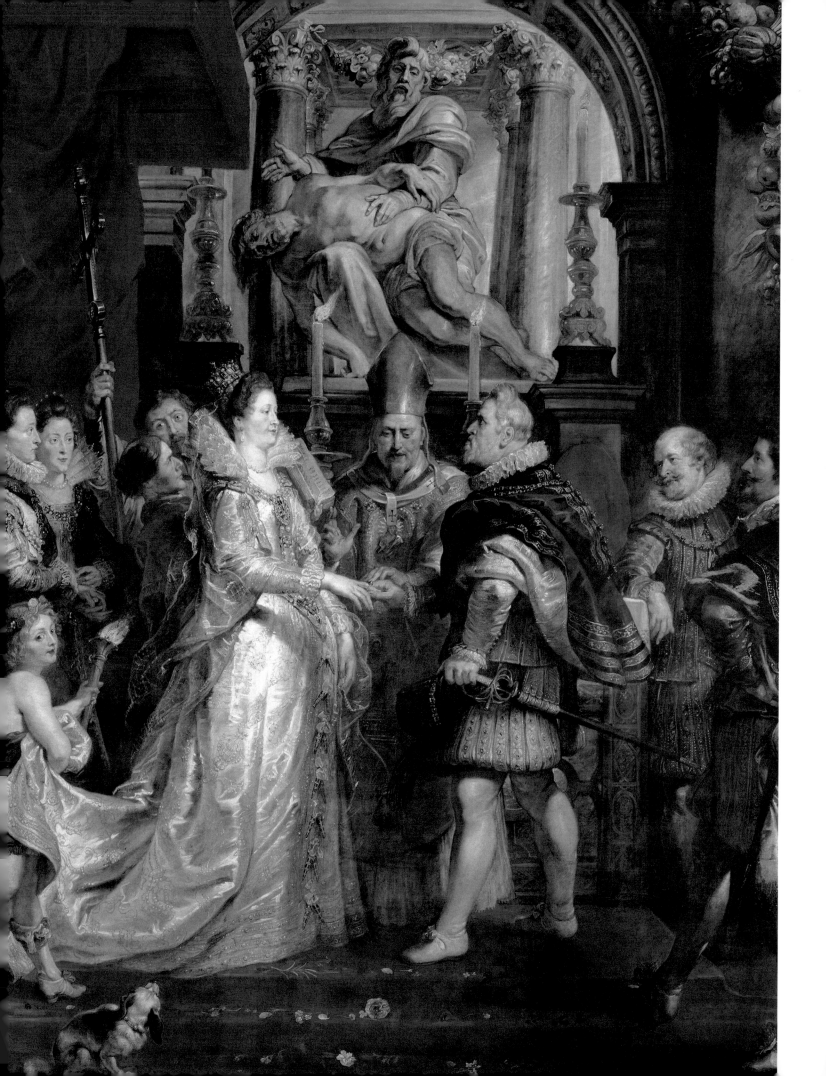

Marie de' Medici
An Italian in France

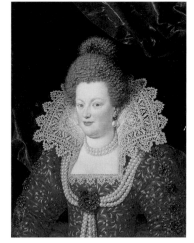

In France, Marie de' Medici gave her name to the towering Medici collar, which looked very similar to the Stuart collar worn in England. At her coronation in 1610, her clothing was embellished with the fleur-de-lis pattern and ermine (below).

Oh, mon Dieu! It had to be an Italian who restored France to its status as a fashion power! Marie de' Medici (1575–1642) may have been small and plump, but she had a taste for pomp, ostentatiousness, and the fine arts. The youngest daughter of the Grand Duke of Tuscany was said to be exceedingly ambitious, and knew how to spot a trend. Although she was one of the wealthiest heiresses in Europe, she did not marry the French king Henry IV until the age of twenty-five. He was able to pay off his debts with her dowry. Her husband was not himself present, but rather sent a representative to the proxy wedding ceremony, which took place in Florence in 1600. And yet Marie was the first woman ever to wear an ivory-colored wedding dress onto which gold ornaments had been stitched. When Henry met her in person two months later, she brought not only her Italian style to France, but also the expression "alla moda italiana," or "in the Italian style." She enchanted her husband with her plunging neckline, which was framed by an upright, fan-shaped lace ruff (typical for its time). What was called a Stuart collar in England became known as a Medici collar to the French. With just one difference: Marie's necklace towered even higher than its English counterpart. Like Elizabeth I, she used it to demonstrate her power and unapproachability. For the Italian also had to establish her authority at court: her husband was known to be a womanizer and refused to give up his mistresses. Marie was even called a "fat banker" by her greatest rival, because of her large fortune and matronly figure. But her retrospective coronation as queen in 1610 strengthened Marie's position: in the case of the death of her husband, she would be allowed to act as regent for her son, who was still a minor. Just one day later, Henry was stabbed to death. From then onward, his widow orchestrated her own aggrandizement. A series of paintings by Peter Paul Rubens (The Marie de' Medici Cycle), representing the different stages of her life, is one of a number of remaining pieces of evidence. Following years of power struggles with her own child, Louis XIII, Marie had no choice but to flee. Not a single ruler dared to give refuge in his country to the former regent after she had been found guilty of high treason. Marie de' Medici finally found shelter in a simple house in Cologne, in which Peter Paul Rubens had lived as a child. There she died in loneliness and poverty. Her legacy is all the more precious: the word "moda" or "fashion." It remains indispensable and cannot be replaced by any other word.

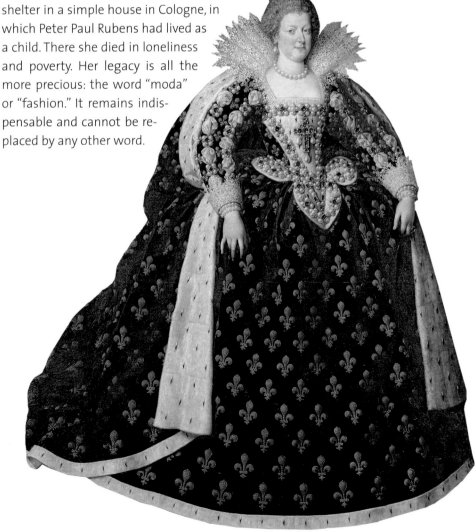

Left: Peter Paul Rubens painted Marie de' Medici wearing the first white wedding dress in history at her wedding by proxy (with a substitute) in 1600.

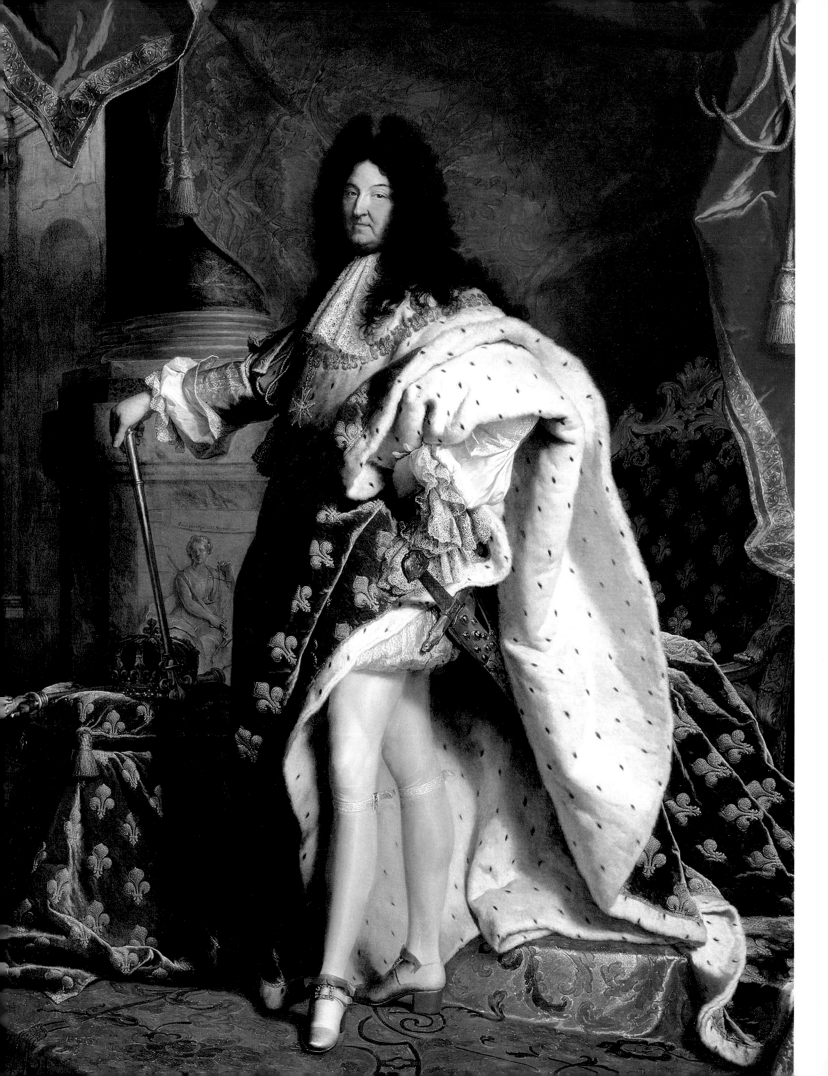

Louis XIV
A High-Heeled King in "Louboutins"

He was considered the greatest shoe fetishist of his time: the red sole was not invented by the designer Christian Louboutin, but by his compatriot Louis XIV (1638–1715) long before him. As the French king was very small, he ordered that the soles of his shoes be underlaid with cork and covered in red leather: the color of kings. Only the aristocracy was allowed to wear these wonder shoes at the time. The king cleverly turned his love of fashion into a source of revenue. France in the seventeenth century became an economic and political superpower once again, and also made a fortune with its new textile factories. After all, the king had to finance not only the wars, but also his excessive and luxurious lifestyle. Louis XIV's royal household at the Palace of Versailles alone included 20,000 servants. After his accession to power in 1661, within a mere ten years the French monarch would become the greatest trendsetter of all times. The absolutist Sun King lived according to the slogan "L'État, c'est moi" ("I am the state") – and also

expressed this through his clothing. He even went so far as to allow himself to be dressed in front of a circle of élite courtiers every morning. All the princes of Europe imitated him, so that it eventually became impossible to distinguish between the fashions at the various national courts. The newly developed textile industry played a role in this development: it disseminated French fashion to the whole of Europe at great speed. While the silk fabrics were manufactured in Lyon, most of the designs originated in Paris.

But Baroque ladies and gentlemen paid less attention to clothing than they did to the leg: during Louis's reign, this became the focus of courtly elegance, so that even the seams of silk stockings were intricately decorated. Overall, the men decked themselves out to look like living works of art. Their clothing was adorned with hundreds of bows, laces, and other frills so that very little of the fabric itself remained visible. For festive occasions, what

Sun King Louis XIV drew attention to his pumps with an elegant gait. The soles and heels were covered in red leather, a prerogative of the high nobility. This most elegant of colors was extracted in a painstaking process from the secretions of the snail Hexaplex trunculus.

27

When Louis started to wear an *allonge perruque*, all male members of the aristocracy also bedecked their heads with false "lions' manes." The hairstyles of ladies reached great heights from 1685 onward (right), and even Mary II of England posed with a hairstyle à la Fontange (below).

Below right: The king in 1711, wearing a brown wig, by way of exception, surrounded by his son, grandson, and great-grandson, whom he loved more than anybody else.

were already precious robes were embellished with as many diamonds as could be afforded, so that the king and his entourage sparkled like Christmas trees. At Louis's court all clothing had to be made of lace, satin, silk, and brocade. At the time, wool was only considered good enough for the common people. Simultaneously, aristocratic men's knee-length legwear became so wide that it developed into a predecessor of the trouser skirt, related to petticoat breeches and rhinegraves. When Louis felt that he was too old to wear such a "youthful" item of clothing, he wore knee breeches, also known by the French term *culottes*.

The hair of the Sun King, too, began to thin as he became older, so that he had to start wearing a wig. Louis turned this flaw in his appearance to his advantage. He wanted to look like a lion, which was at that time a symbol of masculine elegance and beauty, and thus had his hairpiece dyed

blond. Weighing two and a half kilograms, the *allonge perruque* (French for "lengthening wig") became the most important status symbol and representation of high society. Wigs became so voluminous that men considered it prudent not to wear their hats on their heads any more, but to carry them under their arms instead.

While the curls of gentlemen's wigs cascaded down the chest and back all the way to the waist, ladies styled their hair à la Fontange, a work of art made of lace and ribbons, the addition of hairpieces, and a tall bonnet, folded vertically at the back of the head. This hair creation was supported by a construction made of wire. It was Duchess of Fontanges, a mistress of the king, who gave her name to this hairstyle around 1685. Louis was in fact married to Maria Theresa, daughter of the king of Spain (Louis hoped to acquire Spanish land), but the aristocracy of the time considered marital fidelity

Mary II
in 1692

"bourgeois." The following story describes how his mistress started this hair fashion: during the course of a hunt on horseback, Duchess of Fontanges had no choice but to tie her disheveled hair using a stocking. The king was so taken with this look that all women at the royal courts of Europe began to wear towers of hair on their heads. Some of them jutted sixty centimeters into the sky. Whether this story is true or not, one thing is certain: when Louis became tired of his mistress, this powerful man was unable to ban women from donning the beloved hairstyle.

After a strict fashion reign that lasted several decades, the Sun King's death triggered a style revolution. And it was high time for a change. Louis's cumbersome, sumptuous robes were displaced by pastel-colored, frivolous rococo clothing. The *allonge* was cast aside in favor of white powdered wigs. But the aristocracy continued to wear the Sun King's wonder shoes until the French Revolution. Nowadays, Christian Louboutin and the fashion label Yves Saint Laurent are locked in a dispute about the red sole.

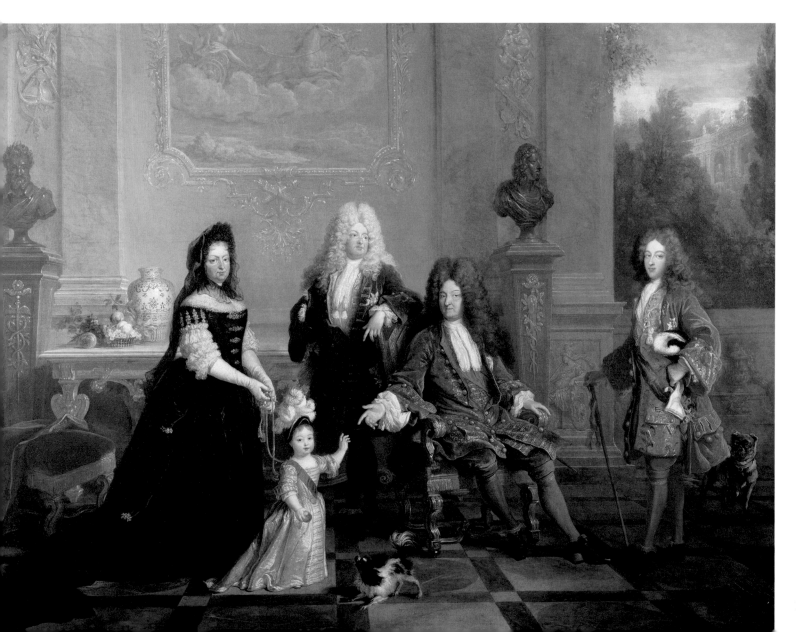

That's All, Folks!
The End of Courtly Fashion

Simply put: during the Rococo period, the aristocracy was in love nonstop – the lords and ladies saw the world through rose-colored glasses. The death of Louis XIV in the year 1715 ushered in the last chapter of courtly fashion. From then on it was all about *amour fou*, coquetry, and all things related to love, even in fashion. The five-year-old Louis XV (1710–1774) inherited the throne from his great-grandfather as all other possible heirs had already died. A regent was appointed for the boy, and the royal court moved to the French capital. The members of the aristocracy, too, turned their backs on Versailles and developed their own ceremonies in their Parisian palaces. They lived as though there were no tomorrow, and refocused the spotlight of fashion back on women. The court did not return to Versailles until 1722. At the latest by the time Louis took charge of the affairs of state at the age of sixteen, the royal residence slowly returned to its status as the center of aristocratic trends. As the sober English fashion became popular in the rest of Europe in the second half of the 18th century, the garments worn at Versailles became increasingly pretentious.

The aristocracy used the laws of good taste as insulation from the dangers posed by the rise of the bourgeoisie. Wearing the most precious fabrics and jewels was just not good enough; good taste was of even greater importance. During the period of Rococo, decoration and presentation played an even larger part than the dress itself. When Marie Antoinette married Louis's grandson, the heir to the throne, in 1770, she established a cult around her clothing. The robes of the queen-to-be and her royal

The aristocracy's fashion mania culminated in a hairstyle craze before the French Revolution: wild works of art made of feathers, bows, and countless knickknacks were created on women's heads.

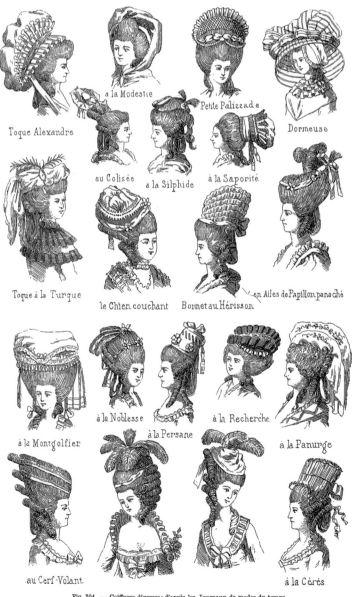

Toque Alexandre

à la Modestie

Petite Palissade

Dormeuse

au Colisée

à la Silphide

à la Saporité

Toque à la Turque

le Chien couchant

Bonnet au Hérisson

en Ailes de Papillon panaché

à la Montgolfier

à la Noblesse

à la Persane

à la Recherche

à la Panurge

au Cerf-Volant

à la Cérés

Fig. 304. — Coiffures diverses; d'après les Journaux de modes du temps.

Caricatures: Around the year 1770, theatrical performances "en miniature" were staged on hats as well as in hairstyles. As their mountains of hair represented a paradise for mice and other rodents while they slept, these women protected themselves using wire bonnets from England.

household were embellished with artificial flowers, frills, feathers, bows, laces, and flounces. Every element had its own particular meaning: the noble ladies developed a silent language and communicated their love, or rejection, through their accessories. Proper trends were considered unaffordable because fashions changed from one week to the next. "Old-fashioned" robes were handed down to servants or sold in the first-ever secondhand shops in history.

In addition to the usual pastel colors, high society constantly invented new color nuances. This included "puce", the color of fleas, which in turn gave rise to further absurd nuances: old flea, young flea, flea head, flea back, and many others. The last hoorah of aristocratic fashion was to be found on women's heads. Here, hair artists created stage sets "en miniature": small dolls,

animals, and all sorts of knickknacks symbolized a woman's inner life. These hair sculptures were not just seen as unbelievably fashionable, but were also a paradise for lice and small rodents. As mice were fond of nesting in sleeping ladies' hair, wire bonnets promising protection were for sale in England.

The storming of the Bastille in 1789 put an end to the excessive splendor with which the aristocracy surrounded itself. Those who survived fled and only wore their sumptuous clothing far away from France, and secretly, amongst themselves. Their fashions did flare up again at the French court, under Napoleon I (1769–1821) and his wife Joséphine (1763–1814). The revolution had, however, given rise to a new and permanent bourgeois fashion stratum: those whose wealth bought social privilege.

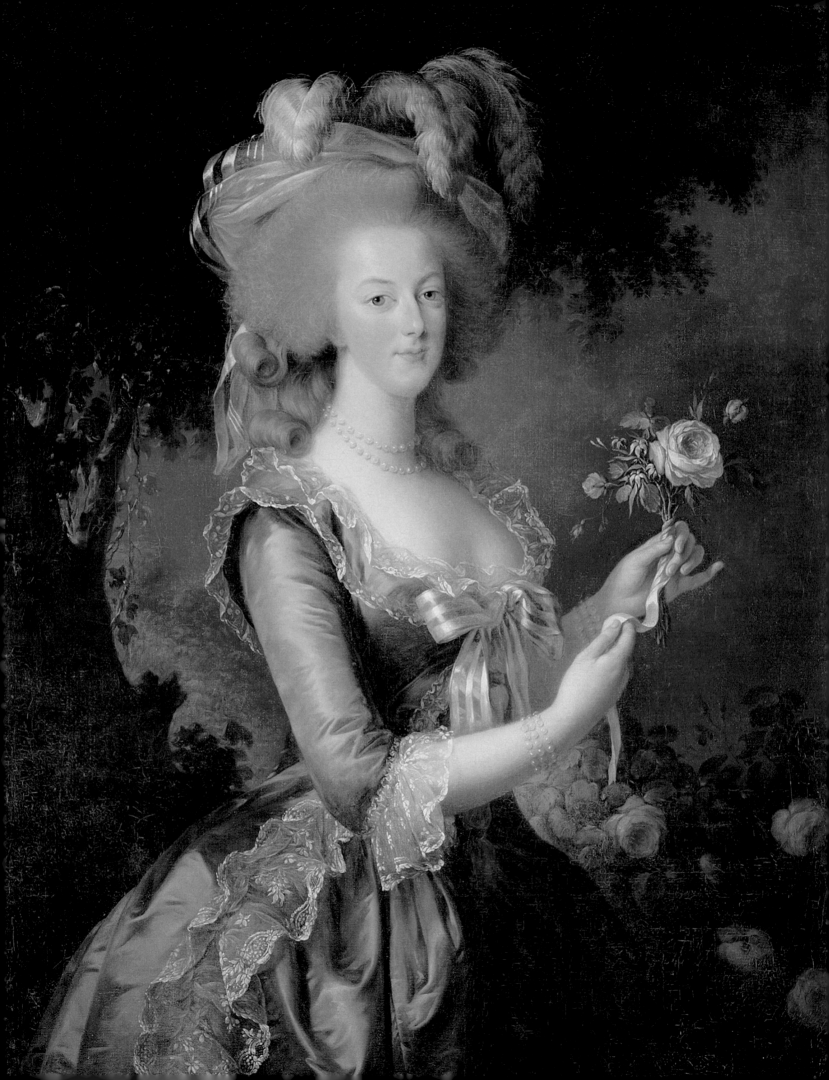

Marie Antoinette, Sisi & Co.

The First It Girls in History

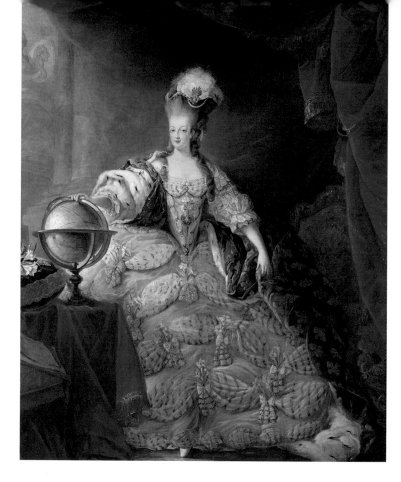

Queen Marie Antoinette
The Paris Hilton of Rococo

She was stupid, arrogant, and crazy about fashion. The French queen Marie Antoinette (1755–1793) drove entire families into financial ruin toward the end of the eighteenth century when all the ladies at the court of Versailles copied her trends, which changed weekly. The wife of Louis XVI (1754–1793) was not interested in politics, economics, or history. Instead, all she could think about was fashion; she was, after all, still young. At the age of just fourteen, the girl became a victim of her mother's marriage politics. Empress Maria Theresa of Austria wanted to ensure peace between the Habsburgs and the House of Bourbon, choosing her fifteenth child for the French heir to the throne. But the fifteen-year-old Louis-Auguste was no more than a boy himself. When Maria Antonia arrived at the court of Versailles, she was given the name of Marie Antoinette and felt completely out of place. The future queen of France was never to see her mother again, and only her brother Joseph II would visit her, once.

Her love life turned out to be even more difficult: Marie Antoinette tried in vain to seduce her husband into bed. Louis-Auguste is said not to have consummated the marriage until years later.

No wonder that the unhappy girl had to look for a way to occupy herself. Her own mother put her up to it: in a letter written in the year of 1770, the empress scolded her daughter, stating that rumors of Marie Antoinette's lack of attention to personal hygiene had reached even her, in faraway Vienna. This criticism is particularly amusing when one considers the state of hygiene at the time: people simply dabbed themselves clean without using water, and masked their own smell with that of heavy perfume. The mother's chastisement had an effect: Marie Antoinette fell prey to an obsession with beauty and soon dictated the trends in fashion at Versailles.

She was aided by Rose Bertin, the Patricia Field of Rococo. The first female fashion designer in history became the future queen's

"Let them eat cake": Marie Antoinette usually exceeded her yearly budget by a factor of two. She loved bows and other decorations, whether on her ceremonial court dresses (top) or on her gala gowns, the *grande parure* (right).

Her expansive hoop skirts resembled the chicken baskets of market women and were therefore referred to as *paniers*.

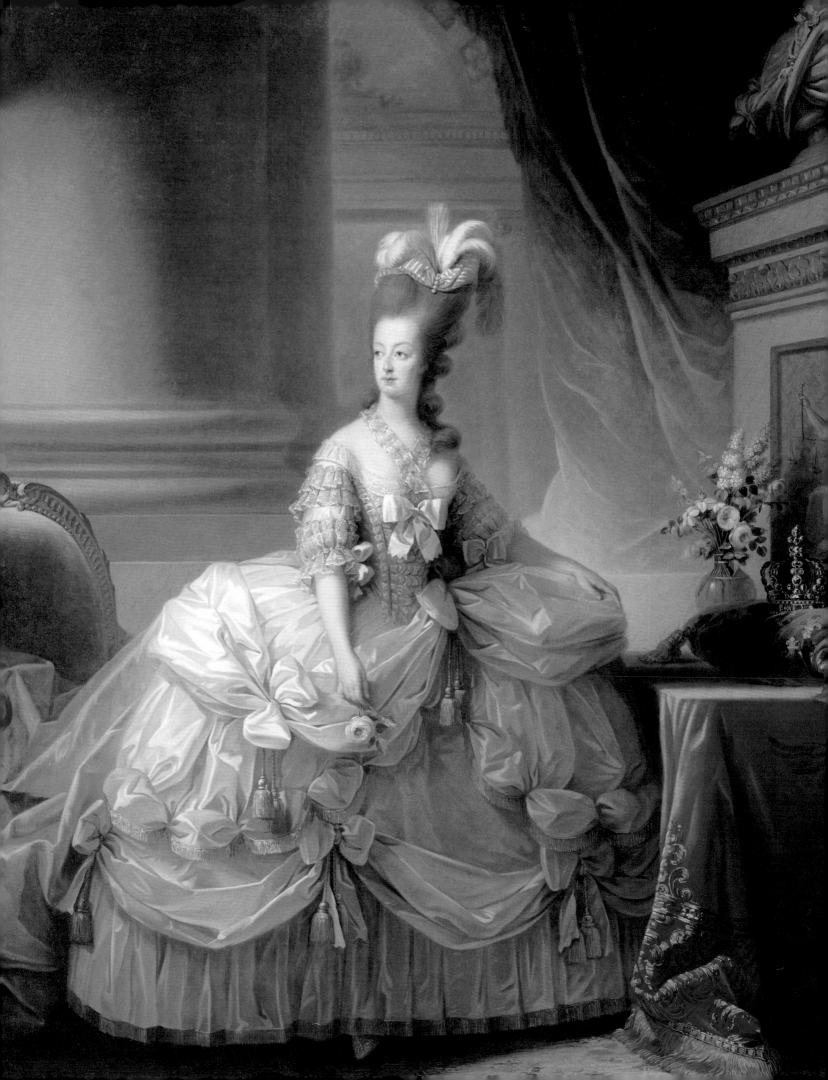

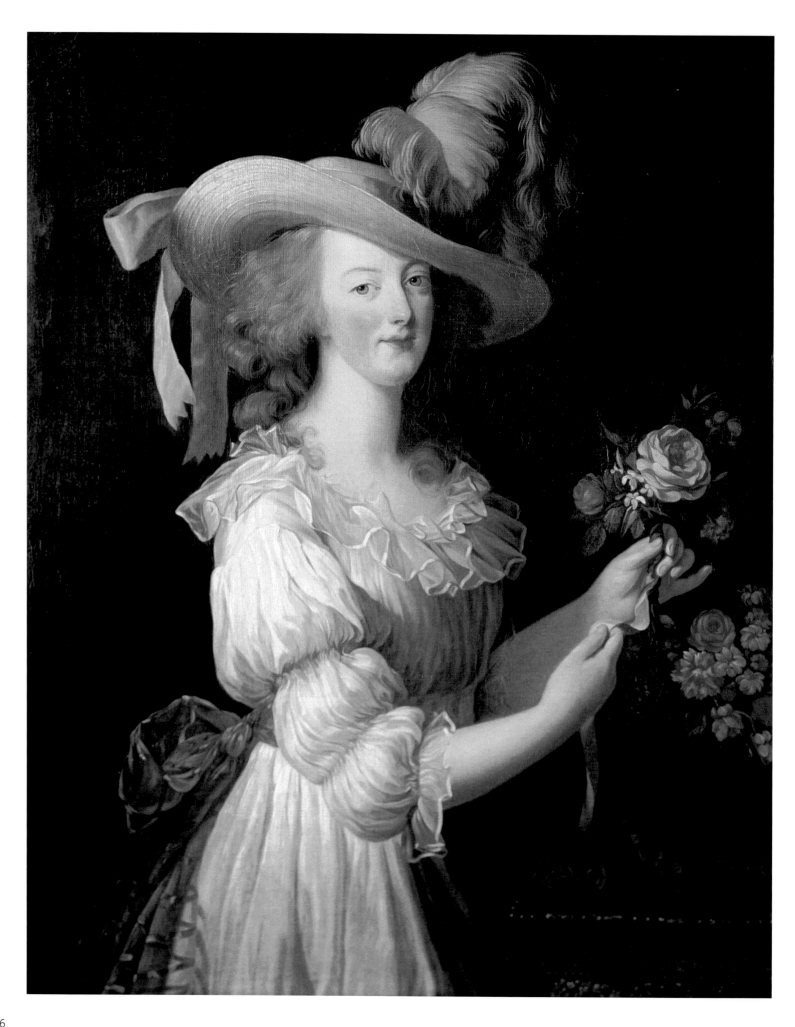

66 I for one, I find her so inspiring. She died so badly, to pay for her sins. Yes she spent money that she shouldn't, but she was young and bored. **99**
Manolo Blahnik

Scandal! In a portrait painted in 1783 by her favorite painter, Élisabeth Vigée-Lebrun, Marie Antoinette wore an airy white dress... as a result, the court gossiped about her "nightdress." The queen determined the newest trends every week, together with her "Minister of Fashion" Rose Bertin (right).

"Minister of Fashion" and closest confidante. With Rose Bertin's styling skills, Marie Antoinette unleashed a veritable fashion frenzy two years after she became queen. Rose Bertin was not a designer in the true sense of the word; she did not tailor, but embellished robes with ribbons, lace borders, bows, and artificial flowers. She adapted the aristocrats' dresses to the very latest fashions in her shop on one of Paris's famous roads of luxury establishments, the Rue Saint-Honoré. Together, she and the queen decided on current trends. For this, they retired to the queen's private chambers twice a week and had several-hour-long discussions. Marie Antoinette decided not only what, but also when something would be in fashion. Many blamed Rose Bertin for the queen's profligacy. The queen always exceeded her yearly budget of 120,000 livres, usually spending double that. A considerable part of this ended up in her enterprising couturier's till. In around 1780, Marie Antoinette favored simple white dresses that conveyed a sense of simplicity but were equally expensive.

When she had her portrait painted in one of these dresses by her court painter, Élisabeth Vigée-Lebrun, in 1783, she caused a scandal: the queen was to be seen in her "nightdress." In the meantime, she had become the object of the hatred of the poor because of her excessively luxurious lifestyle.

In 1785, at the age of thirty, the queen reconsidered her sartorial luxuries, renouncing feathers and flowers and wearing comparatively simple gowns instead. But it was too late by then: Marie Antoinette was guillotined on October 16, 1793, nine months after her husband, going down in history as the Queen of Elegance. During her time in prison, close confidantes supplied her with precious underwear so that she could at least be elegantly dressed under her rags.

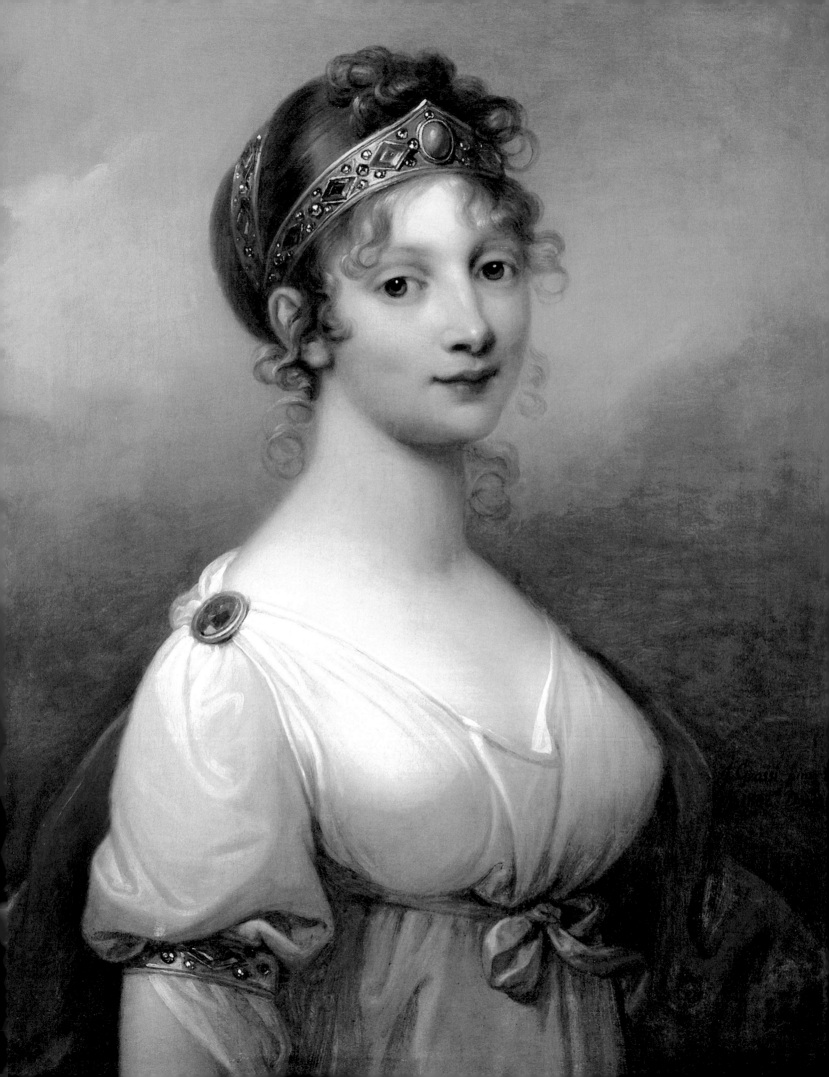

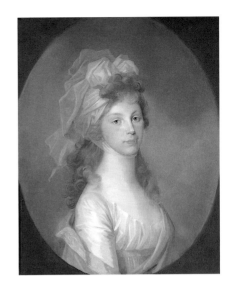

> 66 Yesterday, the Queen of Prussia dined with me. I had to put up quite a fight against the additional concessions she wanted to force me to make to her husband. But I simply remained polite and stuck to my policies. She is very attractive... 99
> *Napoleon*

Louise of Mecklenburg-Strelitz
Supergirl in "Nude Fashion"

She was as sexy as Marilyn Monroe and made the nude look popular. With her blue eyes, blond curls, and translucent empire-line dresses, Louise of Mecklenburg-Strelitz (1776–1810) turned a lot of heads, including that of the emperor Napoleon – not least because she was quite a bit taller than he was. This supergirl of the past went out in the most delicate of dresses and loved light, white robes in the style of antiquity. The queen wore flesh-colored body stockings underneath the dainty muslin fabrics, robbing even poets like Goethe and Kleist of their faculties. But she was happily married: Louise was pregnant for most of the sixteen years following her wedding to the Prussian heir to the throne Frederick William III (1770–1840). Her choice of clothes proved incredibly practical in this respect: the queen gave birth to ten children (one of them stillborn) and concealed her baby bump beneath flowing dresses. "Miss Prussia" became a style icon in her realm – every woman, from countesses to commoners, copied the Louise Look.

But there is no hiding it: the queen had actually copied this sexy style herself. As a woman of the world, she kept up to date about trends in London and Paris by reading magazines such as the *Journal des Luxus und der Moden* (Journal of Luxury and Fashion). Sometimes, the *dernier cri*, or latest fashion, was even delivered by express messenger, in accordance with the queen's orders. The capital had fallen in love with wafer-thin white fabrics. Louise made this look popular in Prussia. The new style did not come out of the blue: the ladies wanted to free themselves from the bombastic ballast of the Rococo style by wearing these light robes. Everything reminiscent of the old kingdom was, after all, frowned upon in the wake of the French Revolution; citizens who wore powdered wigs were labeled Royalists and sometimes even guillotined. Instead of squeezing themselves into corsets, women tied their low-cut dresses loosely beneath the bust. Naturalness was the order of the day! Louise combined her gowns with accessories such as combs, headbands, cameo brooches, and colorful cashmere scarves (draping was regarded as an art in its own right). She is said to have owned sixty-five gowns, which at the time represented a small fortune, even for a queen. Her husband was correspondingly frugal when it came to his own clothing budget. As Louise had introduced the forbidden Viennese Waltz at court in Berlin, society wore flat slippers instead of high heels. And another attribute became a trend, too: when the queen appeared in a white headscarf tied beneath her chin, all women followed suit. The myth about her muslin scarf is often misinterpreted, however; she did not want to hide a swelling on her neck, but was simply taking her cue from the fashionable "Oriental" style.

Not only her look, but also her love for her timid husband was considered unusual. Louise addressed him in an informal manner, which amounted to nothing short of a miniature revolution at the time, and was his closest confidante. The Prussian queen acted as a mediator between the monarchy and the citizenry, and was the first "queen of hearts," long before Princess Diana. She expressed her closeness to the

Long before Princess Diana, Louise of Mecklenburg-Strelitz became the "queen of hearts": her portraits always depicted her looking rather girlish in order to make her appear more approachable in the eyes of the common people.

Top: In tying a scarf tied beneath her chin, this trendsetter was in tune with the latest "Oriental" fashion. Muslin scarves were tied around women's necks or into their hair in a variety of different styles at the time.

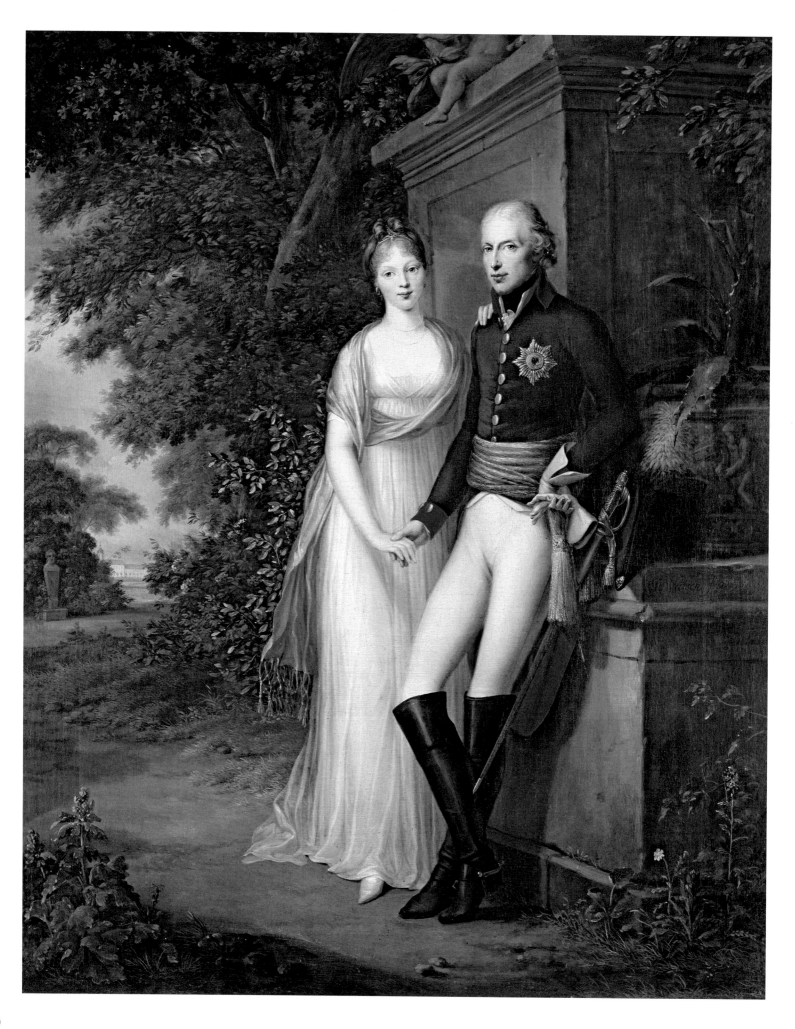

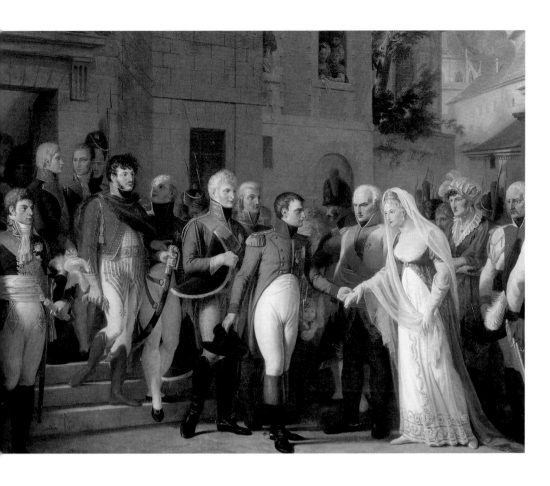

In hopes of negotiating less – punishing peace terms for her country, Louise fluttered her eyelashes at Napoleon in Tilsit in 1807. To no avail. Instead, he showered her with compliments on her dress.

Below: The queen loved white muslin gowns.

Left: Louise and Frederick William's marriage was considered to be unusual as they held hands.

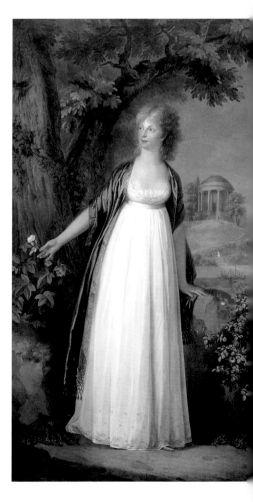

people through her clothing, too: Louise considered her outfit very carefully before a portrait of her was painted, and she made a point of not appearing too regal. Instead, she capitalized on her girlish appearance, so that even her greatest adversary, Napoleon, raved about her after their first meeting.

Their meeting took place under the following circumstances: after Prussia had suffered severe defeats in the war against France, the beautiful queen was employed as a secret weapon. A court lady reported of the famous meeting in Tilsit in East Prussia on July 6, 1807: "I hardly remember having seen Louise look more beautiful than she does during what is for her a very difficult time." Napoleon drowned in her blue eyes and, instead of talking about less punishing peace terms, attempted to steer the conversation to her crêpe dress, interwoven with silver, until her husband Frederick William entered the room. "If the king had come quarter of an hour later, I would have promised Louise anything," Napoleon is supposed to have said following the meeting. This quotation is certainly also part of the myth that grew around the beautiful queen. There is no doubt, however, about the fact that Prussia lost almost half of its territory, and Louise even sold her personal jewelry, one of the most valuable private jewelry collections in Europe, to raise money for her indebted kingdom. The sadness she felt for her country did not leave her until she died. Her death may even have been caused by her seductive dresses: the popular queen died in 1810, at the age of thirty-four, of pneumonia. Because women wore their wafer-thin Empire-style dresses without coats even during the winter, colds were also jokingly referred to as the "muslin disease."

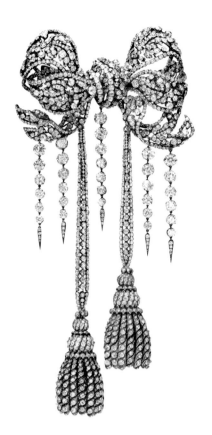

Addicted to jewels: In order to shine at court, Empress Eugénie ordered that the crown jewels be reworked. The pearl tiara was made for the occasion of her wedding.

Left: Her favorite brooch, the famous corsage bow with tassels, is made of 2,634 diamonds. The Louvre bought the jewel at auction in 2008 for nearly seven million euros.

Eugénie de Montijo
A Muse for Tiffany Blue

Her taste alone influenced the entire textile industry: all of France rushed to their tailors to copy whatever the empress consort Eugénie (1826–1920) wore. After the Italian Marie de' Medici, it was now the turn of a Spanish woman to become the greatest trendsetter at the French court. Although the people referred to the wife of Napoleon III (1808–1873) dismissively as "l'Espagnole," Eugénie was able to make a name for herself – in fashion. She brought the court back into the fashion spotlight – in the "second Rococo" period the corset and hooped skirt made a comeback. She was supported in her efforts by her royal colleagues: in England and Austria, Queen Victoria and Empress Elisabeth, two young and ambitious women, helped to make court, and its fashions, trendy once again.

Although Eugénie was happily married to the nephew of Napoleon I, she fell for another man: Charles Frederick Worth (1826–1895), the first couturier in history.

Their relationship was entirely platonic, but he managed to wrap the fashion-obsessed empress consort around his little finger. Worth was the first designer to show the clothes he had made on models, to present summer and winter collections, to transform fashion shows into society events, and to turn himself into a star by signing his creations as though they were works of art. He employed a trick to also conquer the European courts: he offered to dress the wife of the Austrian consul for a "special price" of 300 Francs per robe. For a state ball, he enveloped Pauline von Metternich in a complicated construction made of tulle, daisies, pink hearts, tufts of grass, and silver sequins. Eugénie immediately fell in love with this idiosyncratic creation and summoned the Englishman to the French royal court. From then on, she would no longer be dressed by a loyal court dressmaker, but by a designer who had his own style. This went so far that the empress consort suddenly started to wear skirts that revealed

her ankles, which was at first quite a shock to polite society. Following the brazenness of the empire style, prudishness had become fashionable again, so that even the Austrian imperial couple was outraged by Eugénie's revealing look. During a carriage ride together, Franz Joseph is supposed to have warned his wife, in a sharp tone of voice, "Be careful when you step out of the carriage, the people could see your feet." The Austrian ruler was also among Charles Frederick Worth's clients, but wore only modest, floor-length dresses.

The longer the couturier worked for Eugénie, the more obsessed she became with fashion. When the empress consort ceremonially opened the Suez Canal in 1869, in the presence of numerous princes, she took 250 dresses of taffeta and gold and silver brocade with her. Each one of them was worth a fortune. She loved pearls and diamonds even more than she loved clothes. Like Marie Antoinette before her, the empress consort often had her jewelry

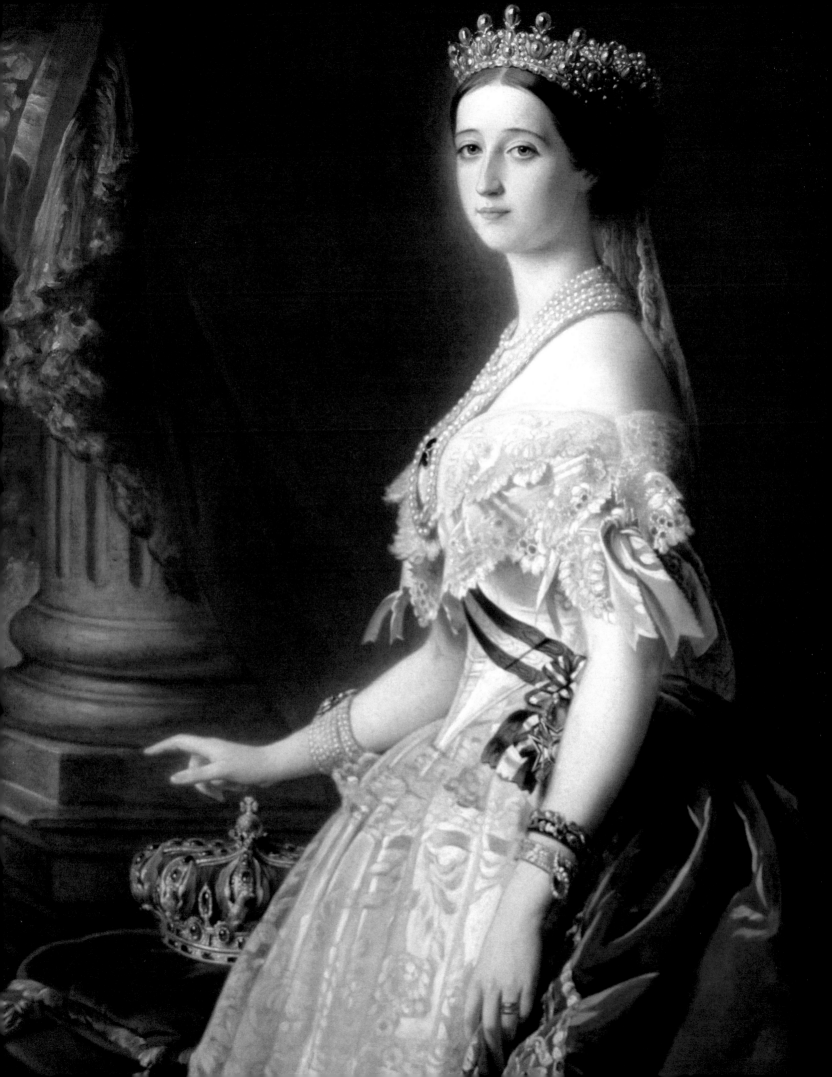

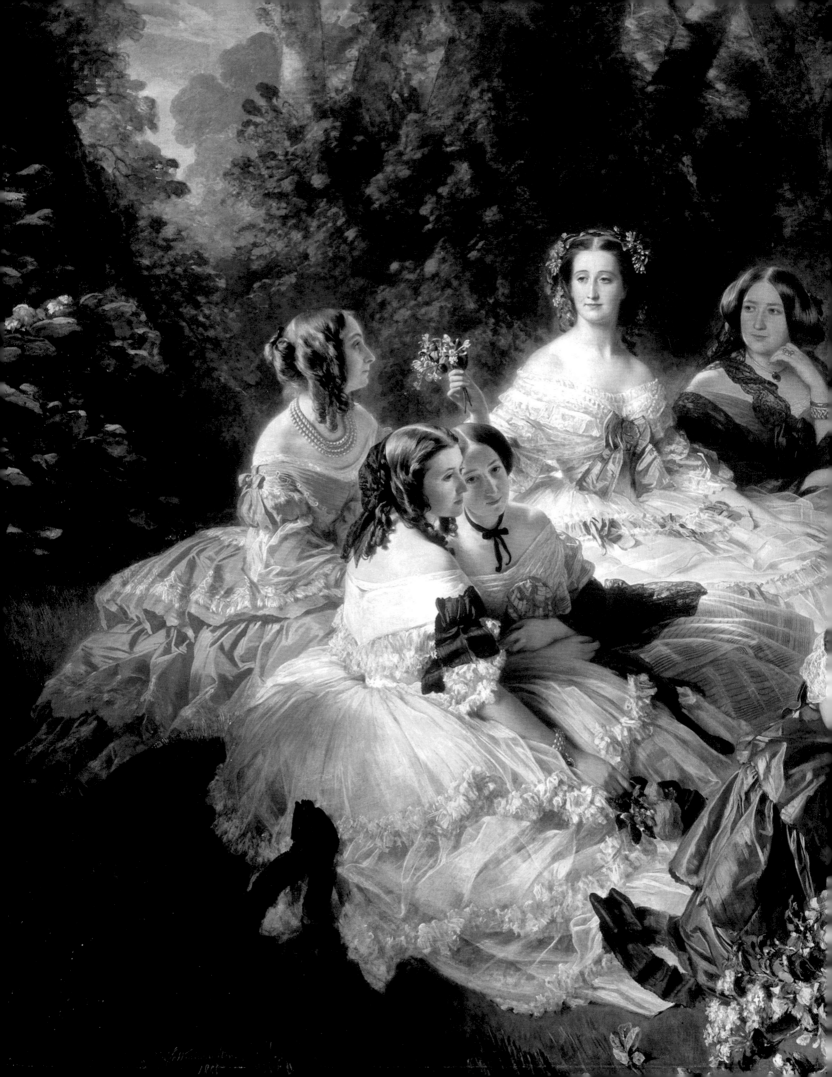

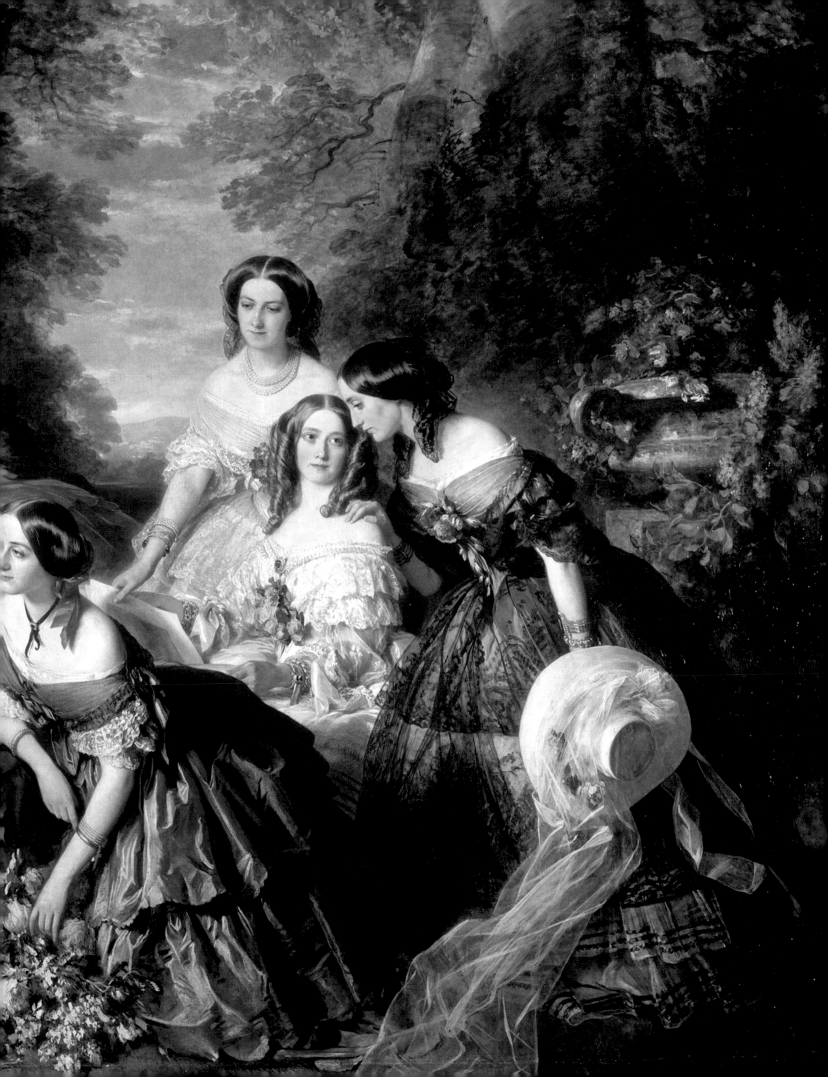

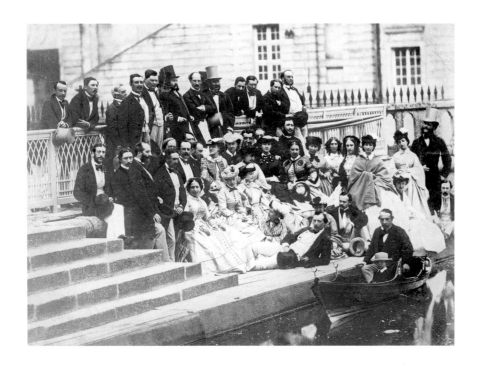

skirts took on hitherto unimaginable dimensions and simultaneously signified the inapproachability of the empress consort. The entire female population followed suit. While the silhouette of suit-wearing men became ever taller, the shape of women extended up to 2.5 meters horizontally, thanks to the use of "artificial crinolines." This new fashion represented a nightmare for every host: while two or three women had fitted onto one sofa in the past, there was barely enough room for one now. Furthermore, it was a highly dangerous affair: there was the risk of being blown off the ground, skirt and all, during a storm, and fatalities resulting from contact with fire were not uncommon, as it was virtually impossible to save the victim among the mountains of fabric. In 1868 Worth invented a new silhouette: he smoothed the fabric on the stomach and hips, and gathered it together above the buttocks to form a so-called bustle.

remodeled, for which she was particularly fond of using French crown jewels. Her favorite brooch was an enormous corset bow with tassels (22 cm high and 10.5 cm wide), made with 2,634 diamonds totaling more than 140 carats. It was originally the centerpiece of a belt that her husband had commissioned from the French jeweler François Kramer in 1855. In choosing her official color for the court, too, she took inspiration from Marie Antoinette, who had selected a bright shade of blue. Eugénie transformed the color into a modern turquoise shade. The American jeweler Charles Lewis Tiffany had recently opened his first European store in Paris and was smart enough to introduce the empress's blue as the color for his elegant packaging.

But with the exception of crown jewels and court colors, the aristocracy of the nineteenth century had to share its status as a trendsetter with those whose wealth entitled them to social privilege. Both the aristocracy and the nouveau riche tried to outshine each other in terms of elegance, with Eugénie miles ahead of everybody else. She loved the crinoline – at the beginning a petticoat of linen stiffened with horsehair. In 1856, when feathery steel splints were invented, her cage-shaped hooped

When Eugénie appeared in this new creation at a ball she probably set a trend for the last time; following defeat in the Franco-Prussian War (1870–71), she spent a lot of her time at the court of Queen Victoria in England. A Spaniard by birth, she died in Madrid in 1920 at the advanced age of ninety-four. To this day, her official court color remains the trademark of the most famous jewelry label in the world and is now known as "Tiffany Blue."

Top: Eugénie (first lady from left) with her royal household in 1860, in front of the Palace of Fontainebleau. In the boat: husband Napoleon III and their only son.

Right: The empress sporting the latest trend: a Florentine hat.

Previous double page: Eugénie commissioned a painting by Franz Xaver Winterhalter of herself with her ladies in waiting. In it, she wears a white gown with purple bows by Charles Frederick Worth.

Eugénie took inspiration from her fashion idol Marie Antoinette, so that France experienced a "second Rococo" period under the empress.

Below: Thanks to the new, lightweight steel splints, women's hoop skirts took on enormous proportions so that dressing became an art form.

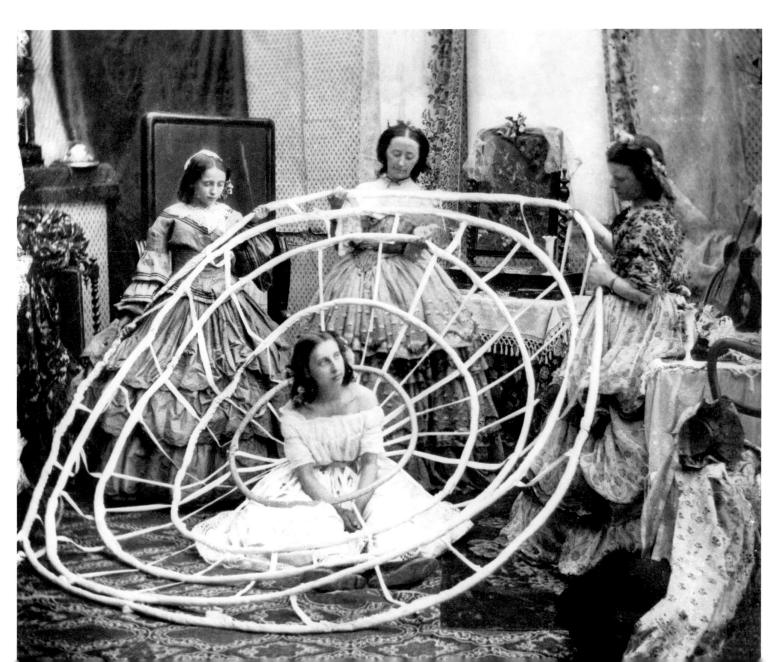

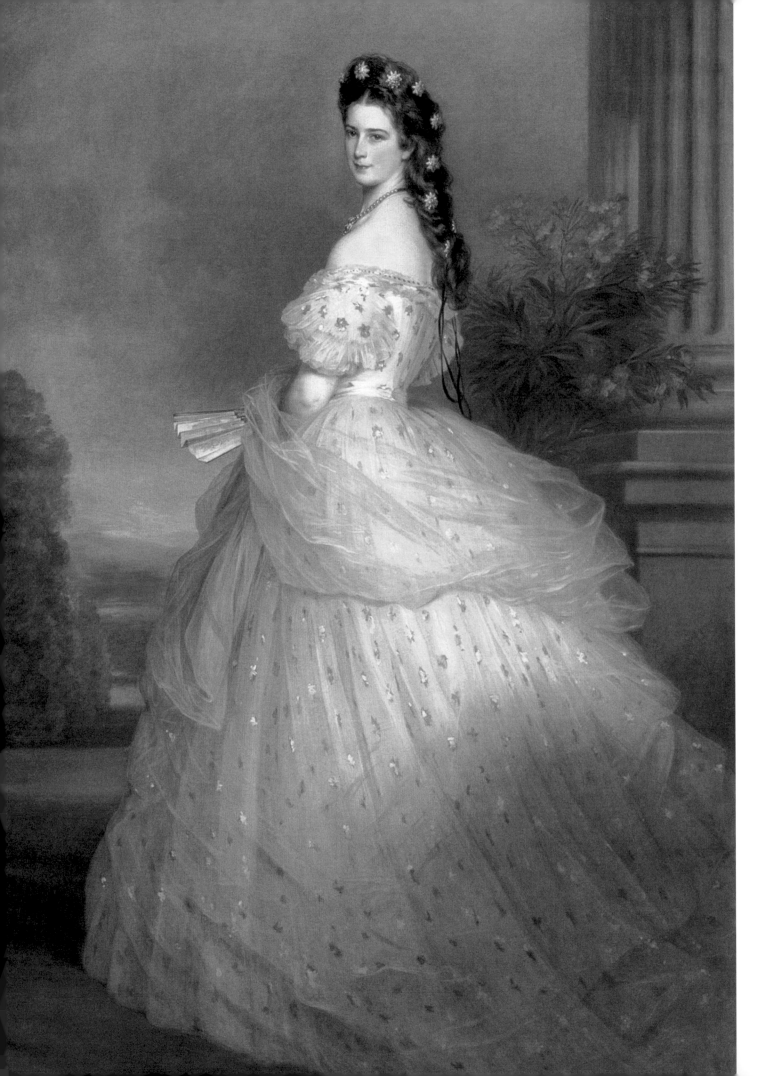

Sisi
The First German Supermodel

Her floor-length hair was a cult object, and often it took three hours to style, plait, and skillfully wind it around her head: Elisabeth, Empress of Austria and Queen Consort of Hungary (1837–1898). The daughter of the Duke of Bavaria became the first German supermodel long before Claudia Schiffer, and was engaged in rivalry with Empress Consort Eugénie for the title of "Beauty Queen". Sisi, as she was called as a child, was so pretty that she became world-famous. No wonder: to compensate for the emptiness of her palace life, she escaped into a beauty cult and tortured herself almost to death with her iron self-discipline. The Empress was busy all day with her beauty routines, dressing, and an unhealthy obsession with fitness (riding, fencing, gymnastics). Just in order to retain her slim waist, she condemned herself to a lifelong diet of coffee, eggs, and meat broth.

Elisabeth was just fifteen years old when her twenty-three-year-old cousin Franz Joseph I (1830–1916) made the surprising decision to make an empress of the untamable girl rather than her older sister Helene, as had been arranged. The girl, who had had a sheltered childhood in Munich and Possenhofen, loved nature, spoke with a heavy Bavarian accent, and

did not really want to leave the environment in which she had grown up. She had no choice, however. Her mother said, "You don't turn down an emperor." The freedom-loving Elisabeth was afraid of the strict Habsburg protocol and sighed, "If only he were not an emperor!" Not long after arriving at court in Vienna, the spirited girl became a depressed, inhibited woman who was dismissed as a "pretty little dunce." Most of the Emperor's time was taken up with matters of state and his mother Princess Sophie took charge of the children's education, and so Elisabeth became very lonely and felt as though she had been imprisoned in the Hofburg Palace in Vienna. After the death of her oldest daughter in 1857, the birth of the heir to the throne Rudolf, and the realization that Franz Joseph was being unfaithful, Elisabeth escaped to Madeira. The official explanation given was consumption.

Two years later she returned an entirely different woman: Elisabeth was at the peak of her beauty, was confident, and even her husband became an ardent admirer once again. And yet the most beautiful monarch on earth would for the rest of her life use clothing as a shield, barricading herself behind her gowns.

The most beautiful monarch in the world: In 1865, Empress Elisabeth ("Sisi") enchanted those who saw her with the star dress by Charles Frederick Worth and her famous signature hairstyle.

Below: Her hair was styled for three hours every day. This "intimate" portrait was intended for the eyes of her husband only, and shows her in her peignoir.

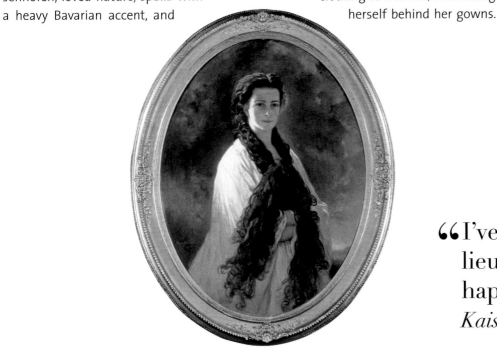

> **"I've fallen in love like a lieutenant and am as happy as a God!"**
> *Kaiser Franz Joseph I.*

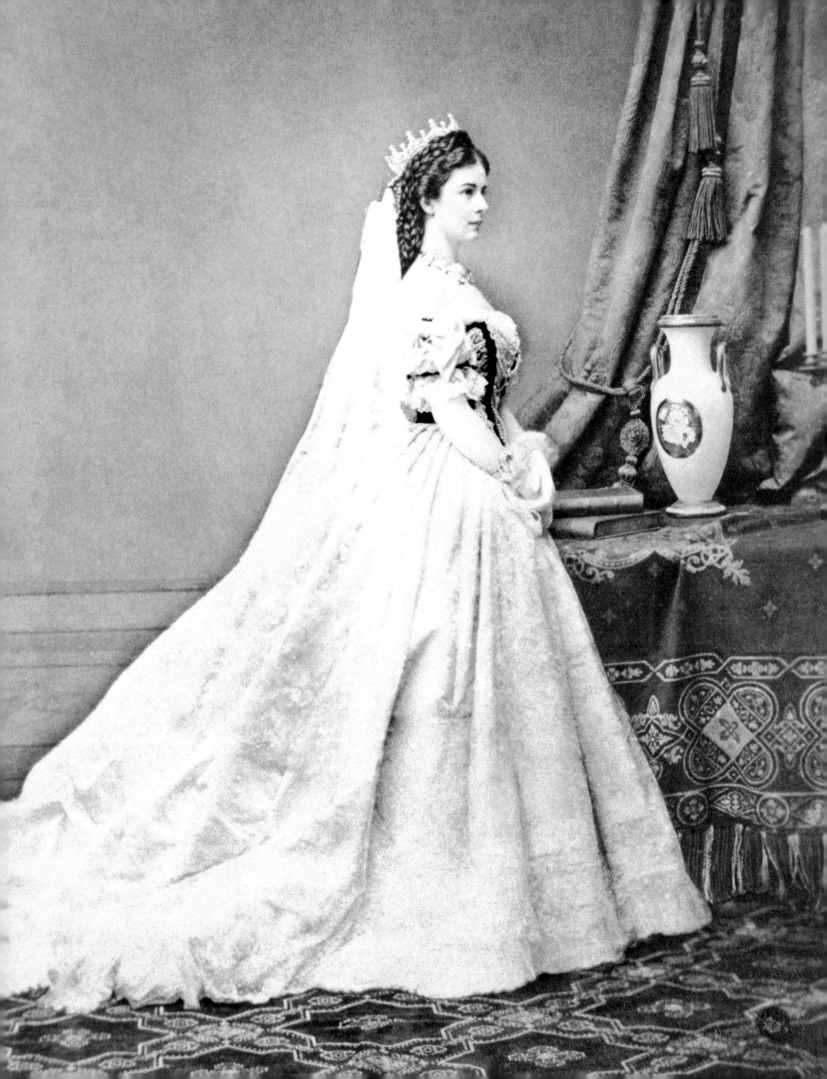

It often took an hour to tie her corset tightly enough to display the Viennese wasp waist to its best advantage. At a height of 1.72 meters, Elisabeth weighed no more than fifty kilograms and was, according to modern medical standards, extremely anorexic. In order to appear even slimmer, she – shockingly – did without petticoats and instead wore leg dresses that resemble present-day leggings. She made even more of a fuss about her magnificent chestnut-brown hair: the imperial mane reached down to her heels and it took almost an entire day to wash it. The vain monarch ordered that loose strands of hair be brought to her in a silver bowl, and she could become extremely cross if there were too many. Instead of following the trend of the 1860s – a tight combed-back bun – Elisabeth had always been fascinated by the imaginative hairstyles of the actresses at the Viennese court theater. She summoned the hairdresser from the theater to court: Fanny Angerer, later Feifalik after her marriage. The hair artist was in charge of the empress's hair from 1863, earned the salary of a university professor, and invented Elisabeth's famous signature hairstyle (see page 48).

Determined not to lag behind her archrival Eugénie de Montijo, Empress Elisabeth was also among Charles Frederick Worth's customers, except that she wore floor-length robes as opposed to ankle-length dresses. The twenty-seven-year-old appeared at her brother Carl Theodor's wedding in 1865 wearing a white robe onto which 500 gold stars had been stitched. The famous diamond stars made by the jeweler Alexander Emanuel Köchert gleamed in her signature hairstyle, and her décolleté was embellished by a camellia bouquet. Franz Joseph was so dazzled by his wife that he had her portrait painted by the court painter Franz Xaver Winterhalter. For the royal coronation in Budapest, the highpoint of her life, she commissioned Worth to come up with a creation incorporating elements of Hungarian national costume adapted to her Viennese wasp waist. After the birth of her favorite daughter, Marie Valérie, in 1868, Elisabeth slowly withdrew from her repre-

sentational duties. She wanted to be the best rider in the world, took part in dangerous hunts in England, and had herself sewn into her dark riding clothes. As soon as she had detected the first signs of aging, she had rooms set up in every one of her palaces and villas as training rooms for gymnastics and fencing. Here, she determinedly lifted weights, swung on rings, and trained using the parallel bars and high bar. Forced marches several hours long, akin to today's power walking and during which the court ladies could barely keep up with the empress, were as much a part of everyday life as was her melancholia.

After her son Rudolf had taken his own life in 1889, Elisabeth banned every last speck of color from her closet. She never recovered from his suicide and wrapped herself in nothing but black until she herself died. Even her magnificent hair became an encumbrance. When her Greek teacher remarked that "Your majesty wears her hair like a crown," the empress replied, "But it is easier to get rid of the other kind." During a visit to Geneva in 1898, the Italian anarchist Luigi Lucheni lunged at the empress, and stabbed her directly in the heart with a sharp file. The tiny puncture was not apparent at first, but was to bring about her death at the age of sixty. Her death triggered the famous "Sisi Myth" – the extent of the empress's unhappiness was buried beneath the luster of her beauty.

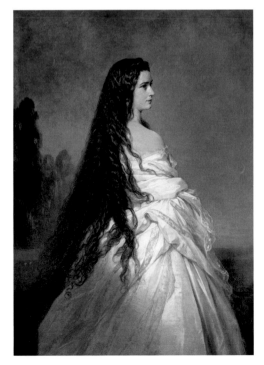

Franz Xaver Winterhalter painted a private portrait of the monarch with open, Rapunzel-style hair.

Left: For Sisi's royal coronation in Budapest in 1867, Charles Frederick Worth (top right) designed a fairytale dress that took inspiration from Hungarian national dress, with a night-sky-blue velvet bodice and pearl tie fastenings.

The sports-obsessed empress had herself sewn into her dark riding outfits. She was the most skillful rider of her time and practiced as though she were a professional sportswoman, side-saddle notwithstanding.

Below: She underlined her melancholy by wearing dark clothes. Often a white collar with a big bow constituted the only dash of color.

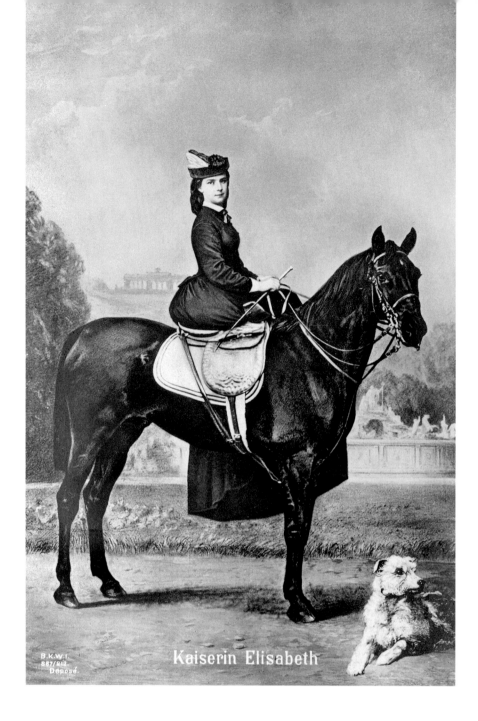

Kaiserin Elisabeth

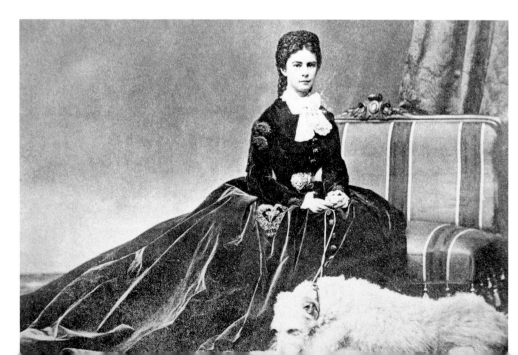

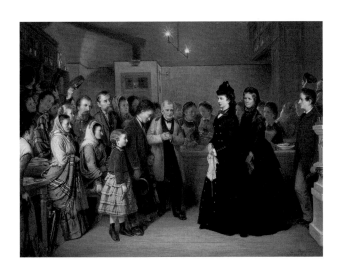

Empress Elisabeth in a gown with a trendy bustle and ruby jewelry.

Top: Sisi was very popular with her people. This painting from 1867 shows her visiting a soup kitchen. The only thing this monarch could not become accustomed to was the strict Viennese court etiquette.

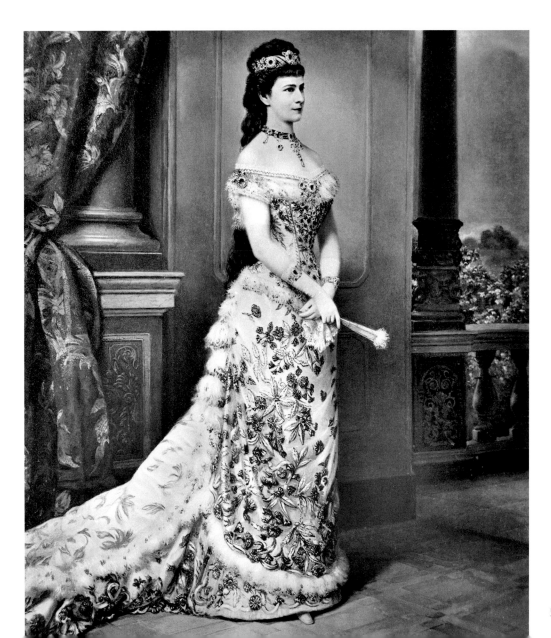

Queen Victoria
The Greatest Bridal Trendsetter

Her face looked like that of an English bulldog: Queen Victoria (1819–1901) was not beautiful, but she was stylish. She, Eugénie de Montijo, and Empress Elisabeth were the three great queens of fashion, and Victoria was also to influence international trends throughout the course of her life. Under her rule, the empire developed into a world power. No British monarch was on the throne for longer than she was. For sixty-three years, the great-great-grandmother of the present queen ruled over a fifth of the world and one third of the world's population. And the first media queen in history knew how to skillfully market herself. At the age of eighteen, the daughter of the late Duke of Kent (1767–1820) quite unexpectedly became heir to her uncle William IV, and thus acceded to the throne. At her wedding to her German cousin Albert of Saxe-Coburg and Gotha (1819–1861), Victoria became the greatest bridal trendsetter: although the French queen consort Marie de' Medici had introduced the white wedding dress in the year 1600, it was the British monarch who made it popular throughout Europe. Victoria transformed her wedding ceremony into an act of state, and so it was held in the chapel of St. James's Palace in front of three hundred guests at midday, rather than in private during the evening.

Although the queen was fairly small (at 1.55 meters) and plump, she looked more beautiful than ever on February 10, 1840. Victoria wore a strapless satin dress with a corsage and comparatively short lace veil. The color, however, was even more unusual: white. At the time, royals usually got married in gold and silver dresses, and commoners in all-purpose black. The queen's hair was adorned not with a sparkling tiara but with a wreath of orange blossoms, and her train was so heavy it had to be carried by twelve bridesmaids. Victoria wore seductive silk stockings under her gown, and she wore silk ballerina shoes on her dainty feet (a size 33, or a U.S. 3!).

The message of the dress was obvious: the queen wanted to please Albert. She was madly in love with her husband, which was a great exception in her circles. Although the marriage to her maternal cousin had been arranged, the two of them had fallen deeply in love with each other much earlier, and provided plenty of material for one of the most beautiful love stories of the nineteenth century. As the queen was constantly pregnant and valued her Albert highly, he secretly took charge of matters of state at Buckingham Palace. While her husband made Christmas trees popular on the sceptered isle, Victoria made the color

> ❝ I wore a white satin dress, with a deep flounce of Honiton lace, an imitation of an old design. My jewels were my Turkish diamond necklace & earrings & dear Albert's beautiful sapphire brooch. ❞
> *Queen Victoria on her wedding dress*

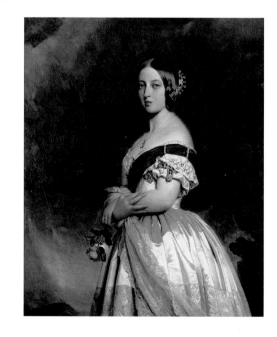

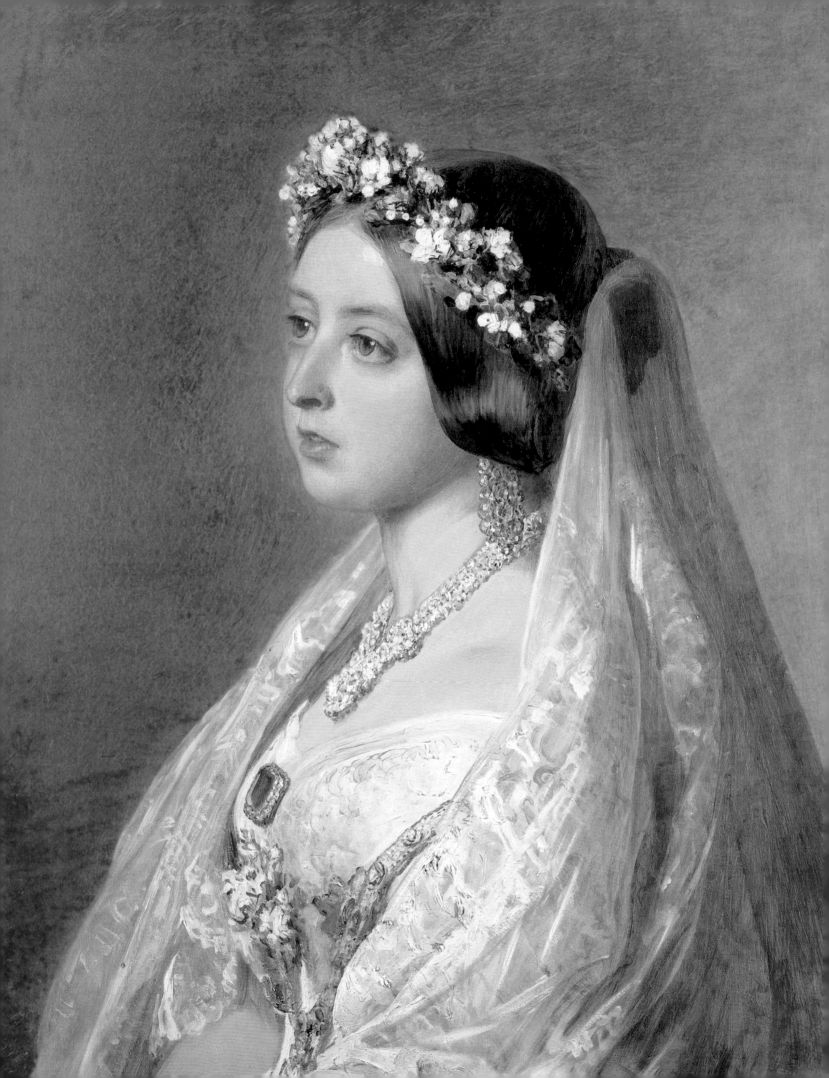

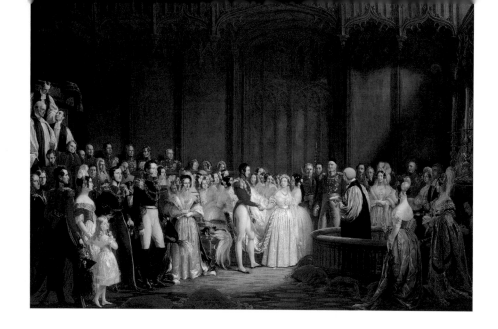

mauve popular at her oldest daughter's wedding: a light purple made from the first artificial dye ever. After traveling to Cambridge to have a word with his oldest son, Bertie, about the latter's love affairs, Albert returned with a fever, and died unexpectedly two weeks later, at the age of just forty-two. Victoria held the crown prince responsible for the death of her husband and would not allow him to handle affairs of state until her death. For almost forty years, she was always dressed in widow's black, lace, and austere blouses, shaping the taste of her time. When she died in 1901, her legacy included not just a name for an entire era – the Victorian Age – but also nine children, forty grandchildren, and eighty-eight great-grandchildren. Thanks to the clever marriage alliances arranged by the "Grandmother of Europe," almost all present-day European monarchs are direct descendants of Victoria and Albert. In accordance with her wishes, all mourners at her funeral wore white, and Victoria herself was buried wearing her bridal veil in memory of her Albert.

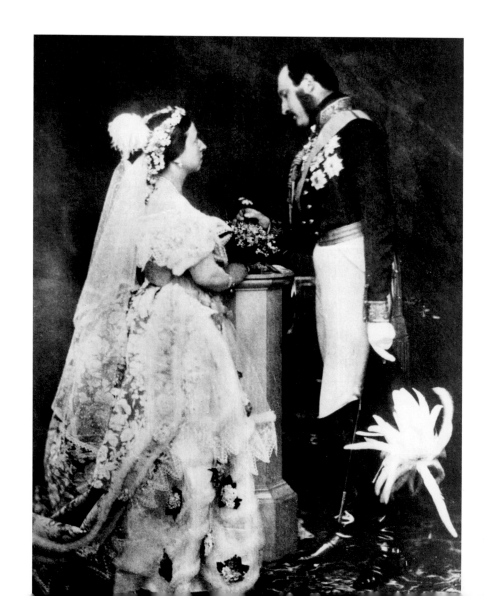

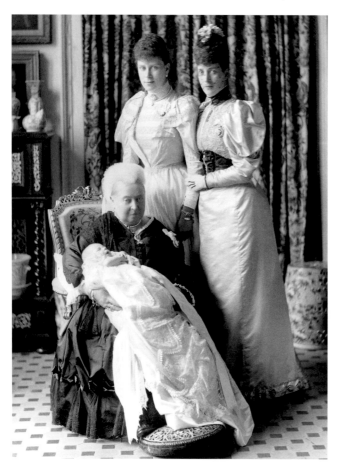

Four generations in one photograph: A photograph was taken at his christening in 1894 of the future Edward VIII, his great-grandmother Queen Victoria, grandmother Alexandra, and mother Mary of Teck (from left to right).

Right: The queen with part of her family. She had nine children, forty grandchildren, and eighty-eight great-grandchildren. Almost all European monarchs today are descended from her.

"The name of Queen Victoria – England's longest-serving monarch – evokes images of the heavy-set, mourning-clad queen of her later years, but the young Victoria was, in her day, a fashion plate to rival the best of them."
Elle

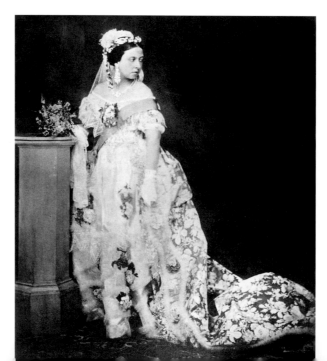

Victoria in her re-enacted wedding photograph. Two hundred people had worked for nine months to make the lace for her dress alone.

Right: In mourning for her husband, the queen wore only black for almost four decades. At her diamond jubilee in 1897, she wore a white widow's veil and a richly decorated black gown.

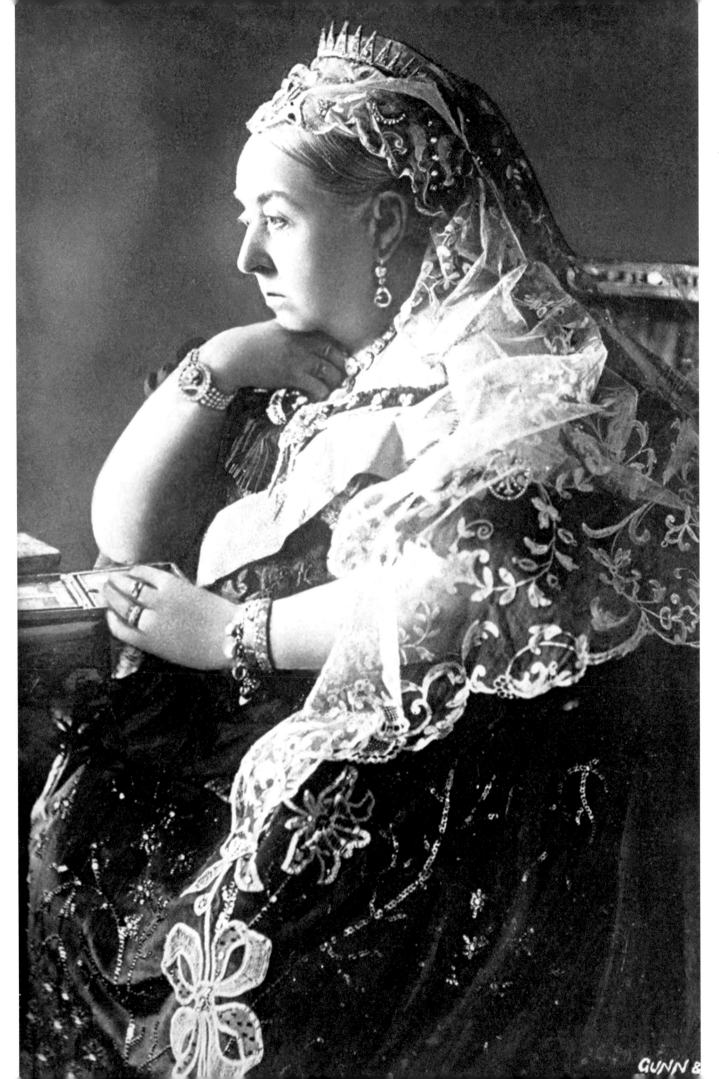

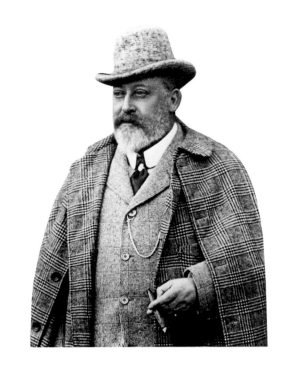

Edward VII
Of Women, Cigars, and Smoking Jackets

Admittedly, this chapter is dedicated to women. But Edward VII (1841–1910), Queen Victoria's oldest son, dressed just as trendily as his mother had, and should therefore not be passed over entirely. His parents were so in love with each other throughout their lives that they paid very little attention even to their firstborn child. Bertie, as his mother liked to refer to him, suffered from his strict upbringing, and perhaps it was for this very reason that he liked to overdo things on occasion. The Prince of Wales passed the time until his coronation with women, parties, and clothes. As crown prince, he became the greatest male trendsetter of his time, and gave his name to glen plaid (which became known as Prince of Wales check). He was equally well known for his love of women: for most of his four-month-long tour of duty in Ireland, for example, the ladies' man hid the object of his affections in his tent. Because the cigar lover enjoyed comfort, he introduced the use of smoking jackets beyond the confines of the smoking salon in around 1860. While men wore their velvet jackets only when smoking, after which they changed back into their frock coats or dress coats, Edward commissioned a smoking jacket of black fabric from the London tailor Henry Poole & Co. and did not take off this "dinner jacket" before eating, either. Historians of fashion are deeply divided over the question whether it was indeed Edward who made this item of clothing socially acceptable. The Duke of Sutherland is also named as its possible inventor. One thing is certain: to decrease the pressure on his protruding stomach, the heir apparent generally left the last button of his suit coat undone: a royal tribute that persists to this day as society feverishly imitated Edward instead of turning their noses up at the custom.

Long before Charles, he was thought of as the eternal crown prince. When the sixty-one year old finally became king after his mother's death, his first official act was to reverse her smoking ban. He invited the men to light up immediately after his coronation: "Gentlemen, you may smoke." Tragically, the excessive smoker caught chronic bronchitis which, after a walk at Sandringham, worsened. Edward died in 1910, fussed over by his wife, Alexandra of Denmark (1844–1925), and his favorite mistress, Alice Keppel (1869–1947), the great-grandmother of Camilla Mountbatten-Windsor (formerly Parker Bowles).

The smartest man of his time: Edward VII often wore the eponymous Prince of Wales check and loved cigars. Alice Keppel, great-grandmother of Camilla, Duchess of Cornwall, was his long-time mistress (below).

Wallis Simpson
"One can never be too thin or too rich"

The most stylish couple in the world: Edward VIII abdicated and married Wallis Simpson in 1937. The bride wore a light-blue Mainbocher gown, after which the label referred to the color as "Wallis blue."

Right: In the Bahamas in 1942. He sports a checked tie and she wears a polka-dot dress.

Next double page: Wallis and Edward in 1941 with their dogs in Miami, Florida.

Their love story is considered the biggest royal scandal of all time, much worse than Prince Charles and Camilla's tampon conversation. The whole of England was perturbed when playboy-king Edward VIII (1894–1972) renounced the crown out of love for the twice-divorced American Wallis Warfield Simpson (1896–1986). The world had never seen anything like it! After 352 days on the throne, he handed the scepter to his stammering and sickly brother George VI, father of the present queen, who was not very well suited to the job at all. In fact, the forty-year-old Wallis Simpson was not even, strictly speaking, pretty: her chin was too pointy, her features a little bit too angular, and the dark Marlene Dietrich eyebrows lent her the charm of a governess. But no woman of her time was as elegant as she was. Wallis was aware of this, and would remark: "I am not a beautiful woman…. The only thing I can do is dress better than anybody else."

The later Duchess of Windsor had a predilection for non-English fashion, and bought at least a hundred couture dresses a year at Chanel, Dior, Lanvin, Givenchy, and Schiaparelli. Sometimes, she would have the same model made in a variety of nuances and fabrics. The trendsetter favored narrow dresses that concealed her boyish figure, and never showed cleavage, wearing high-necked dresses instead. On a hot day in June 1937, at the French Château de Candé, she was married to Edward in a narrow, light-blue wedding dress with long sleeves. It had been made by her favorite American couturier, Mainbocher, the master of prudish elegance and one of the most expensive designers of his time. He considered his clients as faultless beings, and kept a separate design book just for the Duchess of Windsor. All of the rest of his clothes, too, looked as though they had been made for Wallis, however. After all, even though the duchess was detested by many Brits, she and her "buttoned-up" style had a greater influence on fashion than anybody else did.

No wonder. She did everything she could to please her essentially unemployed husband (and herself). For the honeymoon alone, she packed sixty-six dresses with matching shoes and accessories into her suitcases. At home, she summoned her hairdresser three times a day to make sure that not a hair was out of place in her water-wave do. To be quite honest, the eccentric brunette cannot have been particularly charming. She lived according to the man-

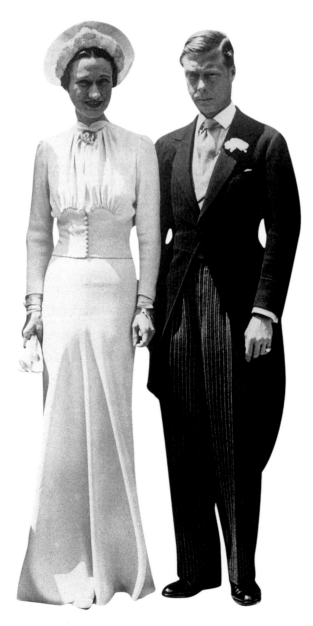

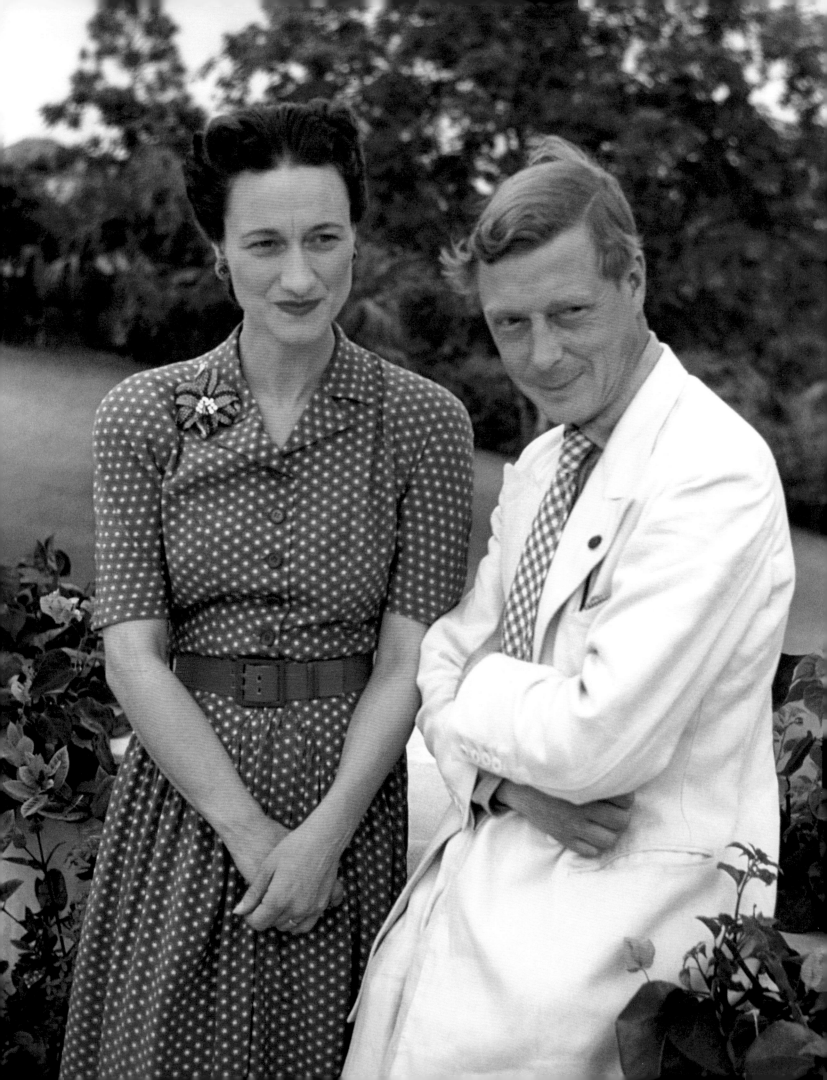

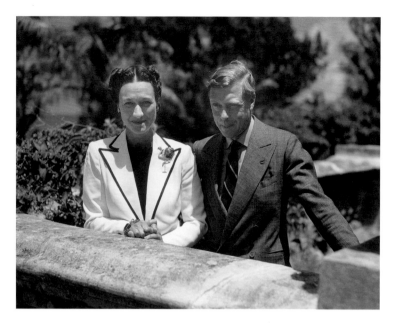

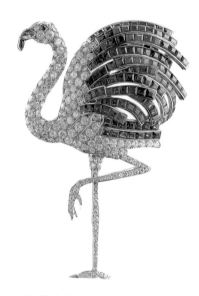

Wallis's flamingo brooch was created by Cartier designer Jeanne Toussaint in 1940. The Cartier bracelet was also among the duchess's favorite pieces of jewelry. The nine crosses symbolize important stages of her life (below).

Right: Wallis posed in Elsa Schiaparelli's "Lobster" dress before her wedding. The lobster decoration was designed by Salvador Dalí.

charming. She lived according to the mantra that "one can never be too thin or too rich," ordered that the napkins be changed twice during dinner, and only communicated with her servants using word cards. She and her husband jetted around between Paris, the Riviera, and the U.S., and she was a welcome guest at every party. And Edward took his cue from his stylish wife by becoming the greatest trendsetter among men, following in the footsteps of his fashion-obsessed grandfather Bertie.

The American fashion industry in particular followed every twist and turn of the British duke's evolving look, and copied his outfits. After he had worn an old tartan suit at the Côte d'Azur in the 1940s, the pattern became the hottest style in America a few months later. The singer Fred Astaire was a member of his fan club,

unquestioningly describing him as "the best-dressed young man in the world" and following his every look.

Edward spent money as if there were no tomorrow. He showered Wallis with the most precious of jewels, and her collection of bracelets, necklaces, brooches, and cigarette cases is considered to have been the most expensive private collection of jewelry of the twentieth century. He bought only unique pieces, such as the famous flamingo brooch by Cartier, so that nobody could compete with the Duchess. In 1987, one year after Wallis's death, the sale at auction of her jewelry proved to be a media event and totaled thirty-one million pounds. The U.S. designer Calvin Klein bought her "eternity ring" at auction, and gave the name to one of his most famous perfumes. After all, every piece of jewelry tells the couple's

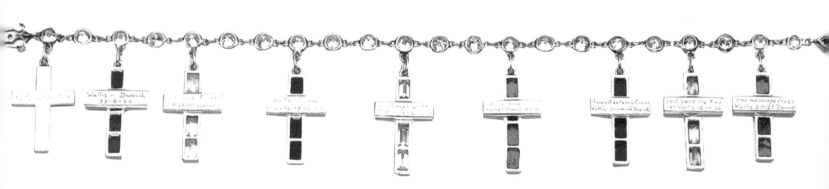

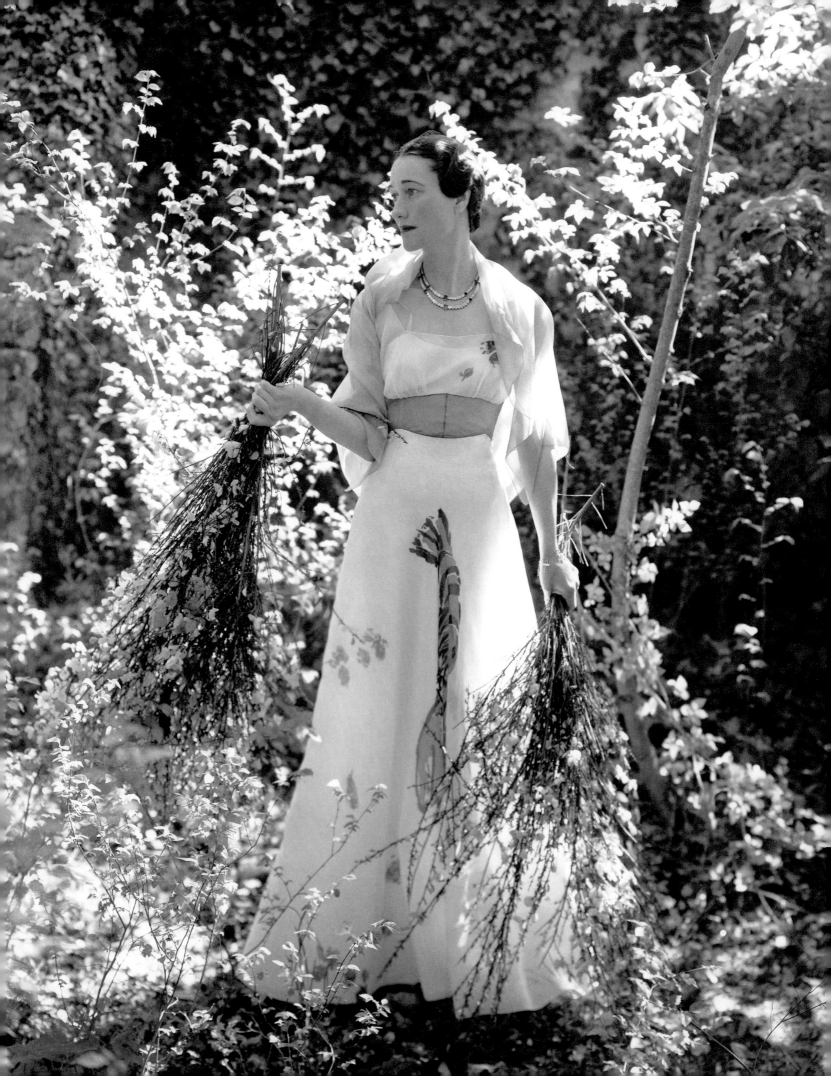

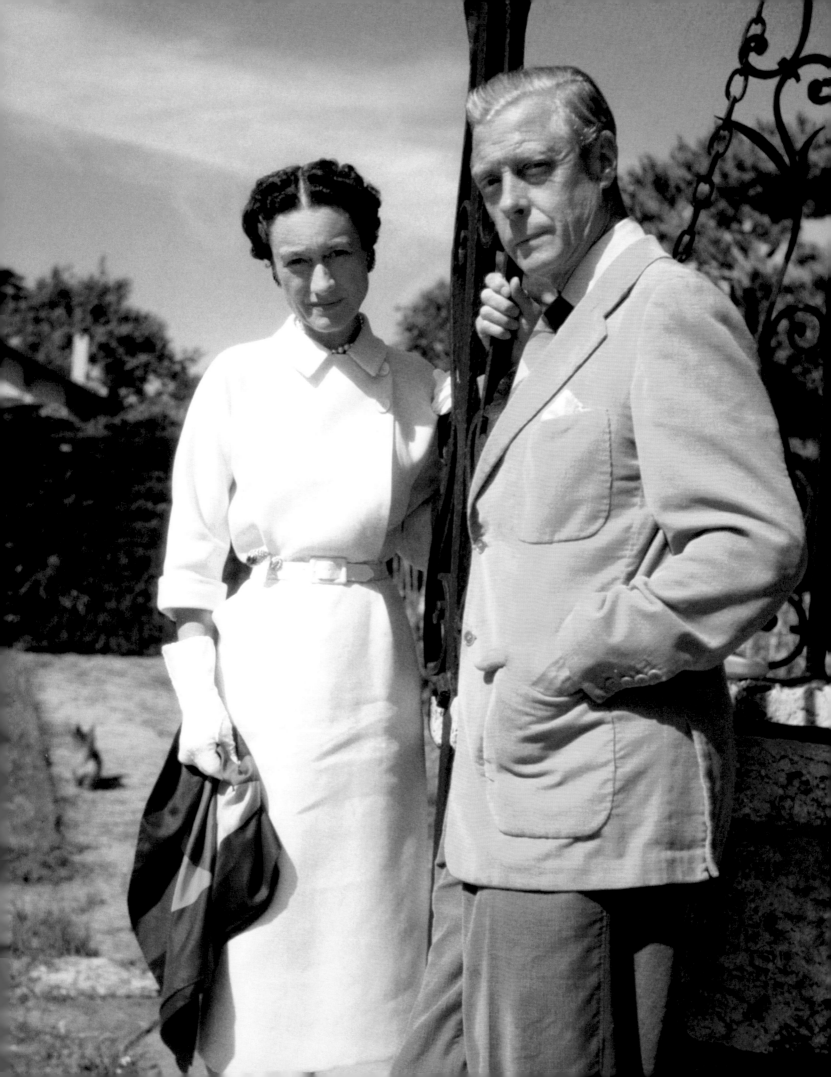

unusual love story. In 1935, Wallis gave her husband a gold cigarette case by Cartier, on which a map of their shared journeys had been engraved.

Diamonds mark places in which they had special experiences. Almost all pieces of jewelry are adorned with the initials WE, Wallis and Edward, which of course also reads as the first-person plural pronoun.

"We – just the two of us against the rest of the world" seems to have been the couple's motto for life. They were only allowed to travel to England when invited by the royal family, and the later Queen Mother

of Elizabeth II in particular gave her detested sister-in-law the cold shoulder until the very end. She never forgave Wallis for the fact that her husband, George VI, was coerced into becoming king. It was a good thing for England, however: Edward made no bones about his admiration for Hitler, and Queen Elizabeth II would presumably not have ascended the throne if it had not been for his abdication. Wallis, Duchess of Windsor, would take her place in history as a queen of fashion instead; for many years in a row starting in 1940, she featured on the "International Best-Dressed List" of

Eleanor Lambert (1903–2003). Every year, Lambert, the grande dame of fashion PR, selected the most well-dressed celebrities with the help of designers, journalists, and fashion dealers, before handing over her famous ranking to the magazine *Vanity Fair* in 2002. In 1958, Lambert invented the Hall of Fame for the most notable trendsetters, and the Duchess of Windsor was one of the first to be admitted, presenting her with the highest of honors for a born-and-bred fashionista.

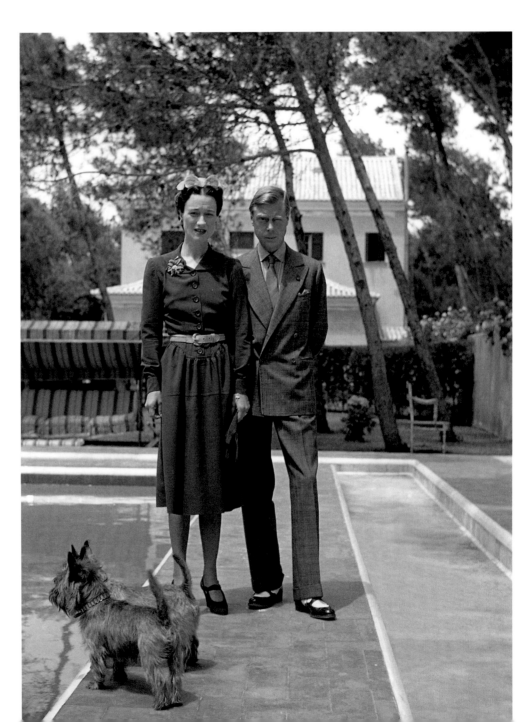

The Duke and Duchess of Windsor in Lisbon, Portugal, donning the "five o'clock tea" look, 1940

Left: They did not relinquish their stylishness over time. They were photographed in front of their villa in the French town of Biarritz in 1951. Wallis wears a white coat dress with gloves, and Edward wears rust-red pants and a matching tie with a rosé-colored jacket.

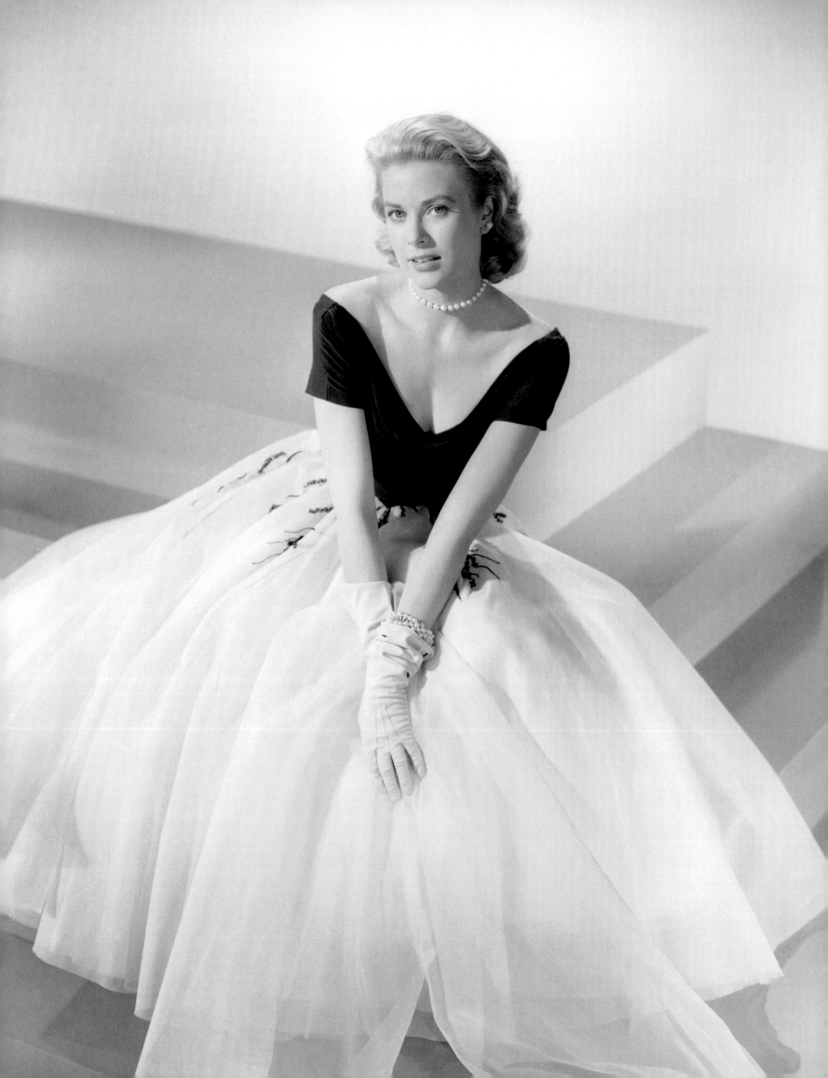

Grace
Kelly

Glacé Gloves and
Frosty Sex Appeal

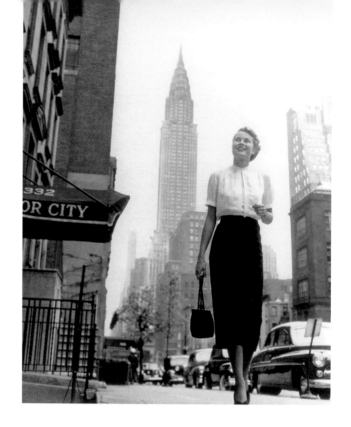

The millionaire's daughter from Philadelphia moved to New York in 1947 and attended the American Academy of Dramatic Arts. Her signature accessory: short white gloves (below).

Right: Grace Kelly was photographed for Life magazine wearing her sea-green Oscars gown by Edith Head in 1955. By Hollywood standards, it was remarkably simple.

Grace Kelly
Glacé Gloves and Frosty Sex Appeal

For mere mortals, Grace Kelly (1929–1982) was like the summit of Mount Kilimanjaro: unreachable. She was the incarnation of frosty sex appeal, but a flame burned brightly beneath the façade. Superstar director Alfred Hitchcock described his crown jewel in similar terms, and waxed rhapsodic about her sexy elegance. In contrast to curvaceous stars like Marilyn Monroe and Gina Lollobrigida, Grace Kelly seduced the audiences of the 1950s with wintry blond hair, flawless facial features, and afternoon-tea manners. She looked like a goddess hewn from stone, so perfect that hardly anybody can have dared to touch her. At the age of just twenty-six, the millionaire's daughter from Philadelphia had everything any woman could want: an Oscar on the mantelpiece, Hollywood at her feet... and the heart of a real prince in the palm of her hand. Grace Kelly married Prince Rainier of Monaco, whose principality was no bigger than the backyard of her production company MGM, and swapped her Hollywood fame for the screenplay of her dreams. Her wedding in 1956 was followed by three times as

many television viewers as the wedding of the Queen of the United Kingdom of Great Britain and Northern Ireland. In a glamorous ceremony, the world-famous actress became princess consort of Monaco and acquired a new name in addition to the 134 titles: Gracia Patricia. She had already influenced the fashion of her time as an actress, but once her engagement was announced, the whole world imitated the "Grace Kelly Look," with its swaying bell skirts, pastel-colored twin sets, and pearl necklaces. For diplomatic reasons, once she had become a princess she wore primarily French couture by Dior, Lanvin, and Chanel rather than American labels, but she remained true to her style throughout her life. Few people have left more of a mark on their time than this elegant blond. And each of her dresses and accessories tells part of her fairytale biography.

A pair of spotless white short gloves symbolized her untouchability. Miss Grace Patricia Kelly – who remained on formal terms with people she didn't know well – was distant when dealing with strangers,

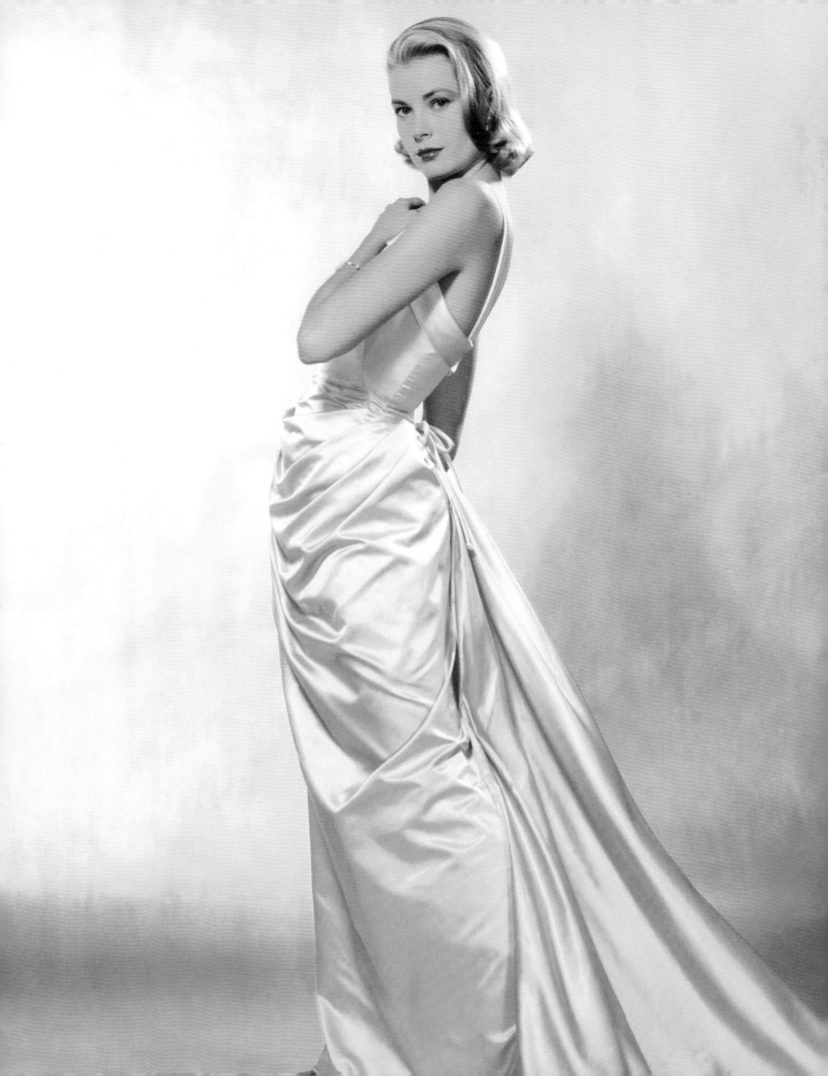

The designer Oleg Cassini conquered Grace Kelly's heart before Prince Rainier came on the scene, and also supplied her with a glamorous look. She wore one of his elegant dresses when he accompanied her to a film premiere in 1954.

Right: The actress's signature Grace Kelly look, with a silk scarf and tied-back hair.

It is hard to believe that the beautiful Grace dressed rather dowdily at first. The elegant, twice-divorced fashion designer Oleg Cassini (1913–2006) took her under his wing: he designed elegant clothes for the actress, as well as conquering her heart. But once Prince Rainier stepped into her life, the Paris-born son of a Russian aristocrat got the short end of the stick. Decades later, Oleg Cassini still gushed about Grace: "Her beauty became apparent only at second glance. The architecture of her face, her fine skin, everything was perfect. But she dressed very badly. Long pleated skirts, glasses, her hair in a bun. She looked like a schoolteacher. A pretty schoolteacher, but a schoolteacher all the same. I had to teach her that glamorous actresses, too, are taken seriously."

Grace Kelly was certainly taken seriously at her first Oscar winning, and her appearance was certainly glamorous. When she was quite unexpectedly awarded the most sought-after Hollywood trophy in 1955 for her part in *The Country Girl*, the actress sobbed in a sea-green, elegantly gathered satin gown and evening coat by Edith Head. While the entire world gazed at the emotional actress, the audience must have looked out of focus to Grace Kelly in the moment of her highest professional achievement – out of vanity she had taken off her horn-rimmed glasses a moment before. Millions of people in front of their television sets were dazzled by her beauty. She looked quite different from the other Hollywood stars: instead of bedecking herself with pompous dresses and furs, she wore a simple but elegant dress and thus showcased her personality. Grace had learned what suited her and became the new fashion icon within minutes. She knew that she looked best with very little makeup and a light shade of lipstick, always combed her blond hair out of her face, and shot her glances at the camera from the perfect angle. Her elegance was reminiscent of the icons of the past, of the allure of Ingrid Bergmann and Greta Garbo. Among lots of twinkling starlets, Hollywood could at last take delight once again in a shining star with a highly cultivated accent. Grace Kelly,

and no accessory better captured this attitude. "She made me feel I was at a reception at Buckingham Palace," a reporter said of the actress. She did not wear her glacé gloves out of arrogance, though; as the daughter of a well-to-do family, she had simply grown up with them. Her mother Margaret had always made sure that Grace and her sisters did not leave the house without white gloves. Although the actress unconsciously imbued the accessory with a dose of sex appeal, it simultaneously boosted her virginal image (she never commented on her secret flirts). Her weakness for gloves is illustrated by the following anecdote: when Grace Kelly went shopping at the luxury boutique Hermès in Paris with the costume designer Edith Head for the film *To Catch a Thief*, she bought so many pairs that she ran out of cash and had to send for more.

With her classic looks, which were always elegant and never vulgar, Grace Kelly wanted, more than anything else, to gain respect. The daughter of the Irish self-made millionaire John Brendan Kelly, who had

worked his way up from mason to building tycoon, and his German wife Margaret, was shy and spent her whole life trying to please her father. As a child, delicate Grace had worn horn-rimmed glasses because she was nearsighted, and she was overshadowed by her two beautiful sisters and athletic brother. But at the age of twelve, she was already celebrating her acting debut in her hometown theater of the Old Academy Players, and began to dream of a career in Hollywood. As the Kelly family did not expect much of the third of their four children, they did not oppose the career that she later chose. Whether or not it is a cliché, it is true that Grace developed into a beautiful swan during her training as an actress in New York, worked part-time as a model for toothpaste and cigarettes, and came to the attention of Hollywood directors through her work on Broadway. When Hitchcock cast the same leading actress for three of his films (including *Dial M for Murder*) for the first time, she had reached the pinnacle of her career and the master of thrillers had found his muse in this cool blond.

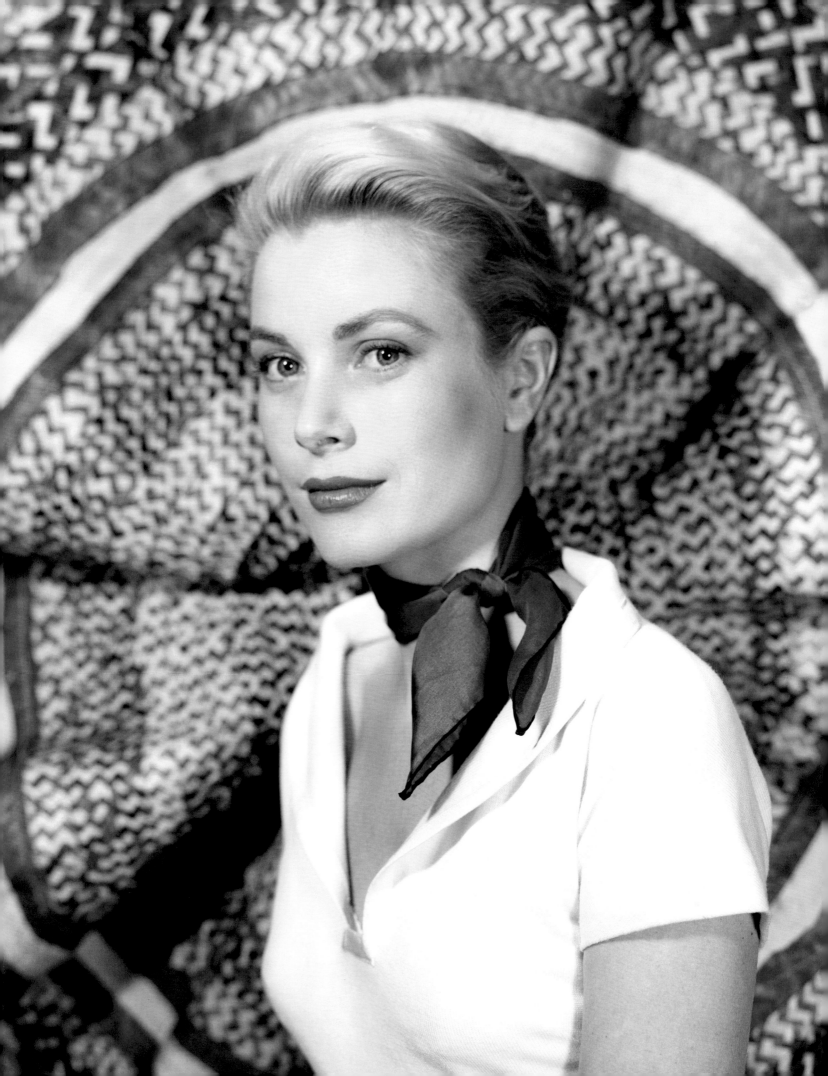

> 66 I have to choose simple clothes, because when I wear something dramatic, I seem to get lost. 99
> *Grace Kelly*

On January 5, 1956, Rainier announced his engagement to Grace Kelly. The diva wore a dress by Branell. Her Hermès bag – an engagement present from the prince – was later renamed the Kelly Bag.

Left: Rainier later bought a second, bigger engagement ring from Cartier. She can be seen wearing it in the film *High Society*.

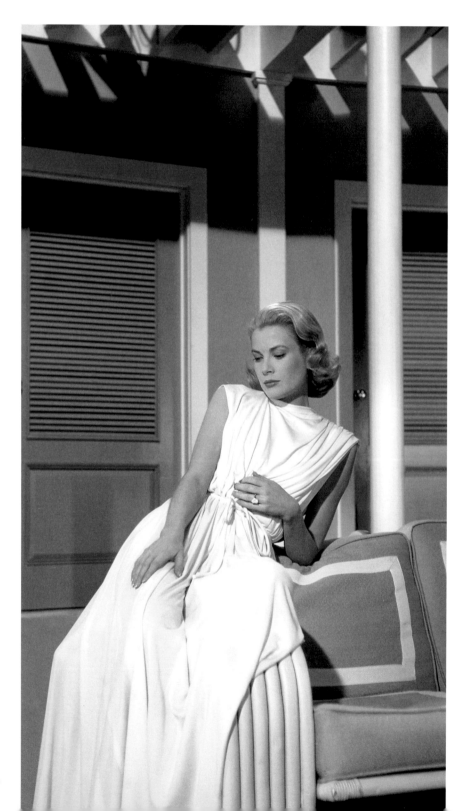

who was described as a "long-stemmed tea rose from Philadelphia" was soon placed under environmental protection in Hollywood. A majestic aura surrounded her even then. In contrast to the media-crazy starlets, the actress always kept a distance when speaking to journalists and was a master of the technique of the empty stare as a response to tactless questions.

Her ascent to the Grimaldi palace did not start in a couture gown, however, but in a floral pattern dress. During the Cannes Film Festival in 1955, the French magazine *Paris Match* set up a meeting with Prince Rainier of Monaco, and put the rendezvous on its front page, even though the preparations had not at all gone according to plan: there was no electricity in the whole of France because of a strike so that Grace Kelly could not even have her clothing ironed in the morning. And so she reached for the only crease-free item of clothing: a black taffeta dress with colorful flowers, a low waist, and swaying skirt from the McCall Pattern Company's book of patterns. As the hairdryer did not work either, she hastily tied her wet hair back into a tight bun and wore a bandeau with artificial flowers instead of a hat. Although Rainier kept the impatient Oscar winner waiting for over an hour in the Grimaldi palace, he enchanted her with his charm. As one of the most eligible bachelors in the world, the prince ruled a two-square-kilometer state on the coast between Italy and France. His ancestors, bloodthirsty pirates, had conquered the cliff of Monaco in 1297 and were considered Europe's oldest ruling family. No

wonder that John B. Kelly was delighted by his daughter's choice.

Prince Rainier, too, appears to have seen in the deeply Catholic Grace Kelly the perfect match. His state was not only on the verge of bankruptcy, but also demanded an heir to the throne. The extinction of the Grimaldi family would have meant the reincorporation of Monaco into France. Rainier lured the actress with romantic letters and endless telephone calls. Although they had met only once, he asked for her hand in marriage at her parent's house six months later. When the prince announced his engagement on January 5, 1956, the news was like a bombshell, surprising even the closest friends of the actress. "I will learn to love him," Grace Kelly declared pragmatically. A diamond ring with rubies in the national colors of Monaco sparkled on her finger. Shortly thereafter, Rainier bought an even bigger one from Cartier: the new emerald-cut diamond weighed 10.47 carats, making it more suitable for Hollywood.

The actress created the greatest stir on the day of her engagement with her Kelly Bag, however. Hundreds of photographers were already waiting when she stepped out of the car in front of her parents' brick house with Rainier after lunch at the Philadelphia Country Club. Grace Kelly was carrying an unusually large, trapeze-shaped bag with a strap: an engagement present from Prince Rainier. The model was called "sac de voyage à courroie" (travel bag with strap) and had originally been a bag for riding accessories. Robert Dumas, head of the Parisian leather goods company Hermès at the time, had designed this classic piece in 1930. The future princess and her bag soon found themselves on the cover of *Life* magazine. With her permission, Hermès changed the name of the model to Kelly Bag and was inundated with orders. Grace immediately ordered half a dozen in different colors. It is even rumored that she wanted to hide the pregnancy that soon followed her wedding behind a large crocodile leather model.

Grace Kelly and Prince Rainier's first meeting was arranged by *Paris Match* magazine. Instead of visiting the palace of the Grimaldi family in Monaco in an extravagantly expensive outfit, Grace Kelly was shown around wearing a flowery McCall Pattern Company dress.

It is hardly surprising that the future princess's trousseau, too, was worth a small fortune. When Grace Kelly was received with twenty-one gun salutes and a shower of red and white carnations in the harbor of Monaco on April 12, 1956, following an eight-day boat trip, the servants dragged sixty cases to dry land. In America, Rainier's fiancée had bought forty outfits, roughly thirty pairs of shoes, and as many hats in American fashion boutiques such as Christian Dior New York and Samuel Winston. The color palette ranged from white and cream to blue to her favorite color, yellow. The American Kelly Look had long since reached France and had even begun to influence the Parisian haute-couture labels. But the future princess made a faux pas as soon as she arrived: when she stepped off the boat, half of her face was covered not only by sunglasses, but also by a broad-rimmed hat of white organdy and Swiss lace – how the photographers cursed.

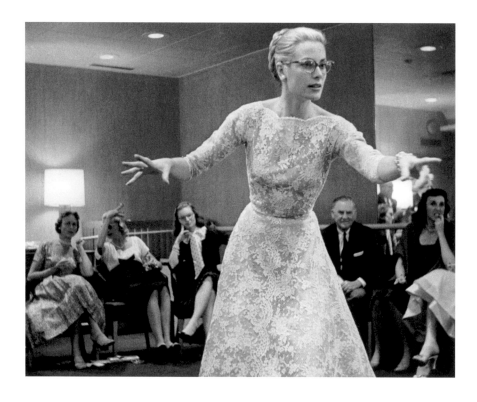

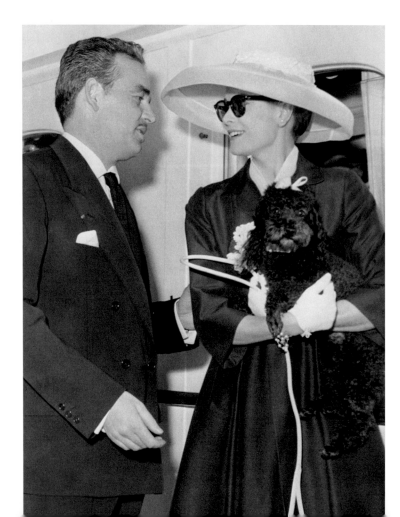

On the occasion of her wedding, Grace Kelly traveled aboard the SS *Constitution*. During her trip, the future princess enchanted the people, wearing a lace dress by Oleg Cassini (top). The photographers grumbled because her face was obscured by a hat and sunglasses (left and right) when she was met by Rainier on April 12, 1956.

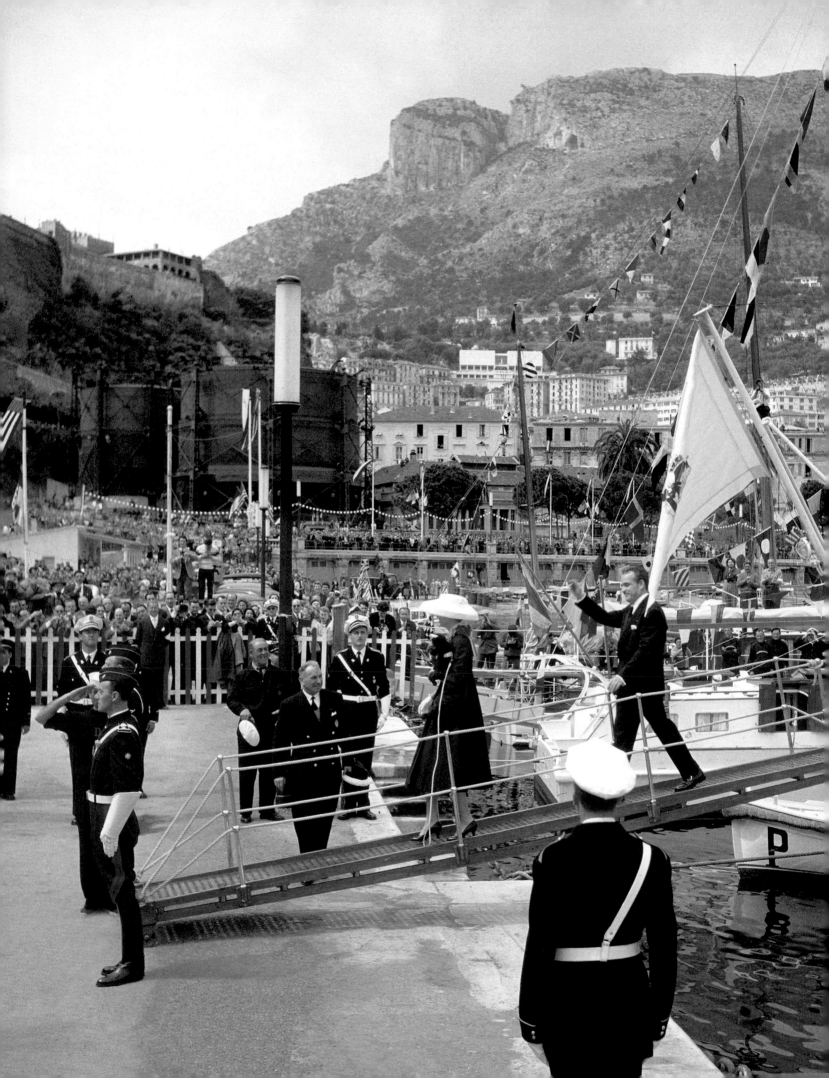

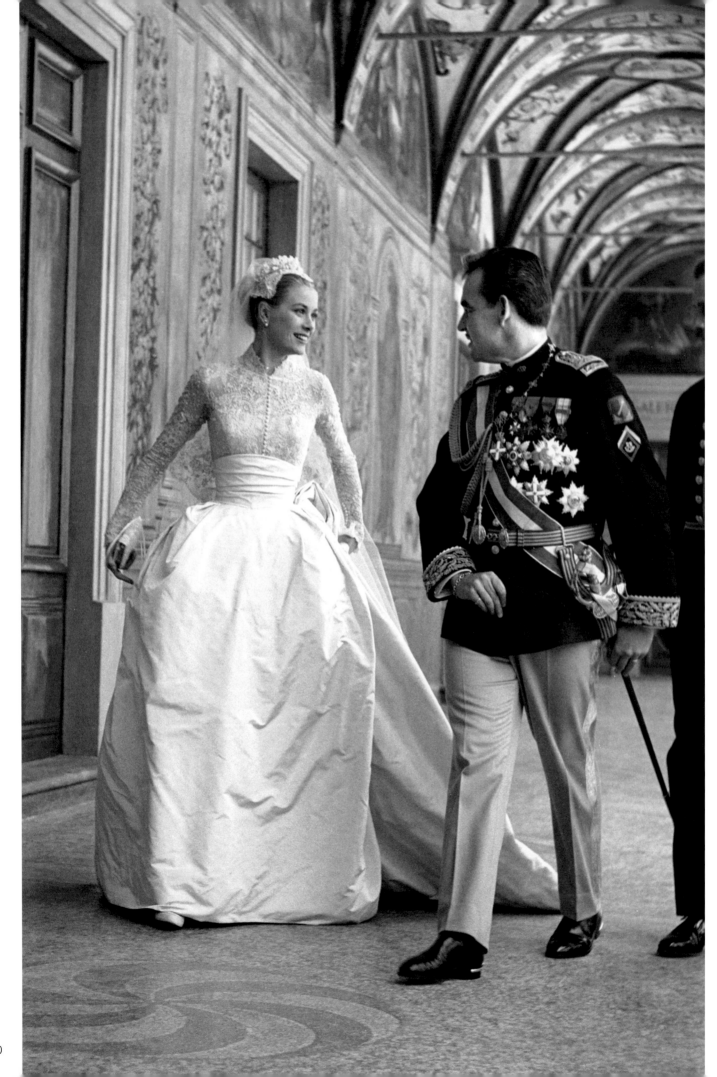

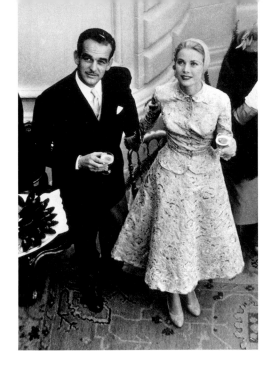

Helen Rose designed the bridal clothing: she created a lace suit with an A-line skirt for the registry office ceremony.

Left: Grace Kelly looked radiant in church, wearing an ivory-colored dress with a lace bodice.

Below: In January 1957, the princess graced the cover of Paris Match in an exceptionally elegant maternity dress by Dior.

This faux pas was soon forgotten as Grace Kelly's wedding dress outshone all other gowns of the time. According to etiquette, Prince Rainier was the last to enter the church and so she stood, for a moment, alone in front of the altar of the Saint Nicholas Cathedral, dressed in an ivory tower of lace, silk taffeta, and thousands of pearls. Reporters described the dress as the actress's co-star – the dream gown made of unknown quantities of Rosaline lace from Brussels, designed by MGM head designer Helen Rose, had kept thirty-five seamstresses busy for six weeks. The $8,000 dress was a farewell present from Grace Kelly's production company MGM, which released a documentary of her wedding in cinemas in the United States. The star had already enchanted the world in a rosé-colored 1950s suit by Helen Rose at her registry office wedding, but this sight was enough to make stars like Ava Gardner and Cary Grant gasp for breath. The bodice, made of 125-year-old lace, fitted her body like a second skin, had a delicate banded collar, long sleeves, and was buttoned at the front. The princess's hourglass waist was emphasized by a broad cummerbund. Her bell-shaped silk-taffeta skirt turned into a three-meter-long train that disgorged precious silk from its wedge-shaped slit. Gracia Patricia's pearl-studded veil (waist-length at the front, floor-length at the back) hung from a silk cap embellished with a crown-like wreath of wax orange blossoms and pear leaves.

She held a dainty Bible as well as a small bridal bouquet of lilies of the valley in her hand, which was covered with the sumptuous lace from which her dress was made. The groom wore a Napoleon-style uniform he had designed himself, with a black jacket and sky-blue trousers with gold ornamental stripes. For guests and television spectators alike, this wedding looked like a dream come true. For the bride and groom, as they would later admit, it had been a protocol marathon without a kiss, nothing like a fairytale. But Rainier's plan worked – Gracia Patricia made Monaco glamorous again, and turned the tiny state into a high-society fairground. Stars like Liz Taylor, Sophia Loren, Sean Connery, and Maria Callas bathed in the princess's limelight. Gracia Patricia's wardrobe filled out once she had taken on this new job; she changed up to four times a day, and always wore an evening gown to dinner. Fashion labels such as Lanvin and Dior sent their models to the diminutive state every season to present the newest pieces to Gracia Patricia far from the bright lights of photographers' flashbulbs.

Two months after Madame la Princesse's return from the six-week honey-

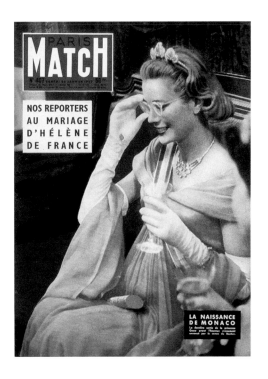

moon on Rainier's yacht *Deo Juvante II*, she announced that she was pregnant, and showed that maternity wear can be fashionable, too. At a time when mothers-to-be did not have much choice in clothes, Gracia Patricia caught everyone's attention in glamorous empire-line gowns by Dior, jewels, and long white gloves. She combined dark dresses and suits with light scarves and hats to draw attention away from her baby bump and toward her face. When Princess Caroline was born in 1957, she was already considered the tiniest trendsetter in the world. Almost all of the clothes Gracia Patricia bought for her daughter were in her own favorite color: yellow. The shade soon became known as "princess yellow" in Monaco. The heir to the throne, Prince Albert, was born in 1958. The two children soon transformed their mother's daily clothing selection into a game and chose the outfits together with her.

Rainier was to have the greatest influence on her sartorial style, however. The prince most liked to see his wife in soft colors and various shades of blue. He had concrete thoughts on her wardrobe. Gracia Patricia stated, "If the prince doesn't like what I choose, I don't buy it." The couple looked at the latest collections from Paris together, and it often happened that Rainier convinced her to buy more than she had originally planned to. But no matter what Gracia Patricia wore, it always became a trend. Even when the princess used an Hermès silk scarf as a sling for her broken arm, everybody copied her. Thanks to her elegant style, she ascended to the fashion hall of fame in 1960. Only rarely did she try out different styles. The young Yves Saint Laurent's Mondrian dress and colorful silk stockings with the Dior logo were among her more unusual experiments. Her hairstyles at this time were all the more adventurous. Her Parisian coiffeur Alexandre conjured the most outlandish artworks onto her head, outdoing themselves with every banquet attended. Glasses remained her trademark. Gracia Patricia, alongside Brigitte Bardot and Jackie Kennedy, was one of the founding members of the "sunglasses society." She even wore her typical

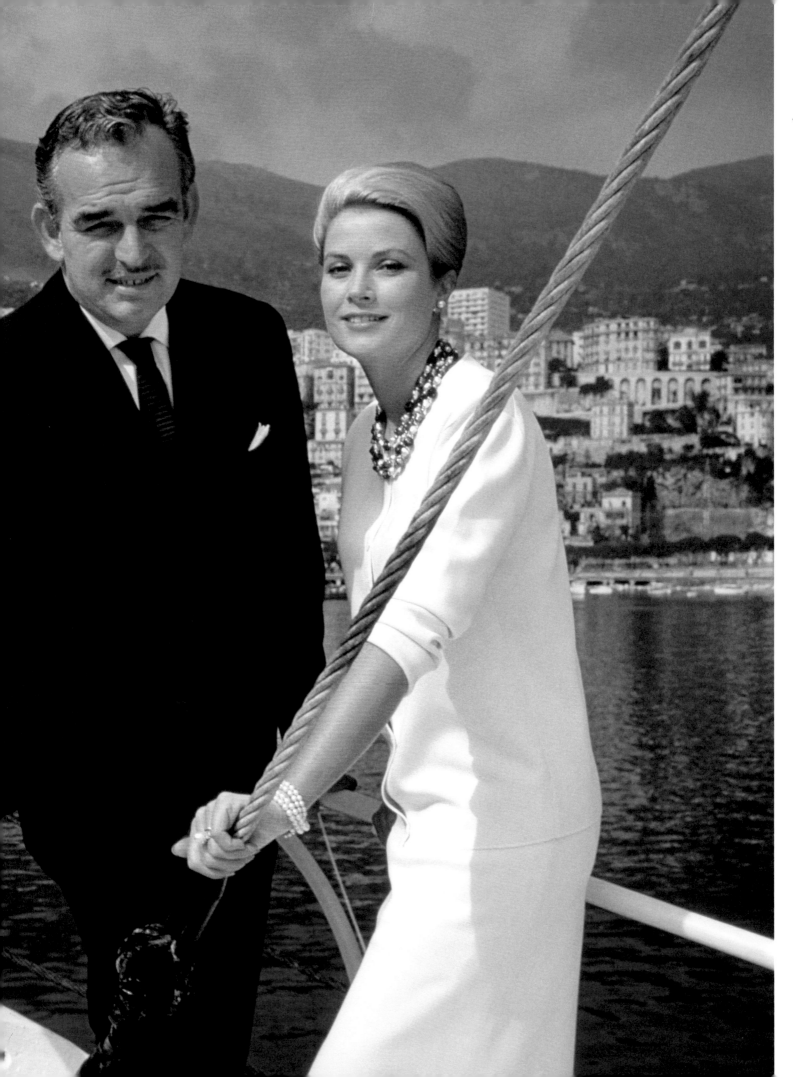

"Grace Kelly is the epitome of style and beauty. In every situation, she radiated immaculate purity and perfection. Her elegant clothing style became legendary and turned her into a style icon."
Elle

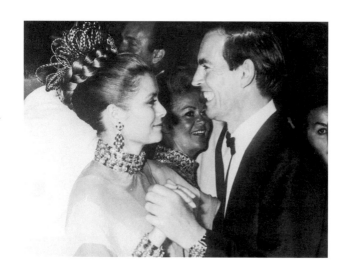

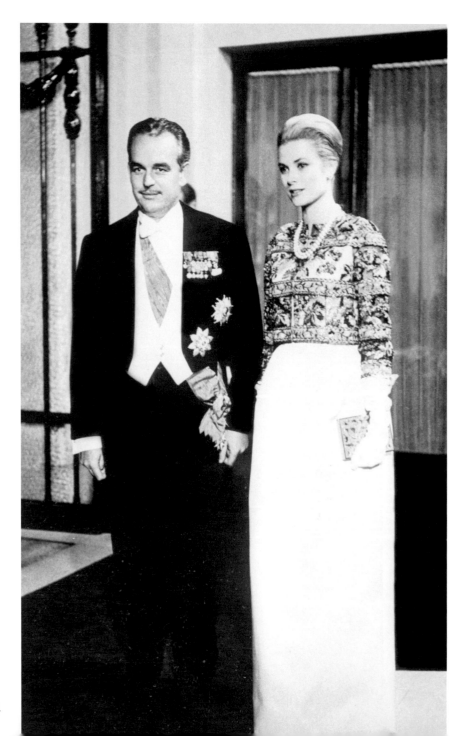

Majestic: Princess Gracia Patricia in Balenciaga.

Top: She created a stir at the Red Cross Ball of 1968 with a braided coiffure of false locks by the Parisian hairdresser Alexandre.

large, masculine frames in the evening, inside, and when it rained.

Despite all the luxury, the princess suffered from living in a gilded cage. She fell into a depression after the death of her father Jack in 1960. The former actress missed one thing above all else: Hollywood. In 1962, Prince Rainier unexpectedly agreed to his wife's comeback, but the people reacted negatively. Her part in the Hitchcock thriller *Marnie* nearly turned into a national crisis: the Monacans asked themselves what would happen if the princess had to kiss the leading actor? And so Gracia Patricia escaped into duties befitting her rank: as president of the Red Cross of Monaco, she dedicated even more of her time to charitable work; she spoke out on behalf of artists; and, following the birth of the baby of the family Stéphanie in 1965, she became an advocate of breastfeeding. Later, she also designed collages made of dried and pressed flowers.

The pious Catholic princess did not warm to the permissive trends of the 1970s. She followed Rainier's conservative clothing etiquette at court with conviction. "I don't like anything too obvious – sex or makeup or a way of dressing. I prefer something that's understated; that leaves a little to the imagination," declared Gracia Patricia. When she put on a little bit of weight as she grew older, the princess frequently draped herself in matronly caftans and wore turbans and wispy hats. One of her last appearances pointed to her tragic end: in March 1981, she met Prince Charles's fiancée Diana Spencer at a charity gala dinner in London. Gracia Patricia, who had been a princess for almost twenty-five years, comforted the nineteen-year-old, whose neckline was far too low for her society debut and caused tongues to wag, with the following words: "Don't worry, my dear. You will see that things can only get worse." Neither woman guessed at the time that they would one day fall victim to similar fates.

On September 13, 1982, Gracia Patricia drove off the road at a hairpin bend on the way home from the summer residence in Roc Agel, her Rover plunging forty meters down the cliff. Seventeen-year-old Stéphanie was in the passenger seat. While her youngest daughter survived, the princess died of her injuries at the Princess Grace Hospital. A hundred million people watched her funeral on television – it was her last leading role. Prince Rainier walked behind his wife's coffin, doubled over with grief, and would never marry again. When she died, Gracia Patricia became one of the greatest style icons in history. A Paramount producer once described her aptly: "With other stars, five seconds after they're on, you've seen all the personality they have. With Grace you see different angles of her as the part develops.... Grace Kelly gives you something to look at, something to anticipate." A nanoparticle of her flawless aura is still to be found in cult pieces like the Kelly Bag.

The princess often wore Chanel in the sixties and seventies, including this bouclé coat dress (above). Below: For the family portrait of 1973, she chose a chiffon dress by Marc Bohan for Dior.

<< The royal couple in the harbor of Monaco in 1963: Gracia Patricia sports a simple yet elegant casual look in white. Eye-catching: her opulent pearl necklace.

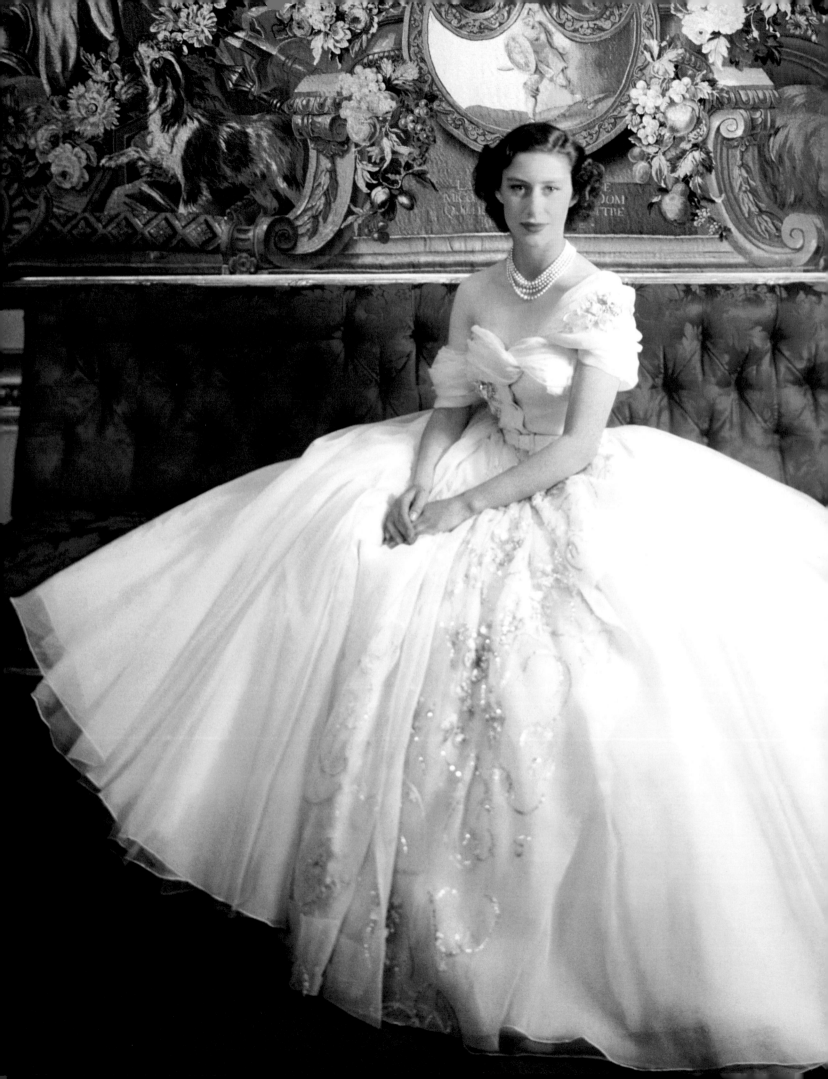

Royals

between

Kitsch and

Punk

Elizabeth Bowes-Lyon, who would later become the Queen Mother, loved pearls, feathers, and hats – the fashionista at a garden party in 1939 (right) and wearing a pompous fur stole (below).

Right: After her own mother's death, the future Queen Mother (who was herself queen at the time) made a great impression in white dresses by Norman Hartnell during a state visit to Paris in 1938. Queen Victoria was not alone in being buried in white. Until the seventeenth century, France's queens wore this unusual mourning color. Elizabeth was later photographed in her "white wardrobe" in the garden of Buckingham Palace.

Elizabeth II & Co.
The Stylish Wives of Windsor

Jam jars with curved rims in every color imaginable: Queen Elizabeth's hats are symbolic of the Windsor ladies' chic, a mixture of pastel-colored suits, box-shaped handbags, and sensible pumps. And yet the secret of the British queen's success lies in the very fact that she is not fashionable. In 1976, the American fashion critic Richard Blackwell declared her to be one of the ten worst-dressed women in the world. But Elizabeth cannot have cared very much; a queen, after all, follows nobody, and she certainly does not follow fashion. And this is why star designers like Vivienne Westwood and Miuccia Prada now consider her a real icon. The queen ignores short-term trends, responding to them with the typical British "stiff upper lip." In terms of clothing, the queen is as persevering as a marathon runner; in the space of half a century, she has depended on just seven royal dressmakers and one stylist, most of whom she has outlived. Norman Hartnell (1901–1979) was given the greatest of honors: the master of elegance dressed not only Elizabeth, but also took charge of her younger sister Margaret and the Queen Mother.

"I have got nothing to wear," was the Queen Mother's motto. No royal was as profligate as the Queen Mother (1900–2002), and nobody was as proud to be, either. A new wardrobe of clothes was tailored for her every year, and she did not wear any of her outfits twice. She stored all of her clothes in enormous mahogany cupboards, which filled the entire second floor of her London residence Clarence House. The Queen Mother threw four parties a week, drank Pimm's, sherry, and vintage champagne even before the bell chimed midday, had five homes, a staff of sixty at Clarence House alone, twelve race horses, and paintings by Monet and Sisley. When she rang for her servants, she did so with a precious little bell by Fabergé. She always exceeded her apanage, usually by double, so that her daughter Elizabeth regularly had to balance her deficits at the royal bank of Coutts & Co. The daughter of a Scottish earl never forgave her sister-in-law Wallis Simpson for having called her a "dowdy duchess," a dig at the ruffles and lace she loved. Elizabeth Bowes-Lyon had celebrated her wedding to the future king George VI (1895–1952) in an ivory-colored gown of crêpe de chine by Madame Handley Seymour, the former dressmaker of her mother-in-law Queen Mary. She followed the trend of the time with the straight-lined silhouette in 1923, but it did not guarantee her a place in the history books. It was not until the 1930s

that Norman Hartnell designed an entire wardrobe for her that suited her rectangular, compact figure better. She became a fashion icon at last on her state visit to France in 1938. Hartnell had already made thirty gowns for her when her mother, the Countess of Strathmore, died unexpectedly. The trip was delayed and the designer created a new wardrobe for her in nothing but white, a reference to the unusual color of mourning at Queen Victoria's funeral. From then onward, the Queen Mother only dressed in single colors from head to toe. Just 158 centimeters tall, the lady always wore a hat and, usually, white pumps by Edward Rayne with her outfits. Even her makeup was conservative: until her death, the Queen Mother used a pinkish face powder made according to a secret recipe by Elizabeth Arden. In short: as well as making corgis, a Welsh terrier breed, popular, the Queen Mother created a beauty myth around herself as well as her daughters "Lilibet" and "Margo."

The princesses were thought to be exceptional beauties and were in competition with Soraya of Persia and many Hollywood stars. Margaret, the younger child, in particular, created a stir with her diva-esque looks. "Her only running-mate was the film actress Elizabeth Taylor," the biographer Christopher Warwick reminisced. She was the opposite of her sensible sister: Margaret went from one bar to the next with actors and artists, smoked cigarettes with a diamond-encrusted tip, painted her fingernails pink, and looked at Dior's New Look with its bobbing petticoats in awe. In the wake of World War II, the large amount of fabric on these new skirts was basically a sensation. Hartnell, too, imitated the look and created puffy skirts to fit the royal daughters' hourglass waists, with the result that women the world over wanted to own similar dresses. But behind the cheerful façade, Elizabeth's younger sister suffered from her lot in life, being the eternal number two. "I used to be Margaret of York, but now that Papa is king, I am nothing," she already moaned as a young child. Margo lightened her mood with fashion: whereas she had often worn white and

Mirror, mirror on the wall... The Queen Mother established a cult of beauty with herself at its center, and it lasted a lifetime. Until she died in 2002, she dressed in single colors from head to toe. In 1984, the Queen Mother posed among the Irish Guards wearing royal blue (top).

Right: The king's younger daughter, Margaret, lived according to the maxim that "true style never dies."

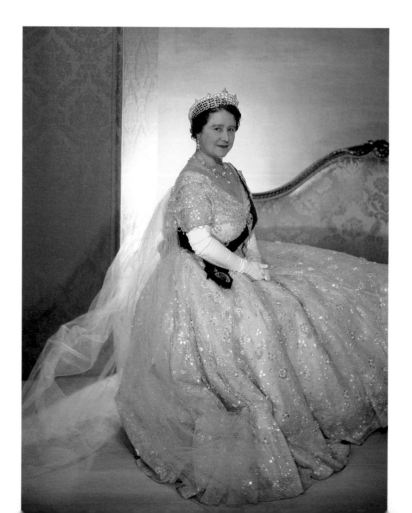

gray as a young girl, she later came to love striking colors like turquoise, royal blue, and pink. The king's daughter made herself look pretty in a ball gown by Christian Dior as early as her twenty-first birthday. The royal trendsetter usually combined her dresses with platform shoes of white or black leather, and put on toeless peep toes in the summer. Unlike the Queen Mother, she abhorred ruffles and lace, but shared her love of sparkling diamonds. Margo lived according to the motto "true style never dies."

Although Elizabeth was overshadowed by her stylish sister, she learned to use clothing as a political statement like no other. So much so that the grumpy prime minister Winston Churchill described her wedding to her distant cousin Philip Mountbatten as a "ray of light on the hard, gray road on which we travel." In the lean postwar years, Elizabeth's splendid wedding dress of silk satin, onto which ten thousand pearls

had been stitched, symbolized the escape from poverty. Fabric was as precious as black truffles at the time, and could only be bought with coupons. Elizabeth was given two hundred clothing coupons by the government to make Norman Hartnell's design, and she contributed the remaining hundred. Her dressmaker took inspiration for the dream gown from Botticelli's spring painting *Primavera*, a Renaissance classic showing Venus, the goddess of love, in an orange grove. The designer embellished the dress and four-and-half-meter-long train with garlands of orange and rose blossoms stitched of pearls and crystals. No wonder that Elizabeth did more than enchant her husband Philip Mountbatten with it: she unleashed a new euphoria for the royal family and its fashions. Prince Charles and Princess Anne had already been born when she was proclaimed queen in 1952 following the unexpected death of her father.

Top: Elizabeth (left) and her sister, both wearing swishing skirts and white peep toes in 1948. Margaret smoked cigarettes using a long cigarette holder (below), and posed with her husband Lord Snowdon in the Bahamas in 1967, where the bow in her hair perfectly matched the color of the sea.

Right: Margaret in a cream-colored dream of a dress – beautiful, but unhappy

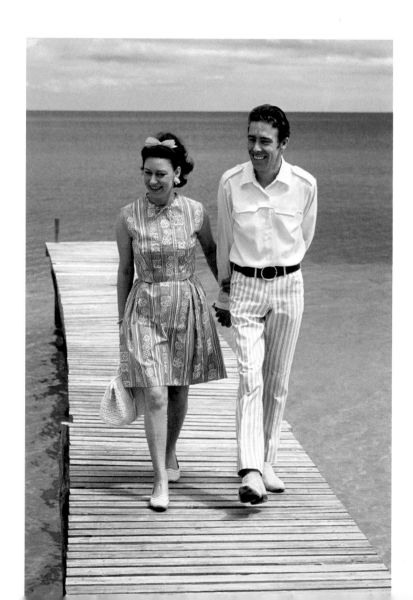

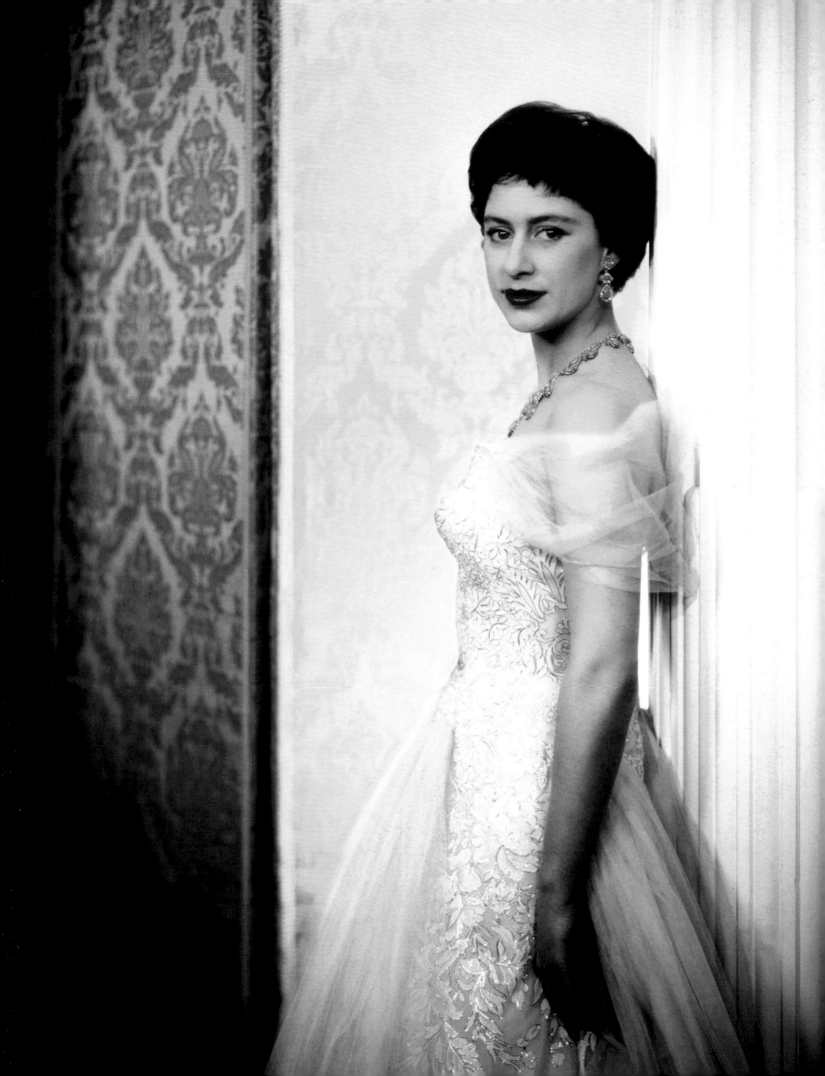

Margaret loved to wear colorful caftans on the Caribbean island of Mustique, her second home.

Below: The princess, sixty-one years old at the time, drew attention to herself on this occasion in London wearing an idiosyncratic pink-red hat of ostrich feathers.

At her coronation sixteen months later the twenty-seven-year-old monarch personified the vigor of a new era in her magnificent robe.

Her sumptuous gown by Hartnell was embroidered all over with the emblems of the Empire and all Commonwealth states. Her pumps were designed by none other than the Parisian god of shoes Roger Vivier. He created goatskin shoes with a fleur-de-lis motif and many little rubies in reference to the lily on Elizabeth's famous imperial state crown. In his autumn/winter collection of 2009, Vivier's successor Bruno Frisoni revived the queen's pumps and dedicated a limited capsule collection to them.

When Elizabeth became queen, her little sister's fall began. While the heir to the throne was allowed to marry her great love Philip, Margaret fell head over heels for the divorced Royal Air Force captain Peter Townsend. She plucked a piece of fluff from her lover's jacket unselfconsciously just after the coronation ceremony, and the relationship came to light. But, unlike her uncle Edward VIII, Margaret reluctantly decided against love and married a man in 1960 who should have remained her court photographer: Tony Armstrong-Jones, later Lord Snowdon. The divorce was written in the stars: the elegant yet simple wedding dress by Norman Hartnell suited their sober wedding. And the former fashion girl soon changed her wardrobe. From then on, Margaret exchanged saccharine chiffon gowns for severe Jacquard dresses and brocade coats and, later, caftans of chiffon. She never got over her great love: Margaret was careless with her health, smoked countless cigarettes, and died after four strokes in 2002, shortly before her 101-year-old mother. The traditional British label Burberry took inspiration from Margaret's sixties style for a collection four years later.

Her sister, the queen, had a very different taste in fashion. She was advised for four decades by Hardy Amies (1909–2003), as well as by Hartnell. The designer, like his famous customer, consistently ignored all trends and created elegant suits and evening gowns in special colors. "I do not dress the queen. The queen dresses herself. We supply her with clothes – there is a difference," he said. While the queen initially most liked to wear blue fabrics that suited her eye color, he dressed her in bright pink

"Ascending the throne in 1953, the twenty-seven-year-old used her wardrobe from the start to create the image of a dignified, elegant world leader.**"**
Vogue

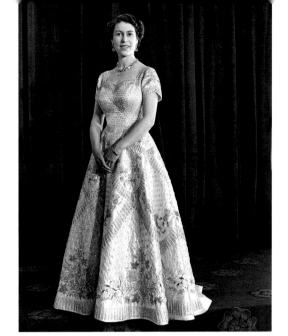

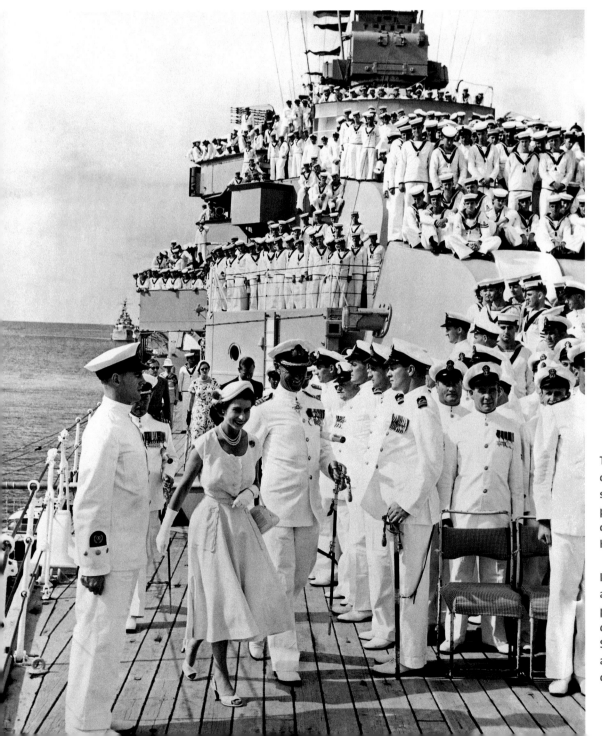

Top: Emblems of the empire and of each of the Commonwealth states were stitched by hand in pearls and crystals onto Elizabeth's coronation gown by Norman Hartnell.

Left: For her first visit to Australia and New Zealand, the queen packed more than one hundred dresses. For a photo session on the SS Gothic, her white clothes shone as brightly as did those of the crewmembers.

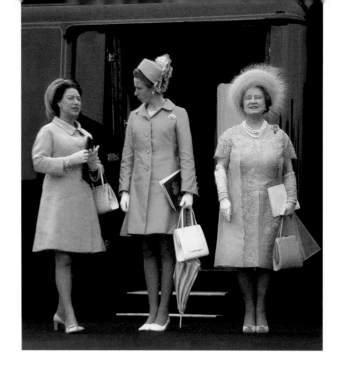

Pastel Parade: Margaret, Elizabeth, and the Queen Mother in flamingo pink, turquoise, and pistachio green at the investiture of Charles as Prince of Wales in 1969 (left). The queen dressed in lilac on a visit to New Delhi in 1961 (below).

Right: For her sister's wedding in 1960, Hartnell designed a gown for the queen in her favorite color: blue, to match her eyes.

❝ I do not dress the queen, the queen dresses herself. We supply her with the clothes. There is a difference. ❞
Sir Hardy Amies

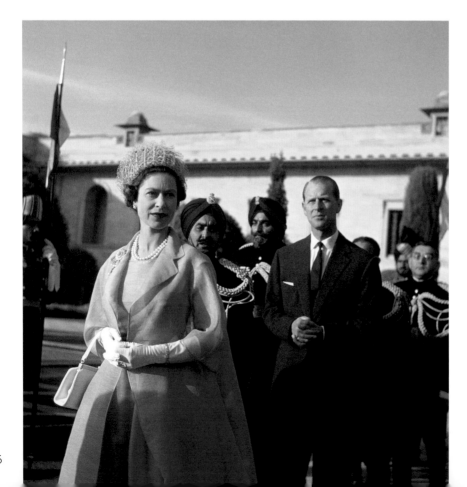

in 1976. She liked it so much that she wore the ensemble twice and wore an increasing number of clothes in pastel colors from then on. Although Amies did not offer the queen clothes in beige, "On the occasion that I did, she decided that 'I can't wear beige because people won't know who I am.'"

The queen is recognized the world over in her colorful uniforms. As head of the Commonwealth, a community of more than fifty sovereign states, Her Majesty has traveled around the world 175 times and has thus been on more tours of duty than every one of her royal colleagues. For her designers, the search for a suitable outfit is an obstacle course. The most important style rule: dresses, suits, and hats must always be in harmony with the national colors of the country she is visiting. The choice of fabric is equally important: it must be suitable for the climate, but always regal. On a state visit to Spain in 1988, a German dressmaker was graced with the queen's favor. Karl-Ludwig Rehse survived his trial by fire when the queen flew to Madrid in his blue-and-white dress and was greeted by King Juan Carlos with a compliment: "Darling, you look wonderful."

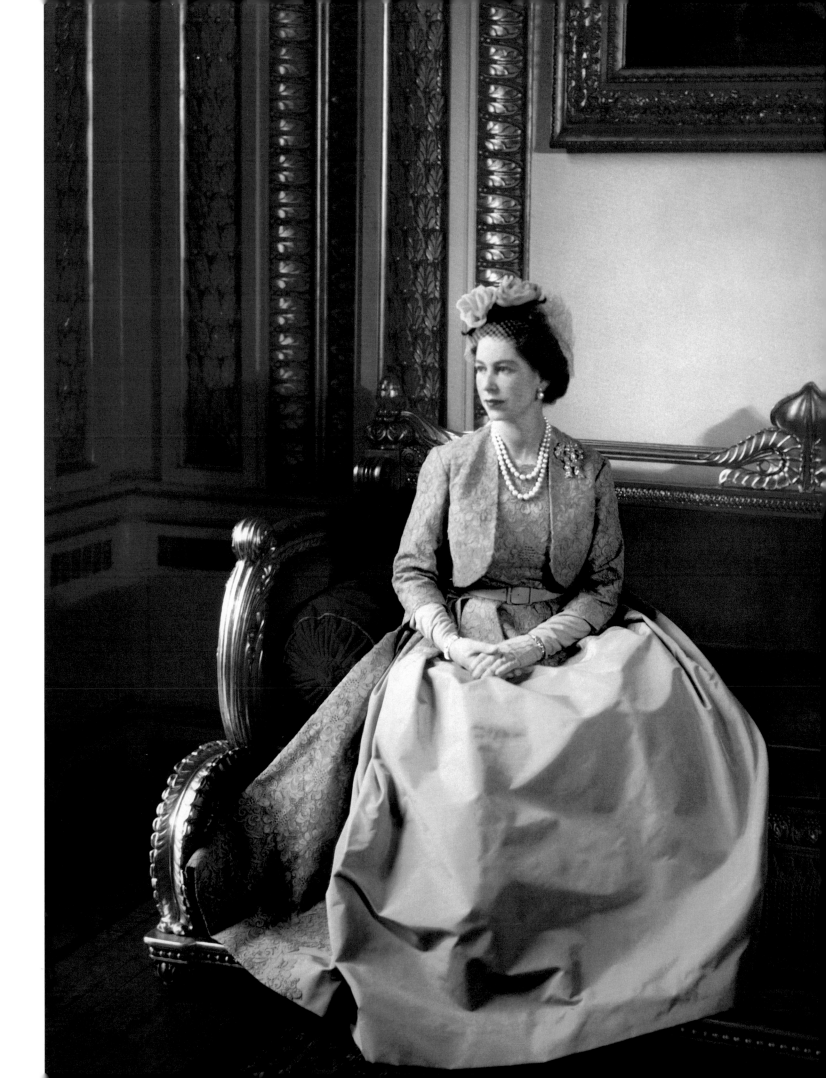

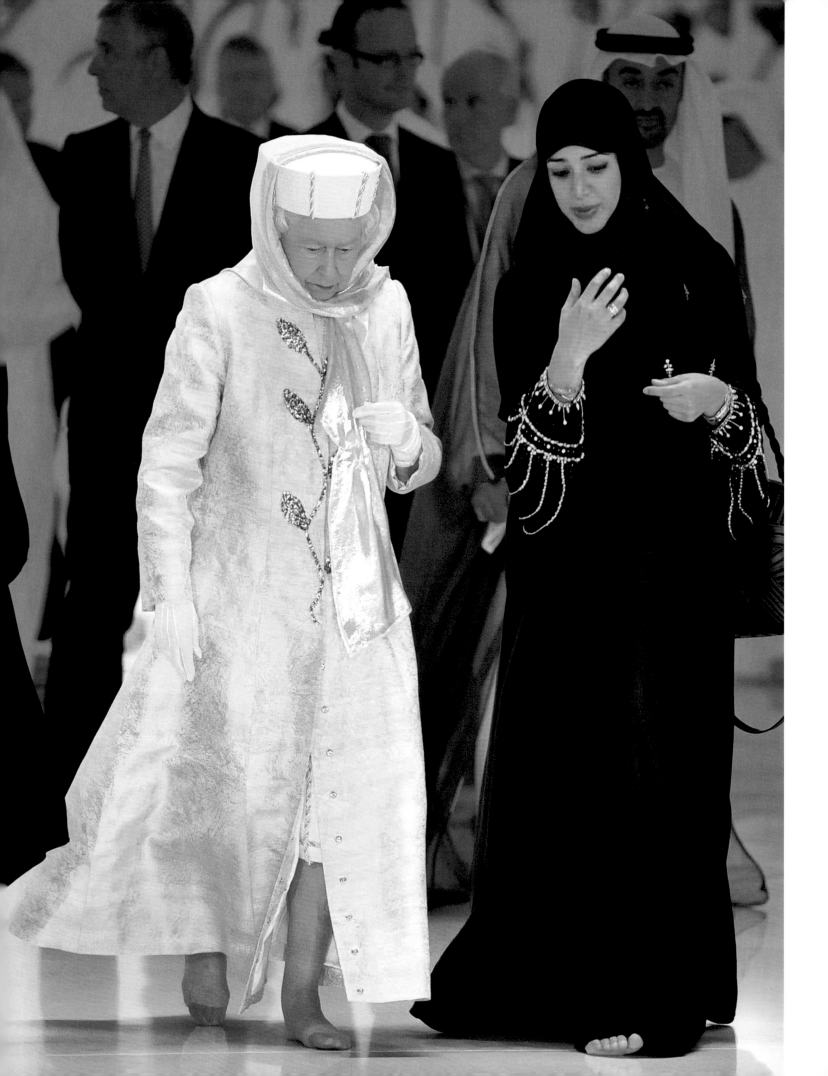

"Glam Granny": On state visits, the queen is advised by her stylist, Angela Kelly. Kelly chose fur and boots for Elizabeth II in Slovakia in 2008, designed a yellow outfit for the queen to wear at William's wedding and advised her to wear flower prints in Oman in 2010.

Left: The queen, barefoot and wearing a brocade coat with Swarovski crystals by Angela Kelly, in the Sheikh Zayed Mosque in Abu Dhabi in 2010.

Designers like Rehse do not speak to the queen herself, however, they speak to her personal assistant and Senior Dresser, Angela Kelly. Kelly has advised the monarch about clothes, jewels, and decorations and has also made her own designs, too, since 2002. She and her team transform the queen into a "glam granny" for the monarch's appearances. The stylist likes to use old brocade fabrics, loves elegant accessories, and convinced her client to show herself to the public in trousers for the first time after knee surgery in 2003. Angela Kelly designed a canary-yellow coat ensemble and matching hat (the queen owns more than 5,000 headdresses) for Prince William's wedding in 2011. The queen combined it with a cream-colored calf-leather bag with a high strap, which was one of a kind, designed by Launer London, purveyor to the court. The bag maker's sales increased by 60 percent after the appearance – all women wanted to have a similar model. Even over the age of eighty-five, the queen is a »Trendsetter Royal«.

Gloria von Thurn und Taxis
Princess TNT

"Shocking" was her favorite word: the flamboyant Gloria von Thurn und Taxis created a stir in 1980s high society with her brightly colored shock-headed hairstyles, leather clothes, and rivet outfits by Thierry Mugler. The Bavarian princess was the enfant terrible of the aristocracy, on a first-name basis with the Khashoggis of this world, and, for ten years, the scintillating center of every party. She danced in New York's Studio 54 clothed in a modern take on a knight's amour and, wearing a bizarre hat, delayed the opening of a fashion show at Chanel in Paris. She barked like a dog during an interview with the U.S. talk-show legend David Letterman; Keith Haring helped her children to paint the doors to their rooms; and Andy Warhol said, "Gloria, you should have your own TV show." The American media gave her the nickname Princess TNT – a reference to her surname, and of course to the highly volatile explosive. Her highness loved to be provocative and took advantage of her status as the wife of a prince for her eccentric performances. Receptions and cocktail parties were part of everyday life to her husband, nearly thirty-four years her senior. "I just got bored of this party society, and so the only amusement I could gain from it was to achieve some sort of 'wow' effect with my outfits," she tells in her biography, *Gloria – Die Fürstin* (Gloria – the Princess).

Top: In 1986, hairstylist to the stars Gerhard Meir styled Gloria von Thurn und Taxis during the television show "Chic." During her wilder years, the princess loved not only punk hairstyles, but also amusing little hats (left). Right: "Princess TNT" wore a fountain-inspired hairstyle to a ball at the Waldorf Astoria in New York. A sapphire sparkled in her hair.

> **❝** What I loved most about it was people's incredulous reactions. They even remember to this day: 'My goodness, Gloria, we couldn't stop laughing at how well dressed you were back then; like a parrot.' **❞**
> *Gloria von Thurn und Taxis*

Top: Gloria von Thurn und Taxis sporting a wacky gel-based hairstyle, in front of a photo wall. **Left:** The princess created a stir when she wore a teddy-bear dress by Moschino during an appearance on the television show "Wetten, dass …?"

She was less sensation-seeking in earlier years. The penniless countess Gloria von Schönburg-Glauchau und Waldenburg met Johannes von Thurn und Taxis when she was just nineteen years old and he was almost three times her age. At the time, she liked to wear pearl necklaces and kilts; in other words, a typical aristocrat. She married Germany's richest prince seven months after they had met. A party-going aristocrat from Regensburg, he was the owner of the castle of St. Emmeram, which, at five hundred rooms, is bigger than Buckingham Palace. Friend to her husband and couturier Valentino designed her wedding dress, which she wore with Empress Eugénie's pearl tiara (see page 43); the piece of jewelry had stayed in the family after her husband's grandfather had bought it in 1890.

Time to misbehave! After five years of marriage and three children, Gloria made her first shocking appearance in 1985, at the wedding of her sister Maya in Salzburg. Hairstylist to the stars Gerhard Meir gave her a stiff lion's mane and dyed the tips of her hair pink. Prince Johannes is rumored to have said nothing more than "Now I can turn you upside down and sweep the castle with you." Later, Gloria even had her hairdresser flown in for TV appearances in America and parties in Versailles. "The styling and backcombing excesses we celebrated were far removed from a wash, cut, and blow dry. I turned her hair into pale-yellow wagon wheels, red tongues of fire, planted diamonds the size of chicken eggs on her head, teased her hair into cascading structures," Gerhard Meir later reminisced. For her husband's sixtieth birthday, Gloria organized a Don Giovanni party, at which she wore a pale-pink Marie Antoinette-style gown with a towering hairstyle and sang the Marlene Dietrich song "Johnny."

Instead of rococo gowns and mountains of hair, the princess now has a business bob and wears Dior outfits and Prada dresses. Little wonder – after her husband's death in 1990, she acquired from one day to the next the responsibility of saving the ailing family business. In order to be able to pay the inheritance tax, she sold furniture, luxury cars, and jewelry. When she put her wedding tiara, handed down by Empress Eugénie, up for sale at the auction of her jewelry in Geneva, many were horrified. But the princess was pragmatic about it. Under her leadership, the business went on to once again achieve success, and in 2002 she was voted the tenth best financial manager in Europe by the U.S. magazine *BusinessWeek*.

Change of style: Instead of punk hairstyles, Princess Gloria von Thurn und Taxis now wears a simple bob and comparatively unobtrusive outfits. Her two daughters Princess Elisabeth (left) and Princess Maria Theresia are part of the young jetset aristocracy, sit in the front row at fashion shows and love extravagant styles.

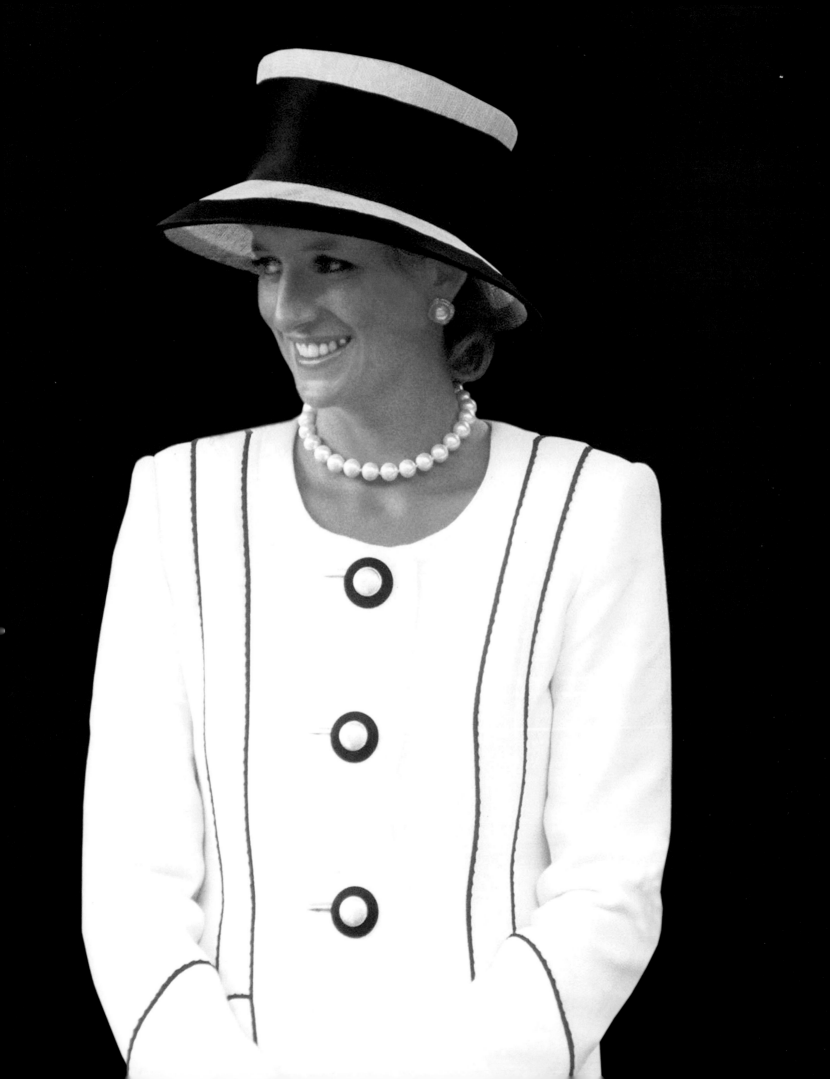

Princess Diana

Fashion as a Mirror of the Soul

Princess Diana
Fashion as a Mirror of the Soul

The shock of her death washed across the world like a tsunami, creating unprecedented reactions. Millions of people cried at the loss of the "Queen of Hearts," the two little princes cried at the loss of their "Mummy," and the fashion world cried at the loss of the greatest icon of the 1980s and 1990s: Princess Diana. An era came to an end when the black Mercedes she was traveling in crashed against the thirteenth concrete pillar of the Pont de l'Alma tunnel in Paris. Her legacy included the blond Lady Di bob, and giving her name to the D-Bag by Tod's as well as a little Dior bag. But she was more than just a trendsetter; she, more than anybody else, used fashion as a mirror of the soul. When she discussed her wardrobe with designers, the statements made by her looks were always part of the consideration. No wonder: until the legendary BBC interview of 1995, in which she appeared with dark eyeliner beneath her big blue eyes, confessed a suicide attempt, her affair with the riding instructor James Hewitt, and Charles's mistress Camilla Parker-Bowles ("There were three of us in this marriage"), the wife of the British heir to the throne had in effect been forbidden to speak. The most photographed woman in the world expressed her feelings with her clothes – there was no need for words.

Diana's gowns are like individual mini biographies and, put together, they tell the story of one of the greatest style icons. The Princess of Wales loved to transform herself, like a chameleon: at her wedding, she lived the Cinderella dream dressed as a giant meringue, and, years later, rebelled against the cold in Buckingham Palace with Dallas dresses of gold lamé. In her marital war against Charles, she finally used her clothes as weapons. In 1992, the scandalous biography *Diana: Her True Story* by Andrew Morton uncovered Charles's affair with Camilla. Diana herself had been the secret inform-ant. When the Prince of Wales attempted to restore his honor in a television interview in 1994, she stole the limelight by appearing at a gala at London's Serpentine Gallery in an off-the-shoulder cocktail dress. This piece of clothing went down in history as a "revenge dress." Never before had a woman selected her outfit with such tactical brilliance. While Charles had actually aimed to damage her image, she pushed him off the next day's front pages in an explosive wisp of black silk chiffon, a pearl necklace with a clasp made of an elongated sapphire, and her matching engagement ring. As Christina Stambolian, who designed the dress, remembered, Diana "chose not to play the scene like Odette [from Swan Lake], innocent in white. She was clearly angry. She played it like Odile, in black. She wore bright red nail enamel, which we had never been seen her do before. She was saying, Let's be wicked tonight!'"

This sweet revenge had nothing to do with the nineteen-year-old "Lady Shy,"

Revenge Couture: While Charles gave his infidelity interview on television in 1994, Diana stole the spotlight from him in a black cocktail dress by Christina Stambolian.

66 When the princess discussed her wardrobe with me, it was always also about the question: What am I communicating if I wear this? It became a real language of fashion. 99
Jasper Conran

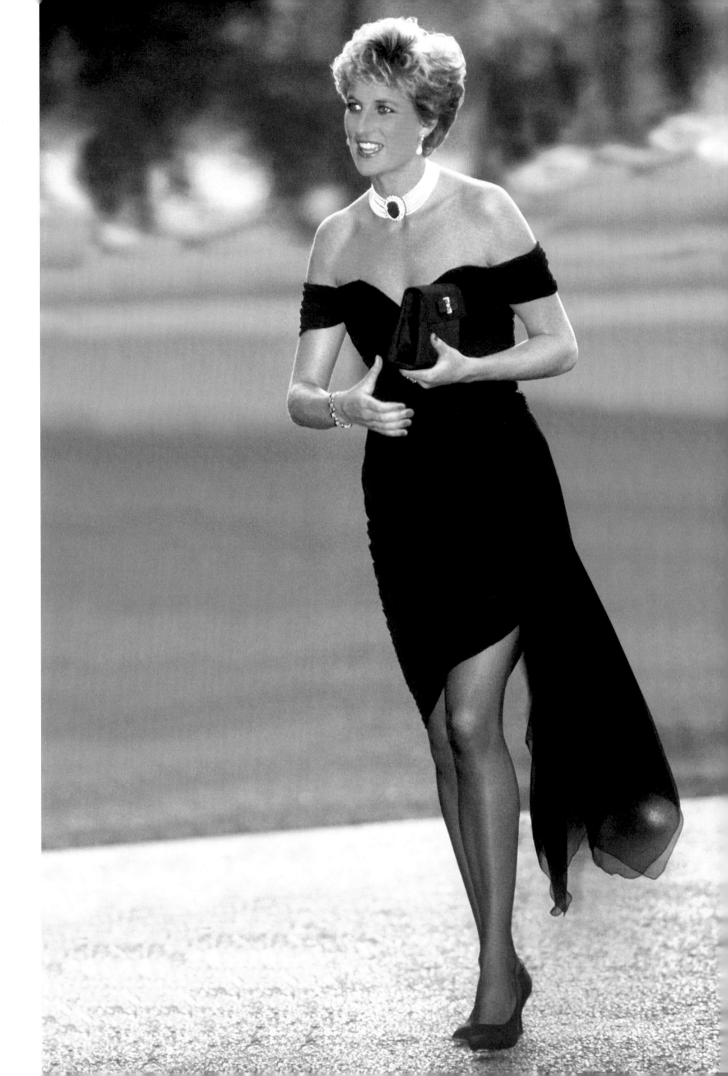

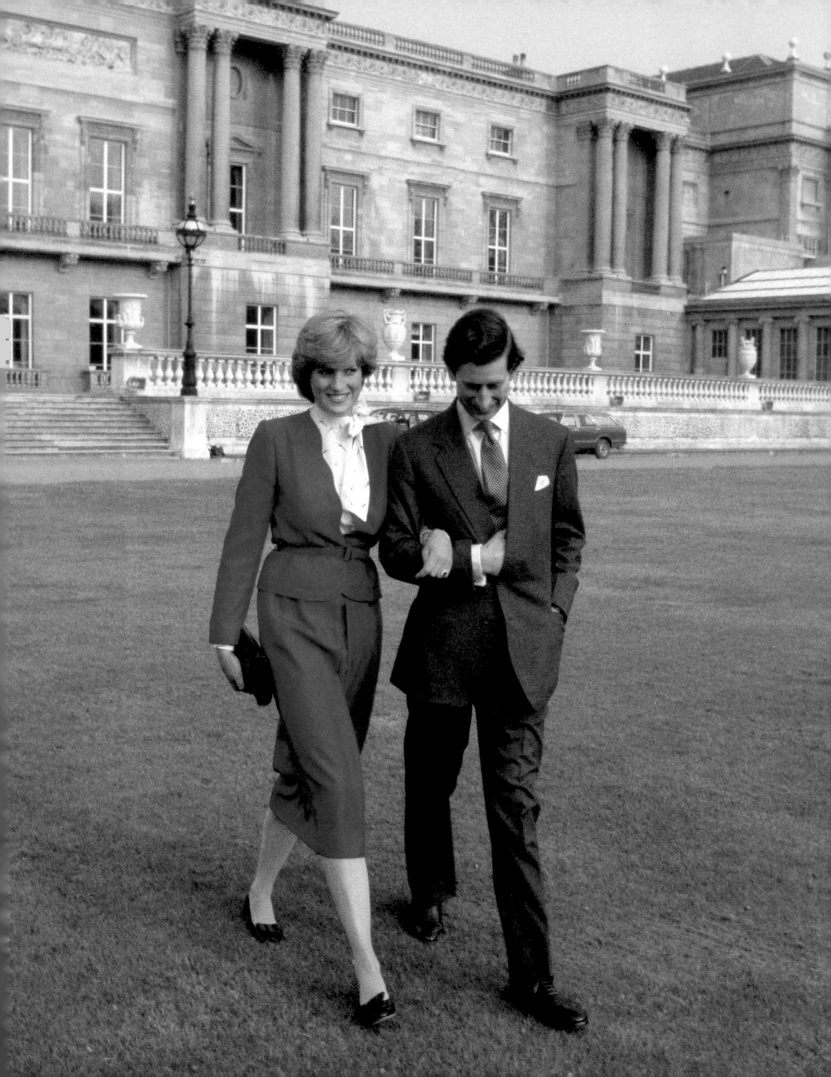

virginal offspring of the Spencer dynasty and daughter of the eighth earl. When the "Playboy Prince" Charles got engaged to the pre-preschool assistant in February 1981, she owned no more than an evening dress, a silk blouse, a pair of elegant shoes, and the aforementioned engagement ring by Garrard, a sapphire with diamonds worth £30,000. At the time, her style sensibilities were limited to lambswool sweaters, pearl necklaces, rubber boots, and Barbour jackets. And yet she made the headlines with her very first famous photograph: one day after her relationship with Charles had been revealed, she was outsmarted by reporters at the kindergarten in Pimlico, posing in a transparent Laura Ashley skirt against the backlight of the sun. While the tabloid press descended like vultures on Diana's bare legs, only one journalist mentioned the plethora of little hearts on her skirt – Diana's first fashion message. Not long afterward, she was faced with a new challenge: to find an engagement dress for the press photograph. Diana only knew that its color had to be royal blue, to match her sapphire ring. But the young fiancée of Prince Charles was not recognized in the shop of design duo Bellville Sassoon, and she finally bought an ordinary Cojana suit with a printed blouse off the rack at Harrods. Her mother, Frances Shand Kydd, could not bear her youngest daughter's awkwardness when it came to fashion and asked British *Vogue* for help. Her elder daughters Sarah and Jane had worked there temporarily and introduced Diana to the fashion editor Anna Harvey, who then searched all of London for the chicest items of clothing. As a future princess, Diana was to be supplied with a foundation of designer clothes so that she could find her own style. In the October 1997 issue of *Vogue*, Anna Harvey wrote of her first meeting with Diana: "When she came in, I initially thought: Oh, this won't be difficult. I noticed her height and good proportions.... Her eyes sparkled when she saw the clothes I had got for her. I think she was incredibly undemanding when it came to clothes and had no idea of the beautiful things that are out there." When the famous Lord Snowdon first

Left: For the engagement photograph, Diana bought a blue Cojana outfit to match her sapphire ring.

Below: Charles's girlfriend broadcast her first fashion message in a Laura Ashley skirt with little hearts. Unfortunately, it was translucent when backlit by the sun.

tographed Diana, *Vogue* approached the young fashion designers David and Elizabeth Emanuel, who were just out of college, and requested something "romantic with a high neck." The married couple dispatched a delicate-pink ruffled blouse that would become Diana's trademark, and which she liked so much that she asked to meet both of them. This was the young designers' big break: they were to dress Prince Charles's fiancée for her introduction to high society at a charity event in London. Diana wanted a strapless black silk taffeta gown; she wanted to be taken seriously next to her fiancé, who was twelve years her senior. "Black to me was the smartest color you could possibly have at the age of nineteen. It was a real grown-up dress," she later said. Nobody had realized that, in addition to the neckline being far too risqué for the palace, the mourning color black was, from the monarch's point of view, completely unsuitable for the occasion. When Diana stepped out of the limousine, one could see deep into her décolleté, causing a storm of flashbulbs. While Charles griped about her dress, the media took to the extravagant piece and discovered something astounding: this young woman had the potential to deviate from the court's dress code and to find her own clothing style.

She lacked the courage to do so, how-ever. Diana was afraid of making another mistake. After all, she wanted nothing more than to please her fiancé. She saw Charles only thirteen times before the wedding, but was head over heels in love with him. She wanted to enchant him as they made their vows in St. Paul's Cathedral, and gave the Emanuels the "commission of the century" – to create her wedding dress. This was not an easy task for the design duo: her fiancé's lack of attention could be measured in Diana's shrinking waist. To the Emanuels' despair, the girl, who was already bulimic at the time, lost almost fifteen centimeters during the engagement period, abandoned by the court amidst a mountain of etiquette. The rest of the gown was all the more bouffant: fourteen meters of ivory-colored taffeta silk decorated with old lace, puff sleeves that looked like candy floss, a ruched neckline, ribbons, and a crinoline skirt in which the bride barely fitted into the carriage that took her to the church. Ten thousand mother-of-pearl sequins, stitched on by hand, shimmered on the eight-meter-long train. Her veil was secured with the Spencers' diamond tiara. The excitement surrounding the dress reached such proportions that the Emanuels locked it away in a safe. Journalists lay in wait outside their atelier, going so far as to rummage through the

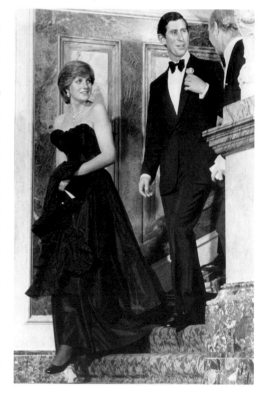

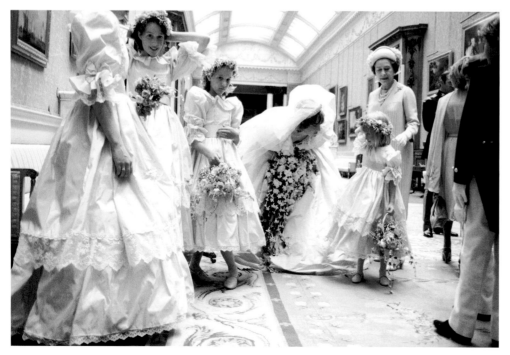

The dress that caused a scandal: The black silk taffeta dress by David and Elizabeth Emanuel was too low-cut and the color a no-go, according to the Palace (above). Charles's fiancée entrusted the design duo with the design of her wedding dress all the same. On July 29, 1981, she said "I do" in a gown with puff sleeves and a crinoline skirt.

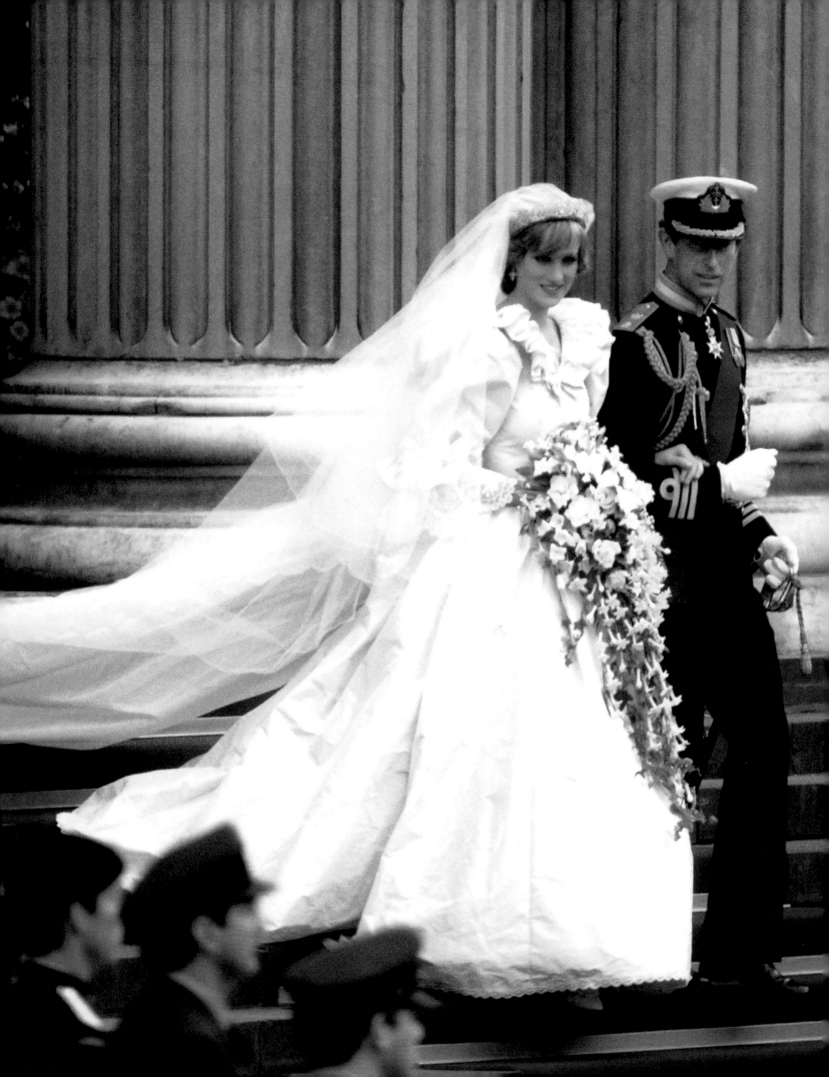

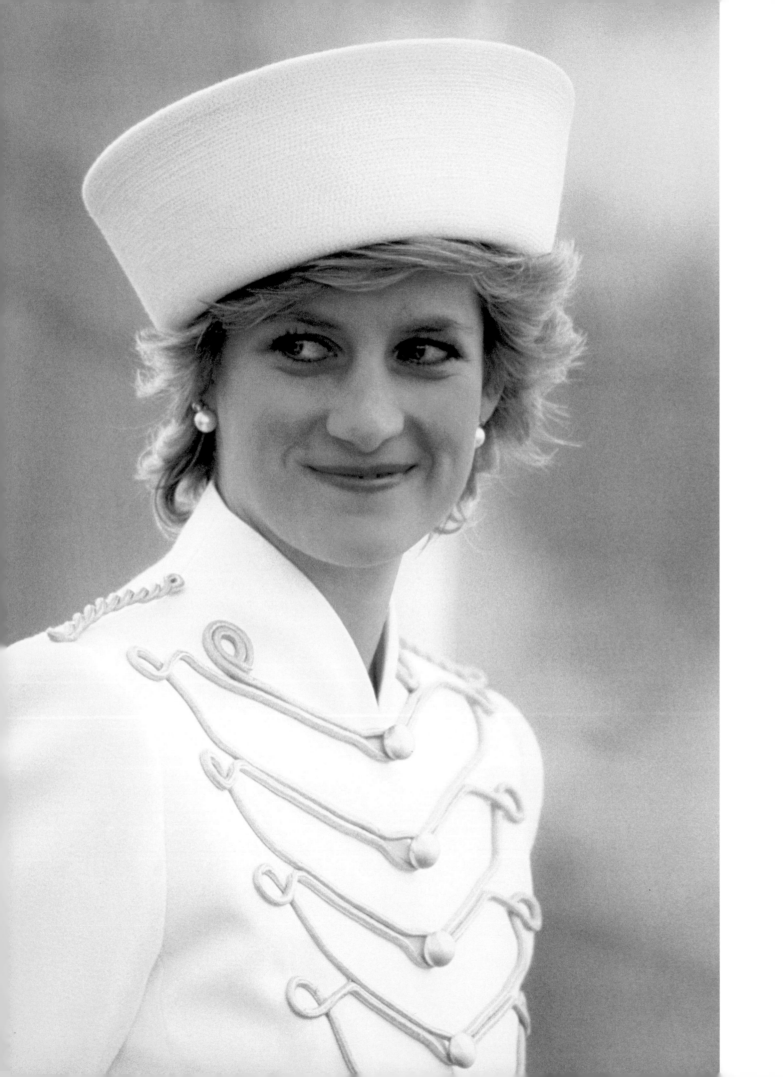

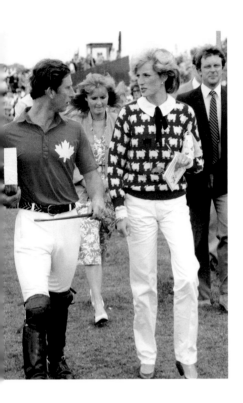

going so far as to rummage through the rubbish bins for pieces of fabric and thread. The secret was unveiled on July 29, 1981, and the opulent gown went down in history. After a pompous ceremony in front of 750 million television viewers, the first copies of the wedding dress were available on Oxford Street just five hours later.

As a young wife, Diana discovered her love of fashion experiments. Having worn little hats with symbolic Prince-of-Wales ostrich feathers, in accordance with court etiquette, to her first appearances as Princess of Wales, she liberated herself from the royals' conventional style with the birth of her sons, William and Harry. In 1983, she kicked off the first Diana Boom that was independent of the palace by wearing her famous sheep pullover. Millions of women

knitted copies of the red sweater on which all of the sheep were white, except for one black one. The princess became more courageous, but also committed fashion crimes such as wearing dotted socks with a polka-dot skirt. On visits, she incorporated particular style elements related to the location or occasion, often overstepping the boundaries of good taste. Diana often looked as though she were in fancy dress, wearing only tartan in Scotland, appearing in a scarlet-red Cossack outfit at Christmas in Windsor Castle in 1986, and shocking people on another occasion in a white hussar costume with oversized epaulettes. But she also had some witty ideas. When wearing backless power dresses à la *Dallas*, the princess knotted her pearl necklace in the nape of her neck, and she wrapped her

66 The princess always wanted to look feminine. She once said that she had great respect for Joan Collins because Joan Collins always looked feminine, by which she didn't mean 'feeble'. **99**
Philip Somerville

Experiments: Diana started a craze with her sheep sweater in 1983, inspiring everybody to pick up their knitting needles (above). She wore a royal blue plissé gown by Yuki to a meeting with Emperor Hirohito in 1986, tying her sapphire and diamond choker around her head.

Left: The Princess of Wales in a white hussar outfit by Catherine Walker

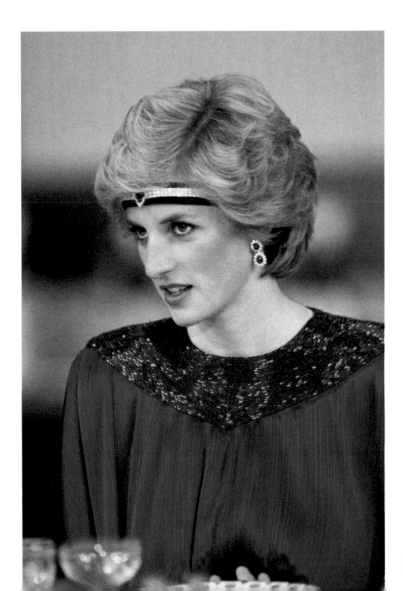

> **66** She began to experiment with glamour and became much more courageous. Unlike me, she was crazy about dresses with just one sleeve. **99**
> *Anna Harvey*

Having conquered her bulimia and developed a new sense of confidence, Diana discovered Catherine Walker's fashions. The Frenchwoman designed one-shoulder gowns for her, and these became Diana's signature style. In Paris in 1988, the Princess of Wales looked dazzling in a red-and-black flower dress of silk taffeta.

sapphire choker around her head as a bandeau at a state banquet in Japan in 1986. The ups and downs of her taste in clothing also reflected the changes in her emotional state. While she blossomed as a mother, her marriage experienced difficulties and she continued to suffer from bulimia.

Although she was the most frequently photographed woman on earth, Diana became increasingly lonely. Her designers became her closest allies because she was able to count on the fashion world's discretion – after all, none of them wanted to lose their most famous client. Paparazzi hounded her on the streets, so the Princess of Wales did not even attend fashion shows. Couturiers like Victor Edelstein therefore invited her to the dress rehearsals or visited her at the palace. Her favorite milliner, Philip Somerville, who often delivered boxes full of hats with the aid of his assistant, says in her fashion biography, *Diana: Her Life in Fashion*, "It was always so quiet in Kensington Palace. When we were shown in, the princess was already waiting for us at the top of the stairs. When we left, she accompanied us to the car, and sometimes, when the boys were with her, they jumped into the car and played at driving. One day, they had just been given camouflage outfits, like soldiers. They stood at the gate and saluted us as we drove

out. We looked back and saw Diana standing next to them and, strangely, we had the impression that we had been the highlight of her day."

"Enough is enough!" Diana took charge of her life in 1987, overcame her eating disorder, and began to make fashion work for her. She knew how she could enchant the media, sometimes forgetting protocol in the process. When the princess attended a pop concert without Charles, she wore tight black leather trousers by Jasper Conran – a superb photo op for the paparazzi but far too risqué for a future queen. The more she distanced herself from the royal family and its fashions, the closer she became to the common people: her clothes made her the "princess within reach." She asked for a satin suit for a visit to a home for the blind because it felt nice and soft. She never wore the countless suede leather gloves that Anna Harvey sent to her at Kensington Palace. As the *Vogue* editor remarked, "Goodness knows what happened to them, she never wore them but wanted skin contact."

At this time, Diana began to play with glamour and underlined her sexy figure with one-shoulder gowns by the designer Catherine Walker, the first trademark of what would become the Diana Look. The native Frenchwoman became her soul mate and made more than a thousand dresses for the Princess of Wales. Catherine Walker did not follow short-lived trends but concentrated on outfits that were timeless in their elegance. The designer wrote in the German magazine *Bunte*, "I soon noticed how many roles this woman had to play: she was a mother, member of the royal family, future queen of England,

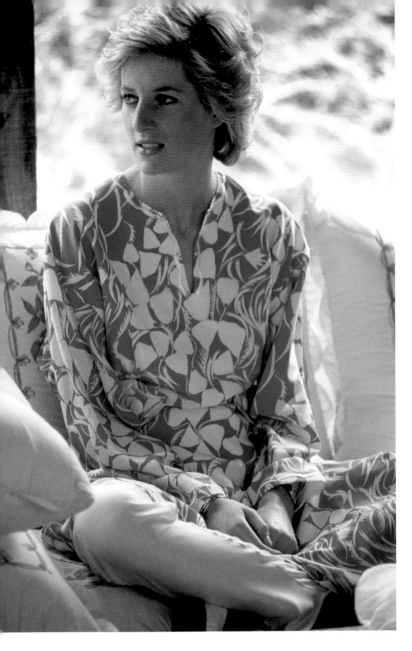

> ❝When the state visits began, the criteria changed completely… All of a sudden, everything imaginable became significant, from the simplest things such as national colors to local traditions such as sitting cross-legged for a picnic in front of the tent.❞
> *Catherine Walker*

Top: Catherine Walker designed a comfortable tunic with trousers for a desert picnic in Saudi Arabia in 1986.

Right: As the princess admired Grace Kelly, she wanted an ice-blue chiffon gown like the one worn by the actress in the film *To Catch a Thief* for the Cannes Film Festival in 1987.

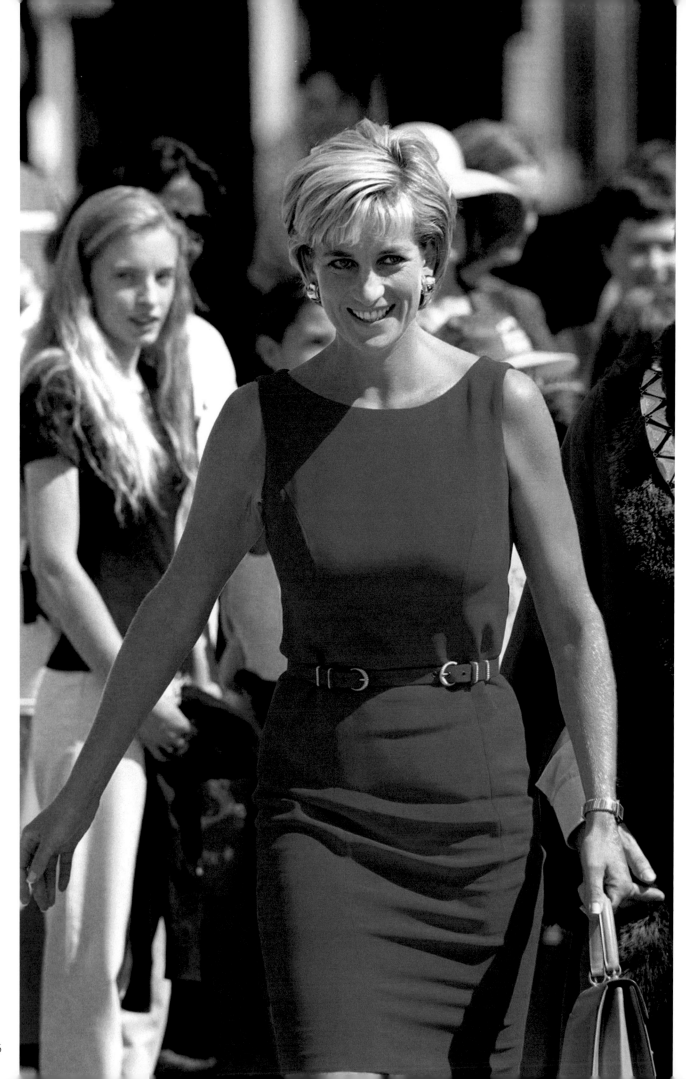

Below: Taking inspiration from the Queen Mother's "white wardrobe," Diana wore a cream-colored gown by Victor Edelstein at the Élysée Palace in 1988.

Left: The icon of "clean chic," wearing a trademark etui dress in red

ambassador, and icon. I began to see my work within the wider historical context." Diana's schedule required the appropriate outfit for every occasion: Royal Ascot, Easter at Windsor Castle, Christmas at Sandringham, and, most importantly, state visits. The designer furnished Diana with clothes for most of her close to twenty foreign visits, which were meticulously planned as much as four or five months in advance. Every detail had to be considered, from national colors to local customs, such as sitting cross-legged in an Arab tent. Said Catherine Walker, "It was easier to design for some countries than for others. India, Pakistan, and Indonesia were an invitation to let my imagination run wild; Hong Kong and Thailand were exotic because Diana could wear all of these strong colors there." Diana faced her greatest challenge when it came to a 1988 trip to Paris, the capital of haute couture. The royal family's style had been raked over the coals by French fashion critics since a visit by Queen Victoria. There was one exception: the Queen Mother. Diana, taking her cue from the triumphant state visit of 1938, also wore primarily white dresses. She stole the limelight from all other women with her outfits. The Princess

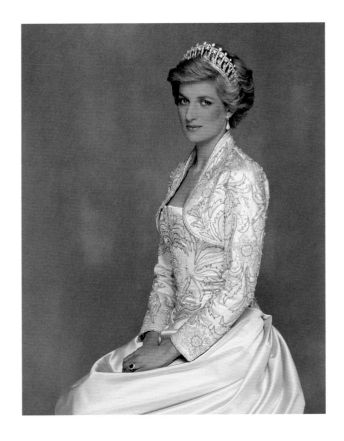

of Wales wore the most expensive dress she had ever owned to a state banquet at the Élysée Palace: a richly embroidered, cream-colored Victor Edelstein gown with a bolero, worth £55,000. No wonder that the people complained about her luxurious lifestyle: the *Times* estimated her wardrobe for a sixteen-day trip to be worth an average of £80,000. In the nineties, Diana took a less ostentatious approach to fashion, as her private life was turbulent enough. Charles had rediscovered the love of his youth, Camilla Parker-Bowles, shortly after Harry's birth in 1984. In 1992, the queen's *annus horribilis* came to a head with the official separation of the Prince and Princess of Wales, adding to the failed marriages of her children Anne and Andrew. As though to apologize to the people for the scandal, Diana eschewed courtly frills and dressed in an increasingly classic style. She picked the princes up from school in leather blousons and Armani jeans, wore blazers and stretch trousers, and promoted the business suit to her work uniform, with big gold buttons instead of precious jewelry. Diana found fulfillment in charity projects and was as convincing in jeans, a white blouse, and Tod's slip-ons as she was in grand evening gowns.

The cover shoot for British *Vogue* marked a milestone in the development of her style: Patrick Demarchelier portrayed Diana as an independent, modern woman with a low-maintenance, short hairstyle by Sam McKnight and a simple, dark pullover. Although he was not a Brit, Diana made him her personal photographer. "Diana didn't pose like a model, and I had to work at getting her to relax. But I knew what I wanted because I had seen paparazzi pictures of her laughing, and that was when she was at her prettiest," Patrick Demarchelier later said. Instead of striving for perfection and glamour, Diana dressed to please the people.

When she revealed her innermos thoughts on television in 1995, the queen lost her cool: she demanded a divorce. The "Wales vs. Wales" case ended in a pile of smoldering ruins on August 28, 1996. Diana was still allowed to call herself "Princess of Wales," but had to give up the title of "Her Royal Highness," and she and Charles were

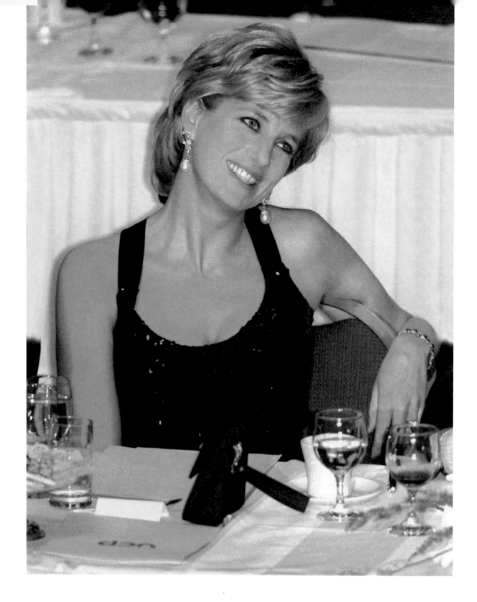

Armani jeans, cotton shirt, and Tod's slip-ons: Diana on site for the anti-landmine campaign in Angola (top). She was awarded a prize for her dedication to humanitarian projects in New York in 1995, stepping into the limelight in a sequined black dress by Jacques Azagury. Her liberated laugh was her most beautiful accessory.

granted joint custody of William and Harry. She expressed her new freedom in her hairstyle as well. Diana swept her hair straight back out of her face and her wet look was responsible for the increase in sales of hair gel throughout the kingdom. Once she was no longer part of the royal family, she paid no attention to fashion diplomacy anymore; she preferred clothes by foreign designers such as Valentino, Moschino, Yves Saint Laurent, and Chanel, and appeared increasingly majestic from one appearance to the next. Couturier Jean Louis Scherrer was delighted: "Diana is to royal fashion what the Beatles were to music: a revolution."

"Less is more!" Diana established her own style, dubbed "clean chic" by British Vogue. It was based on elegant fabrics, clean lines, and simple forms. Her private life was sorted out, too. She no longer dressed to create a big show. Although her outfits became simpler and simpler, they increasingly emphasized her trained body – the skirts became shorter, the necklines more daring. Karl Lagerfeld swooned over Diana's "perfect legs" and Valentino enthused about her "wonderful figure." The princess ascended to the ranks of a style icon with her etui dresses by Versace and high heels by Jimmy Choo (which she had done without in the past in order not to tower over Charles). She favored ice blue, red, and black for her clothes.

In 1997, she also freed herself symbolically of the tight palace corset. On June 25, she sold seventy-nine gowns with the auction house Christie's in New York. In this way, she not only said goodbye to her life at court, but also responded to the years of complaining about her life of luxury. The $5.6 million in proceeds went to charity projects for people suffering from AIDS and cancer. She and her new boyfriend, the son of multimillionaire and heir to the Harrods empire Dodi Al-Fayed, died in Paris. When Diana was buried privately on the Spencer estate after a worldwide memorial ceremony, she wore her last grand dress: a secret design by Catherine Walker.

She had found herself, and her style: wearing a blue-gray etui dress and flat shoes, Diana strolled along London's Bond Street in 1997, carrying Gucci's "Diana" bag. The princess also gave her name to models by Tod's and Dior.

Below: The style icon in a light-pink outfit by Catherine Walker

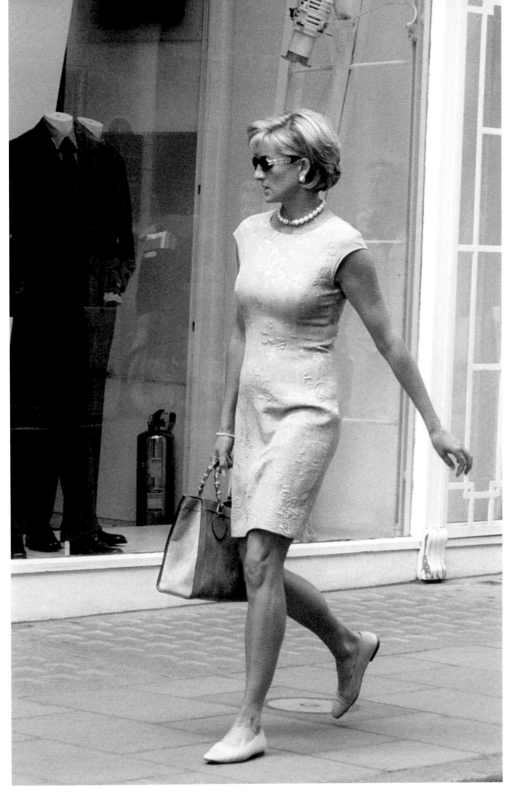

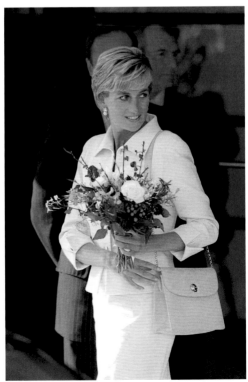

66 Her looks during the last year of her life demonstrated that she was finally completely comfortable with herself. 99
Amanda Wakeley

Triumph
of the
Commoner Princesses

Fashion queen: Mary of Denmark has a weakness for chandelier earrings by Amrita Singh (top), loves to wear extravagant hats, and acts as an ambassador for local designers, as when she wore this dress by Malene Birger (below).

Mary of Denmark
A Kingdom for Fashion

The Danes dubbed her "Her Royal Beauty" because of her Snow White complexion, the neatly curved eyebrows, and her dark brown hair. And Karl Lagerfeld rhapsodized, "I like her romantic aura, she reminds me of a painting from 1840." Mary of Denmark leaves nothing to chance, however; the crown princess spends so much money on fashion and furniture that one could say: "my kingdom for fashion!" She loves one-shoulder gowns in pink and petroleum, leopard-print pumps by Dolce & Gabbana, pastel-colored chiffon dresses, enormous chandelier earrings, and the Chanel 2.55 cult bag (the number stands for the date of its invention: Coco Chanel designed it in February 1955). She flies to New York, London, and Sydney (where she used to live) to go shopping. The native Tasmanian has brought the sun to cool Denmark with her feminine looks and weakness for cartwheel hats. Fashion experts have been speaking of a "Mary Mania" since her wedding to Crown Prince Frederik in 2004: whatever she buys becomes a trend. The master of self-PR, who specialized in advertising and marketing after a BA in commerce and law, makes use of this to boost the national fashion industry. She made the Danish label Malene Birger famous throughout the world and wears creations by Britt Sisseck, Ole Yde, and Heartmade by Julie Fagerholt. Her influence is felt beyond the world of fashion: before Mary moved to Denmark, few Australians paid attention to the tiny Nordic country. The crown princess has strengthened trade relations between the two states and Nordic products have turned into commercial hits in her native country. Through Mary, Australians have become aware of Danish jewelry designers, such as the official purveyor to the court Ole Lynggaard. The latter's daughter Charlotte designed the "Midnight" tiara – an artwork of leaves and buds in rosé-colored white gold, black oxidized silver and moonstones – worth 210,000 euros – for an exhibition at Copenhagen's Amalienborg Palace in 2009. Mary liked the piece so much that she has borrowed it on more than one occasion.

While she sparkles with increasing levels of elegance now, she wore baggy jeans as a young woman: "My friends were much more fashionable than I was. I usually went around in leisurewear," the crown princess declares in her fashion biography, *Mary: Princess of Style*. The twenty-eight-year-old met the crown prince dressed in this manner during the Olympic Games in Sydney in 2000. He introduced himself casually as "Fred from Denmark" in the harbor-side pub Slip Inn. "I had no idea who I was talking to," Mary admitted at her engagement,

Mary loves modern jewelry such as the "Midnight" tiara, made by Charlotte Lynggaard of more than 1,300 diamonds and precious stones.

Below left: On the occasion of her mother-in-law's forty-year jubilee, she made a great impression with a wine-red hat that perfectly matched her skirt. Below right; The Danish princess often wears one-shoulder gowns in bright colors.

Right: On May 14, 2004, Mary was married in a dress with box pleats by Uffe Frank.

> 66 Mary has a very sophisticated, European style that truly is worthy of a princess. 99
> *Tommy Hilfiger*

three years later. Known to have a sense of humor, Queen Margrethe expressed her enthusiasm for Frederik's choice of partner in her own way: "The more expensive the airplane ticket to her home country, the lower the chances are that Danish journalists will go there and dig up old stories." But the native of Tasmania did more than just win over her mother-in-law with her spotless past; she enchanted the whole of Denmark. She discovered a new sphere of activity as part of her new role – fashion. Mary soon dedicated herself to her style with such enthusiasm that even the international media paid attention. In 2004, she was to be seen on the cover of Australian *Vogue*; the *International Herald Tribune* enthused about her royal elegance; and the Spanish magazine *Hola* crowned her the best-dressed princess, second only to their own heir to the throne Letizia. The hype in Denmark was even greater: countless women copied her, wearing their hair à la Mary.

Mary made a great declaration of love to her people in the form of a wedding dress by the Dane Uffe Frank. Accompanied by Georg Friedrich Handel's "Zadok the Priest," the commoner with her six-meter-long train walked through the nave of Copenhagen's cathedral leaning on the arm of her father, John Dalgleish Donaldson, a professor of mathematics with Scottish roots. The groom, Crown Prince Frederik of Denmark, waited by the altar and shed tears of emotion when he saw her. Mary wore a mother-of-pearl-colored silk satin gown made of twenty-eight meters of fabric with a scoop neckline, three-quarter sleeves, and marked box pleats on the skirt. The plain dress featuring one-hundred-year-old lace from the Irish convent of Connaught had been sewn at Amalienborg Palace under the utmost secrecy. Mary's lace veil had already been worn by Queen Margrethe and her female ancestors at their weddings.

This was not surprising, as the small country with the harsh climate takes pride in tradition. The Danish monarchy is the oldest in

The twins Josephine and Vincent were born on January 8, 2011, joining their older siblings Christian and Isabella. In the first official photograph, Mary is shown wearing a blouse by Zara.

Below: In the sunshine, the light-blue gown by Ole Yde looked like a white dress. The media judged it inappropriate for the wedding of her sister-in-law Marie.

Europe, its rulers reaching back to the tenth century. Margrethe, also known as the "Volcano Queen" because of the cigarettes she smokes, is very popular with the people, and free of scandal. This must have increased the shock when her daughter-in-law caused nasty headlines after the wedding: the media criticized Mary's expensive lifestyle. The catalyst for the criticism was the statement of accounts for the year 2005, according to which the crown prince and crown princess's apanage had been depleted before the end of the year. This was a no-go for the Danes!

Mary worked on her image and added to her charity engagements. The crown princess established the Mary Foundation and, as its president, speaks out for all who are on the fringes of society. Furthermore, she is a patron of more than twenty-five organizations. Nowadays, she wears not only designer pieces by Prada, but also affordable labels like H&M and Zara. For her official appearances, Mary depends on two people: her stylist Anja Camilla Alajdi accompanies her to fashion shows, Søren Hedegaard is responsible for her hair and makeup.

She has committed just one fashion faux pas: she sauntered along the red carpet in a light-blue volant gown at the wedding of her brother-in-law Prince Joachim to the Frenchwoman Marie Cavallier, who looks as though she could be her twin sister. In the bright sunlight, many thought she was wearing a white dress, and thus suspected a fashion intrigue. Mary was probably unperturbed by this. Perhaps just one thing is a pain in the well-dressed woman's side: while she had been included among the ten best-dressed women in the world in the U.S. magazine *Vanity Fair*'s Best Dressed list of 2010, her place was taken by Duchess Kate and Monaco's new princess Charlène in 2011. But she is probably too busy to think about that – at home in the designer palace of Amalienborg, four young children vie for her attention.

"I like her romantic look, she reminds me of a painting from 1840."
Karl Lagerfeld

At Victoria's wedding, Mary (holding her son Christian's hand) looked enchanting in a light-green gown by the Dane Jesper Høvring. A ruby tiara that used to belong to Frederik's grandmother Queen Ingrid gave the look its finishing touch.

Left: When she is not wearing high heels, she likes to walk around in two-tone Chanel ballerinas, as when she went to the circus with her daughter Isabella in 2010.

Letizia Ortiz Rocasolano celebrated her engagement to Crown Prince Felipe in a white pantsuit by the Italian Giorgio Armani instead of the usual knee-length ensemble (top right). For her wedding on May 22, 2004, she relented and selected a Spanish designer. Manuel Pertegaz designed a formal-looking gown with a col cheminée and embroidered embellishments.

Letizia of Spain
Rebel in "Letizio" Pumps and Miniskirt

She made platform pumps so popular in Spain that they are now known as "letizios." Crown Princess Letizia is the rebel among Europe's fashion princesses, kick-starting a little fashion revolution at the pious Catholic royal court with her miniskirts, pencil trousers, and leather jackets. Europe's strictest fashion diktats governed life behind the thick walls of the Zarzuela Palace in Madrid. Until Letizia Ortiz Rocasolano showed up, that is. She was a famous television news presenter, the granddaughter of a taxi driver, and once divorced. The royal family did not consider her a suitable match, but Crown Prince Felipe fought for his great love. He won by playing his ace: "I don't want to be king without Letizia."

But Letizia got into trouble with her strict mother-in-law Queen Sofía as soon as they got engaged. When Felipe introduced his fiancée on November 6, 2003, she not only interrupted him in front of rolling cameras ("Let me finish") but also wore a white trouser suit by Armani instead of the usual knee-length ensemble, as though to say "I'm the one wearing the trousers."

She made this mistake just once: on May 22, 2004, she wore a wedding gown designed not by her favorite designer Valentino, but by the eighty-six-year-old dressmaker to the court, Manuel Pertegaz. When she stepped into the cathedral in Madrid, she dragged a four-and-a-half-meter-long train bearing the royal family's coat of arms

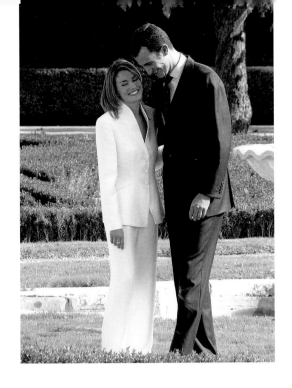

behind her. The pompous ceremony was prepared, down to the last detail, for several months, but all emotions appeared to have been washed away by the deluge-style rain outside the cathedral. It was a wedding ceremony without tears and with just a whisper of a kiss on the cheek, in accordance with Spanish court protocol. "It was like caffeine-free coffee, a great disappointment," ranted the Spanish newspaper *El Mundo*. Letizia's wedding dress was as formal as the vows: a twenty-strong team headed by Manuel Pertegaz and working closely with the crown princess had created an austere gown with col cheminée and flared arms. In order to safeguard the secret until the very last moment, the Valencian silk was woven

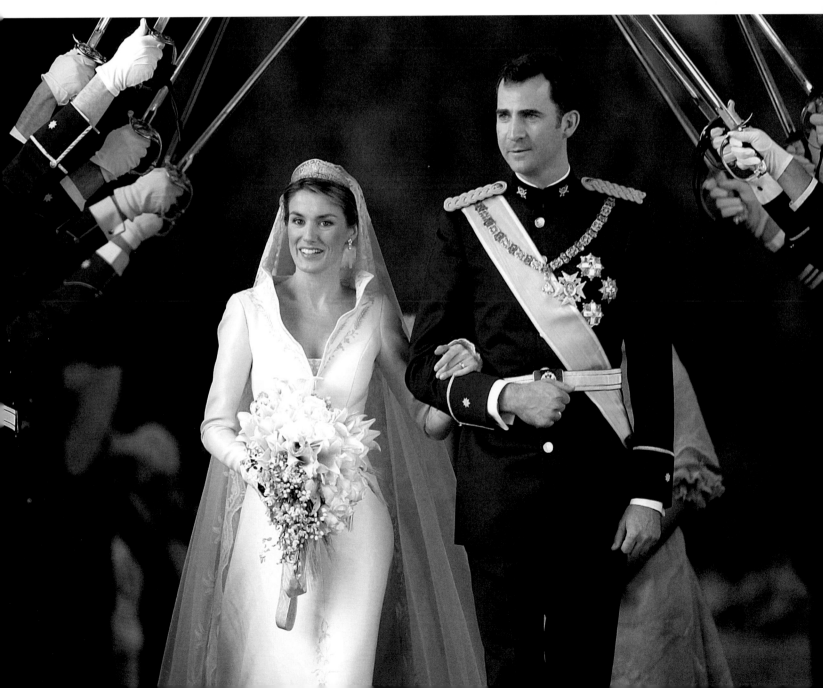

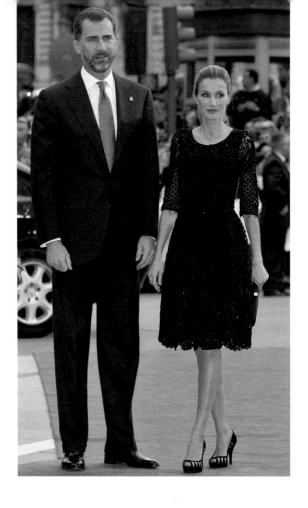

66Letizia dresses like a top manager. One can see that she has become more confident. Perhaps that is because she now approaches her job more calmly.**99**
Marie Claire

only at night. The collar, hem of the skirt, and veil (a wedding present from Felipe) were embroidered with lilies, the heraldic flower of the Bourbon family. Letizia wore it with a platinum tiara encrusted with diamonds that had already been used for the wedding of Queen Sofía in 1962.

Letizia, whose name actually means "the joyful one," had to subjugate herself sartorially to her new job. The tough journalist starved herself down to a size zero after her wedding. The media spoke of "adjustment issues" to the strict etiquette and watched as the crown princess's radiance became gradually dimmer in the court-approved ensembles. When her younger sister Erika committed suicide in February 2007, Letizia showed her feelings openly for the first time, winning over the hearts of the Spaniards. Nowadays, she delights the people not only with her two daughters Leonor and Sofía, but also with her looks. And then the inevitable happened, with a few changes in 2008: she had her nose corrected and

got rid of her conservative clothes. Letizia loves red flamenco dresses by Lorenzo Caprile, and dramatic dresses in black. She competed with France's fashion icon Carla Bruni in a figure-hugging raspberry-colored dress by her favorite Spanish designer, Felipe Varela. The Spaniard drew attention to her slim legs in a minidress and leather jacket at an official engagement in Chicago. In contrast to other European crown princesses, she does not buy Parisian haute couture but supports her home country's fashion industry with greater enthusiasm than any other. Letizia presents herself in affordable Spanish labels such as Mango and Zara as well as appearing in outfits by Adolfo Dominguez. She pays particular attention to her shoes; as her husband towers almost fourty centimeters over her, the petite crown princess likes to wear platform pumps. She usually wears Spanish labels such as Pedro García and Pura López – and has made her "Letizios" a Europe-wide subject of discussion.

Right: Letizia and Carla Bruni gracefully ascend the steps of the Zarzuela Palace in sync with one another. The Spaniard triumphed in a raspberry-colored bandage dress by Felipe Valera and "Letizio" pumps by Magrit.

Letizia always wears fashion by local designers, with a preference for gowns in black (top left). And she even looks elegant in a nude-colored sixty-nine-euro minidress by Mango.

Mette-Marit of Norway
The Cinderella Princess

In Stockholm in 2010, Mette-Marit looked radiant in a pink volant gown with a decorated waist by her compatriot Peter Dundas for Pucci. She took part in a state visit wearing a Valentino dress, dark blue coat, and T-strap heels in 2010.

Right: The blond crown princess in a billowing chiffon dress by Valentino

In the land of fjords and fantasy novels, her life is like a modern fairytale in which she herself plays the part of Cinderella. Norway's crown jewel Mette-Marit started as an Oslo rave girl and became the future queen. Not only her smile, but also her style have become economic driving forces: Mette-Marit has enchanted her five million subjects with her Cinderella looks. The straw-blond Viking princess likes to wear the colors sky blue, raspberry, pink, and buttercream. She loves flowing flounces, delicate chiffon, and a 1940s water-wave cut in the style of the old Hollywood stars. During state visits, she shines in Jackie Kennedy looks with pillbox hats and pastel-colored silk crêpe dresses by her favorite designer, Valentino. Plain jewelry, little or no makeup,

and the hair of an angel – this is what the famous Mette-Marit Look looks like.

She won the crown prince's heart with her natural charm. With just one difference: she wore worn-out jeans, old trainers, and wool sweaters at the time. When the heir to the throne announced his engagement to a certain Mette-Marit Tjessem Høiby in December 2000, the Norwegians were perplexed. Just what sort of woman had the future king chosen to be with? The twenty-seven-year-old used to let her hair down in the Oslo party scene, and had taken part in the Norwegian version of *The Dating Game*. The single mother to little Marius worked as a waitress and in a boutique in addition to studying journalism and anthropology. She met heir-to-the-throne Haakon at a music festival in her hometown of Kristiansand in 1999. "It was not love at first sight. We got closer to each other through conversation," Mette-Marit later explained. The crown prince would even have renounced his claim to the throne out of love for her. This gesture is not uncommon in the Norwegian royal family; in 1968, Haakon's father Harald was the first crown prince of his generation to be allowed to marry a commoner, following many years of wrangling. Her parents-in-law supported Mette-Marit from the very beginning, but the people remained skeptical. When rumor upon rumor about her emerged, she made a stand at a spectacular press conference three days before the wedding. With tears in her eyes, Mette-Marit admitted to have "transgressed the boundaries of what is allowed" in the past. The Norwegians were won over by her openness.

The entire country celebrated the wedding on August 25, 2001 as a

triumph of romance. Visibly unburdened, Mette-Marit glowed with happiness as she stood at the altar, and made a favorable impression with her clothing for the first time. She wore a modern copy of the wedding dress of Haakon's grandmother Queen Maud (1869–1938), the daughter of Edward VII. The Norwegian designer Ove Harder Finseth had developed the flowing, simple gown composed of 110 meters of ivory-colored silk. The seven-meter-long net lace veil was so airy that Mette-Marit could move freely in it. Even her bridal bouquet resembled Queen Maud's long bouquet: the crown princess held a garland of leaves with white and purple flowers in her hand. Mette-Marit wore a fan-shaped diamond tiara from 1910 in her straw-blond hair, a wedding present from her parents-in-law. Her simple wedding dress was not the only thing to go down in history, however; Haakon's moving speech also created quite a stir: "Thank you for your love and for everything you have done. I am proud to be allowed to call myself your husband. Mette-Marit, I love you!"

But his bride could not cope with her new role at first. To her subjects' surprise, she dared to engage in eccentric fashion experiments, wearing such things as a denim skirt with a zip sweater and golden boots, as well as discovering expensive designer clothes. To make things worse, the Norwegian was committing fashion adultery: she had a preference for Italian labels such as Valentino, Miu Miu, and Prada. When the couple allowed themselves a study year in London in 2002, the poll ratings for the royal family sank dramatically.

The drama has long since died down. After their return in 2003 and the birth of their children Ingrid Alexandra and Sverre Magnus, the people's affection returned. Mette-Marit also found the right look for herself — she eschewed fitted cuts and began to wear primarily flowing fabrics. She draws attention to her slim legs by wearing Bermudas, knee-length skirts, and extravagant high heels. But her clothes are never too short or too figure-hugging. She combines trendy pieces (such as fascinators by Philip Treacy) with homegrown classics. The tanned princess usually wears white in the summer. Garish, unsuitable colors are as much a thing of the past as are her worn-out sneakers. Since her Norwegian friend Peter Dundas became creative director at Pucci, Mette-Marit has frequently worn his fairytale creations to banquets, such as volant gowns in pink and sky blue – dresses that appear to have been made for a future queen. And yet she always looks natural, even in the most elaborate dresses. Mette-Marit only employs a stylist for state visits. She has never been a narcissistic fashion queen. If anything, she is a Cinderella with style.

Left: At her wedding in 2001, the commoner Mette-Marit enchanted all, wearing a contemporary version of the wedding dress of Queen Emma, great-grandmother of her husband, Crown Prince Haakon. It was designed by Ove Harder Finseth.

Mette-Marit loves pillbox hats (top) and looked delightful in a Ferrari-red etui dress by Emilio Pucci in 2011.

Máxima of the Netherlands
Fashionably High Spirits

She beams as though nothing could trouble her: wherever Máxima of the Netherlands goes, high spirits reign. And her looks are as cheerful as her resounding laugh. She loves red valance gowns as fiery as her Argentinian blood, unusual hats, Missoni patterns, and opulent jewelry.

The crown princess buys a lot of couture, with a preference for Valentino; the Dutch royal family is among the richest families in Europe. Máxima stocks up on pieces by Graciela Naum whenever she is in her native city of Buenos Aires. At home, in the land of windmills, tulips, and Gouda cheese, she brings royal flair to official engagements by wearing pink suits and pillbox hats by Natan, whose designer Edouard Vermeulen also frequently supplies the Belgian royal family. Despite the usual sartorial consultations, Máxima experienced a fashion catastrophe – and laughed – when the Belgian crown princess visited and both appeared wearing a similar coat with a houndstooth pattern. While Máxima had bought hers from Oscar de la Renta in New York, Mathilde was wearing Natan. Edouard Vermeulen said, "After the engagement, both of them phoned me from the royal limousine, laughed, and said, 'You can't imagine what just happened to us. Next time, we must consult with you even more carefully.'"

Máxima does not simply enjoy fashion. She also faced her most difficult challenge with a sense of humor. The New York investment banker's engagement to the crown prince in 2001 almost caused a national crisis in her new homeland by the North Sea. In the 1970s her father, Jorge Zorreguieta, had served the reign of terror of the Argentinian dictator Jorge Rafael Videla as Secretary of State and Minster for Agriculture. When Willem-Alexander (nickname: "Prince Pilsner") introduced his blond bride-to-be in The Hague, the journalists did not even rise from their seats: "somebody like that" was not welcome. But Máxima won over the fifteen million hearts of her future

subjects within minutes with a combination of charm and perfectly learned Dutch.

On February 2, 2002, she went on to enchant the entire world. Her fingers were so swollen from holding hands that the crown prince struggled to slip the 2.5 millimeter-wide platinum ring onto her finger at the altar. When the notes of a tango rang out in the Protestant Nieuwe Kerk of Amsterdam, the first tears rolled from her dark eyes: the melody was both a farewell to her old life and simultaneously a message to her father. Jorge Zorreguieta had agreed to stay away from his daughter's eleven-million-

Máxima has a sense of humor when it comes to fashion. When Crown Princess Mathilde showed up wearing a similar coat in 2007, she laughed.

Below: She looked radiant in a supersleek gown by Valentino at her wedding in 2002.

Left: Máxima in 2011 with a cartwheel hat by Fabienne Delvigne.

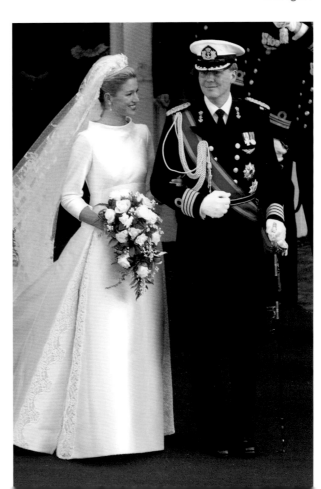

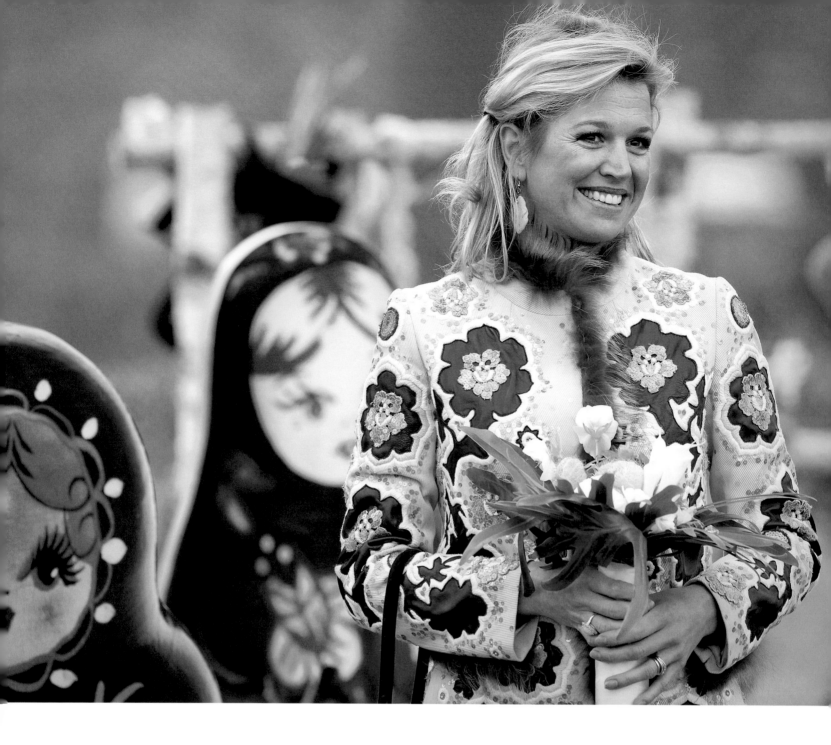

euro wedding for diplomatic reasons. In accordance with her own wishes, her mother-in-law Queen Beatrix stood by her side as her maid of honor. The latter presumably did not object to the unusual choice of wedding dress. Contrary to tradition in European royal families, Máxima's gown was not by a local designer but by the Italian couturier Valentino. She was radiant in a high-necked, simple gown of ivory-colored mikado silk and a seven-meter-long train. The dress's beauty lay in its straight lines. Instead of a collier, Máxima's only adornment consisted of four quilted decorations on the loose-fitting stand-up collar. The silk

veil had been hand-stitched with flower motifs and was as long as the train. The bride wore tear-shaped earrings and a tiara of white gold and diamonds that once belonged to Willem-Alexander's great-great-grandmother, Queen Emma of the Netherlands (1858–1934).

But Máxima was already used to such luxury: she had grown up like a little princess. She was born into a great landowner family in Argentina that had amassed a fortune through cattle breeding. After completing secondary school, she studied economics at the Catholic University of Argentina and started her career in New York.

When she met the Dutch crown prince at a party in the Spanish city of Seville, the media described her as a dancing party girl; she had to forswear her beloved miniskirts after the wedding, however. The crown princess adheres to the royal court's sartorial etiquette: she never wears truly casual clothes, but usually opts for knee-length skirts. She makes up for conservative cuts with color. When she is not wearing classic camel, Máxima often reaches for the bright shades of orange, pink, and frog green. It is said that Valentino himself advised her to wear red: "It underlines your temperament!" Her proclivity for exotic hats is also

Cheerful looks: Máxima loves her bow hat by Fabienne Delvigne and is bold enough to carry out fashion experiments, such as an Indiana Jones hat with an evening gown. She looked charming in a white chiffon gown by her compatriot Jan Taminiau when she visited Berlin in 2010.

Left: At a flower show in Holland in 2010, Máxima made an appearance in a folksy coat decorated with embroidered flowers.

legendary; the crown princess even wears turbans and makes the headlines with unusual combinations such as a slouch hat with an evening gown. But Máxima is true to her style – and to herself. And she expresses her joie de vivre through her clothing. Instead of surrendering to the diet fad, she highlights her curves with flowery valance gowns, polka-dot dresses, and patterned suits.

The crown princess communicates more than pure cheerfulness with her looks, however; Máxima, the most popular member of the royal family, uses her appearance to create a sense of connection with the people. At the Edison Pop Awards ceremony in Rotterdam in 2010, she eschewed the royal dress code for once. Instead of a little dress and jacket with a pillbox hat, the future queen rocked the house in a black, above-the-knee (!) leather dress with high boots. In fact, her royal uniforms are so popular that the museum Paleis Het Loo in Apeldoorn staged an exhibition of her most beautiful outfits on the tenth anniversary of her entry to the royal family. Máxima made everybody laugh at the opening of the exhibition: "There they are! I've been looking for my pumps all over. I had forgotten that I'd lent them to somebody!"

Máxima wearing Natan, her favorite label. In Monaco in 2011, she looked dazzling in a mustard-yellow dress. The crown princess rocked in a leather miniskirt at the Edison Pop Awards 2010. On Queen's Day 2008, she ice skated in a pink outfit and pillbox hat.

Right: Designer Valentino Garavani is said to have been the one to advise Máxima to wear red.

66 Red, her favorite color, is as fiery as her temperament. Crazy hats, bright colors, and what must be the most beautiful smile by a royal are her trademark. 99
Bunte

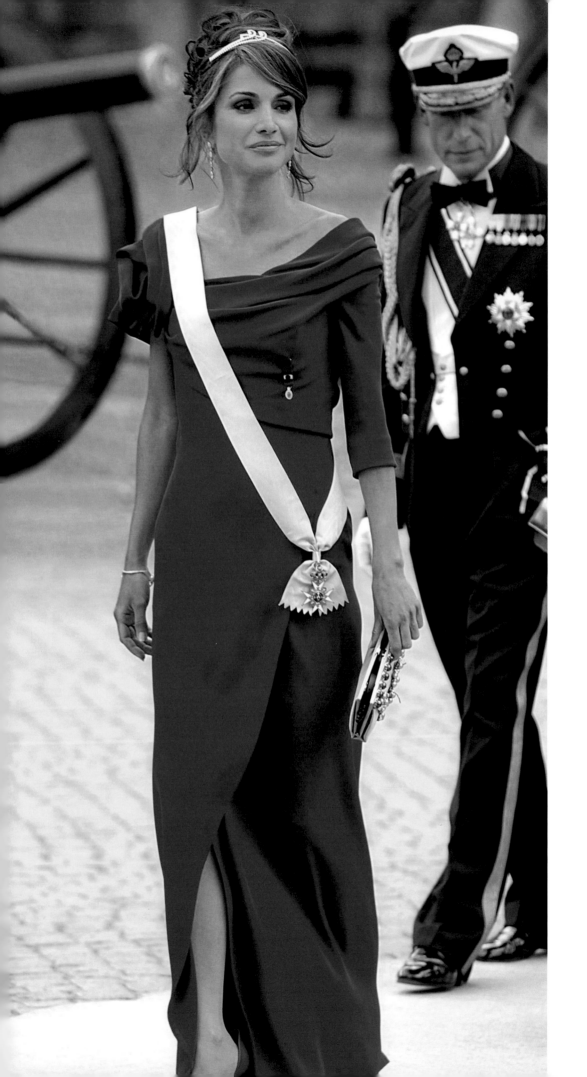

Rania of Jordan was the only one to make an entrance in a gown with a high slit, by Armani Privé, at the wedding of Sweden's Victoria in 2010. In order not to overshadow the dress, she accessorized it with a delicate tiara by Boucheron.

Rania of Jordan
Queen Between Couture and Koran

Western chic: A Muslim herself, she greeted Pope Benedict XVI in a knee-length black skirt.

Right: Business look à la Rania – the queen wears a bright orange dress by Giambattista Valli and Fendi's Firenze bag.

Many call her the "Lady Di of the Orient" – Rania of Jordan is not simply a queen unafraid to get close to her subjects, but is also one of the most elegant women in the world. She is a fairytale character from the Middle East with doe eyes, Dior suits, and couture gowns by her favorite Lebanese designer, Elie Saab. But there is much more to her looks than just luxury clothes: Rania makes a conscious decision not to wear a veil, mixes Western trends with Arab glamour, and – atypical for the Muslim world –

shows no fear of figure-hugging outfits. At the wedding of Sweden's crown princess Victoria in 2010, she was the only woman to wear a gown with a sophisticated slit at the side. The pious Muslim reads the Koran to her children, listens to hip hop by Lauryn Hill, and watches American soap operas on television with her husband. Her style is as immaculate as her business English: "Clothes are a form of creative expression for me."

The queen does not regard herself as a decorative accessory on her husband's arm: she dominates Facebook and Youtube, fights against child abuse, speaks up for equal rights for women, and insists on better education for girls. A Palestinian, she was born the daughter of a doctor on August 31, 1970, studied business administration at the American University in Cairo, and worked at Citibank in Amman, amongst other things. When the director, a son of King Hussein, invited her to a banquet, the young woman fell in love with his brother Prince

66 She has the body of a model and the posture of a queen, which is of course exactly what she is. What more could one want? 99
Giorgio Armani

143

At Felipe's pre-wedding dinner in Madrid, Rania posed for the photographers in a silver-gray satin gown with sophisticated layers. A page held an umbrella over her head, as it was raining.

Abdullah. Two months later, he asked for her hand in marriage, and the grandiose wedding followed in June 1993. His grandmother was delighted, reportedly telling her, "You are a diamond that will be added to the Hashemite Family." The youngest queen in the world wore her sister-in-law's tiara, worth $1.5 million, to the coronation on June 9, 1999.

Through her choice of clothing, too, Rania lives her love of luxury. She wears only the most fashionable designers and is more than just pretty to look at in them. Instead of asserting herself in the world of men by wearing austere business suits, the mother of four children highlights her femininity – and is listened to all the same. Her contemporary, feminine style is revolutionary for an Arab ruler: Rania likes to wear her chestnut-brown hair down, and loves high heels, suits with flounces, and delicate colors. Her outfits are usually color coordinated, and she adds flair to simple cuts using trendy accessories. She is also known as the "Handbag Queen" because of her predilection for clutches, crocodile-leather, and shopping bags (ideally by Fendi and Prada). The queen sometimes ignores protocol when it comes to the perfect outfit: at the strict Spanish wedding of Crown Prince Felipe in 2004, the dress code for the female guests at the church ceremony was "knee-length dresses." Rania appeared in a floor-length couture skirt by Givenchy – a privilege accorded only to the mother of the groom, Queen Sofía. As a style icon, she sets her own fashion rules and makes political statements with her clothes: she fights for the strong women of the Muslim world – and the queen herself sets the best possible example.

> **❝ Rania and company are not ordinary women. They don't buy clothes to feel like a princess for a night – they are princesses. ❞**
> *Elie Saab*

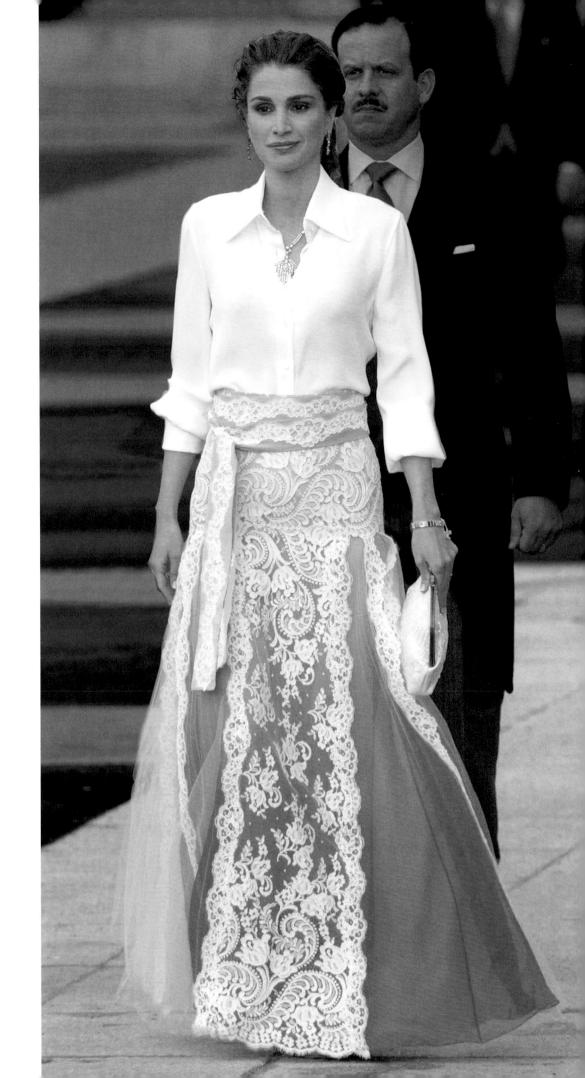

At the wedding of Spain's crown prince Felipe in 2004, Rania ignored the protocol and wore a floor-length couture skirt by Givenchy instead of a knee-length outfit suitable for church. In order not to look too glamorous, she combined the sophisticated skirt with a cream-colored blouse.

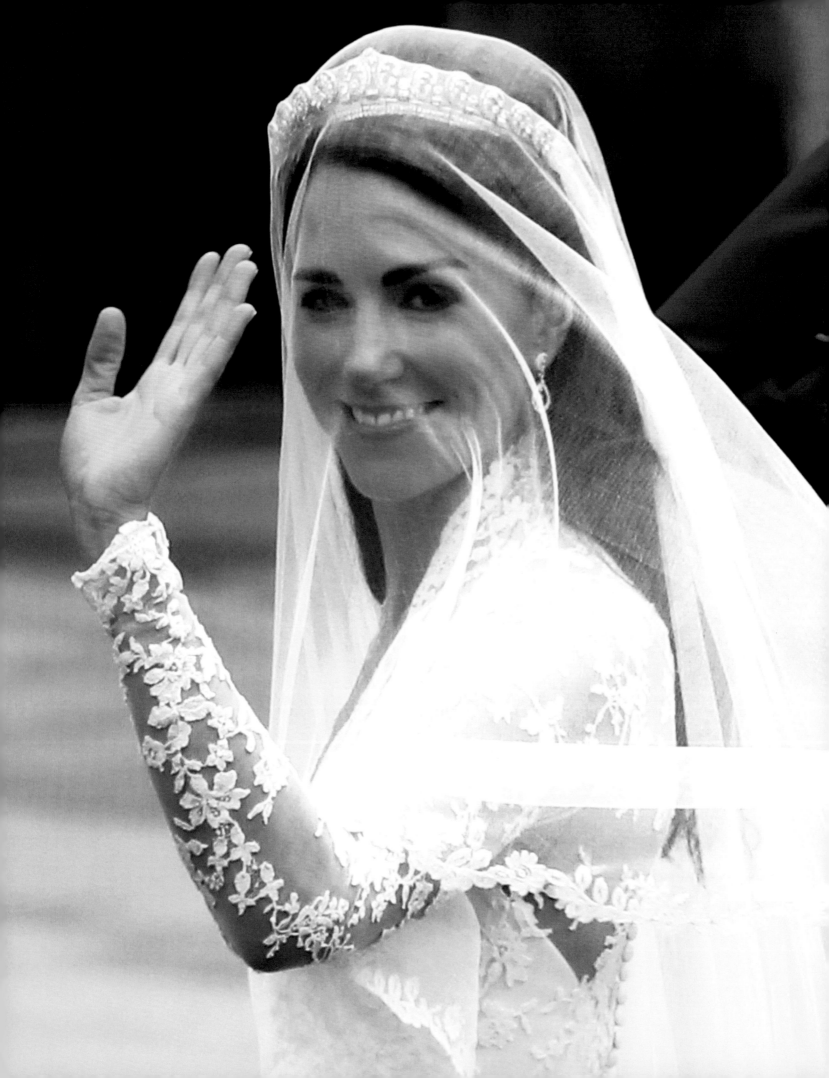

7

The Young Brides

Duchess Catherine
High Street Fashion, Recycling Looks, and More and More Couture

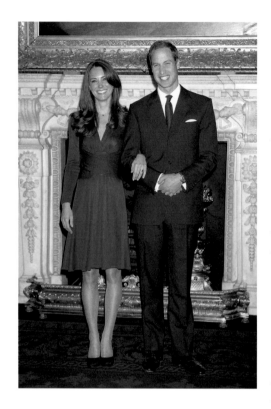

Royal debut: When Prince William faced the media with his fiancée, Miss Middleton, she started a craze around her sapphire-blue drapé dress by Issa. She also made glossy sheer tights hip again (top). The Duchess of Cambridge made an appearance in a £49.99 Zara dress and L.K. Bennett wedges on the day after the wedding.

When Prince William presented himself and his new fiancée to the press, a piece of Diana was with them: he had slipped his dead mother's bright blue sapphire onto "Waity Katy's" finger. Weighing eighteen carats, set in white gold and framed by fourteen diamonds, this piece of jewelry had been created thirty years ago by Garrard, jewelers by royal appointment, for £30,000. It is now priceless. And there it suddenly was, the famous "Kate Moment": the middle-class bride-to-be followed her future mother-in-law's example and wore a dress to match the ring, just as Diana had in her day. Not only did Chinese entrepreneurs immediately start to peddle cheap imitations of the rock, but the sapphire-blue drapé silk-stretch dress by Daniella Issa Helayel (approx. £400) was sold out worldwide within a few hours. Since then, the Duchess of Cambridge, an eighth wonder of the world of sorts, has taught us a thing or two regarding fashion, for example the following equation: 68 percent acetate + 32 percent rayon = 100 percent glamour. In the twenty-first century, royal fashion does not even have to be expensive. In the official engagement portrait by star photographer Mario Testino, Kate posed in a white dress with a volant neckline by the middle-class label Reiss. The aforementioned "Nannette" dress of a acetate-rayon blend can be bought off the rack for £159. And so every woman can buy a bit of royal glamour nowadays. Kate has introduced us to affordable labels like Whistles, was responsible for the comeback of nude-colored patent leather pumps and glossy sheer tights, and L.K. Bennett has produced a new edition of her beloved wedges.

Her wedding dress was a touch more expensive. Fashion experts estimate its cost at around £40,000. When Catherine Elizabeth Middleton stepped out of a black 1977 Rolls-Royce Phantom IV in front of Westminster Abbey at eleven o'clock in the morning local time on April 29, 2011, for a brief moment two billion TV spectators held their collective breath. It is rare for such secrecy to surround a dress before it is unveiled. The British fashion label Alexander McQueen had kept its greatest coup secret until almost the very last minute. The truth did not emerge until fans broadcast via Twitter on the evening before the wedding that creative director Sarah Burton had silently slipped into the luxury hotel, the Goring, where the bride was spending her last night as an unmarried woman. The talented fashion designer had caught Kate's attention in 2005 with the wedding dress worn by Camilla's daughter-in-law Sara Buys.

Sarah Burton designed this masterpiece of British craftsmanship in close collaboration with the bride. The lace top of Kate's dress was reminiscent of Grace Kelly's gown from 1956, while looking simultaneously stricter and more daring, thanks to the deep V-neck. The back was embellished with fifty-eight organza-covered buttons; the bodice was gathered at the hips – an homage to Victorian times and also the trademark of the late head designer Alexander McQueen. The long folds at the front of the skirt symbolized an opening flower. Kate's veil was very short at 2.7 meters, but beautifully staged by her sister Pippa Middleton. The media paid a great deal of attention to the elaborate lace, which was sewn by hand onto the neckline, arms, hem of the skirt, and veil by the Royal School of Needlework under the strict supervision of Sarah Burton. For this, the sewers used an Irish technique called Carrickmacross, developed in 1820, and had to wash their hands every thirty minutes to avoid dirtying the delicate fabric. The flower motifs – English rose, Scottish thistle, Welsh daffodil, and Irish shamrock – symbolized the four

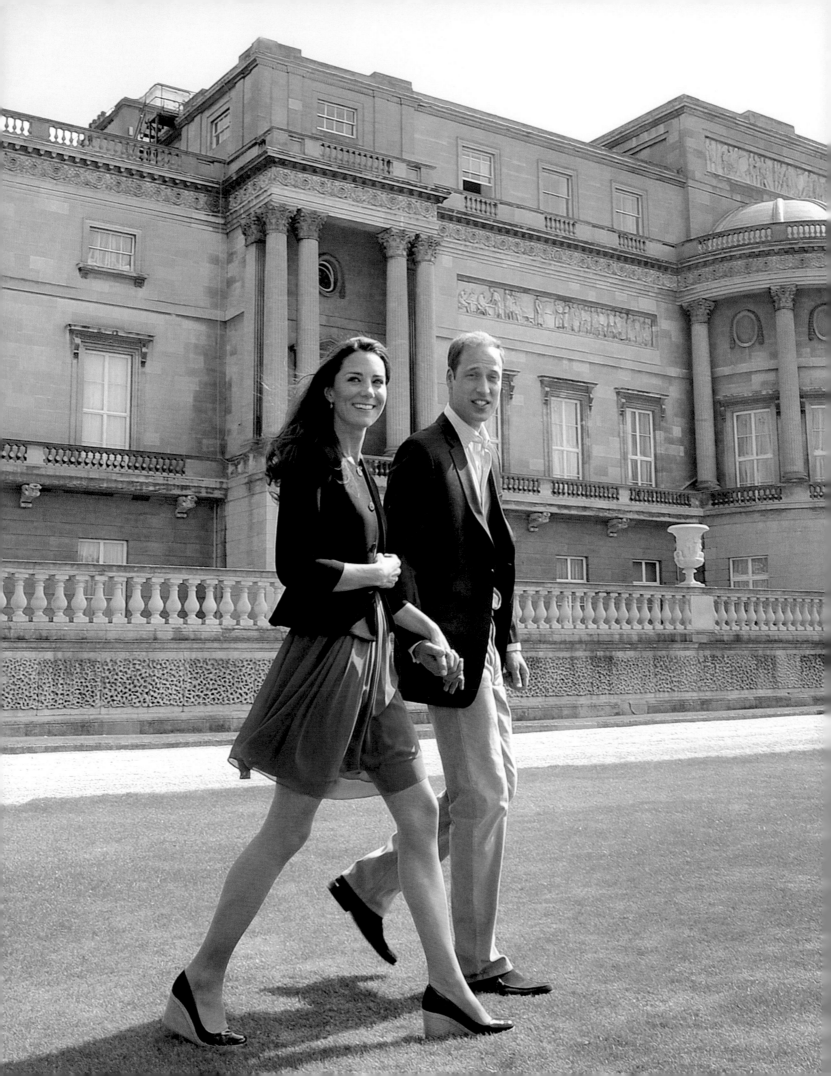

constituent parts of the United Kingdom. Even Kate's bridal bouquet was awash with symbolism: in addition to lilies of the valley (returning happiness), white hyacinths (constancy), and ivy (love and friendship), it contained the traditional twig of myrtle from a bush that Queen Victoria had planted herself in her garden on the Isle of Wight in 1845. Kate also made a very personal declaration of love to her husband: the bouquet featured a plant called Sweet William.

The bride rounded off her majestic performance with delicate jewelry and an unostentatious hairstyle. Her lace veil was held by the fan-shaped halo tiara by Cartier, loaned to her by the queen. This was combined with oak leaf-shaped earrings by the London jewelry shop Robinson Pelham, which had been commissioned by Kate's parents to match the Middleton's new family crest. Because Kate usually wears her long hair down, James Pryce, stylist at the London salon of Richard Ward, arranged it into a demi-chignon, a loose half-bun: "We started at 6:30 on the morning of the wedding day. We had practiced countless times over the previous months. We had taken inspiration from Kate's suggestions and magazine photographs. She was not in a hurry and said that we could keep trying until it was perfect. Fitting the tiara was nerve-wracking all the same." This piece of jewelry was attached to a rubber band, just like a hat. Pryce also had to use hairpins so that everything would stay in place.

The fashion world oohed and aahed – Kate's entry to the royal dynasty could not possibly have been more elegant. After her stylish appearance in the church, Catherine (as she is officially known since the wedding) changed into a corsage gown of lace organza

with a rhinestone belt by Sarah Burton. But these precious pieces were followed the next morning by something costing £49.99 at Zara: the new Duchess of Cambridge flitted away to a secret honeymoon weekend wearing a blue chiffon dress from the previous season. It was as though she wanted to say, "Despite all the luxury, I am still a commoner!"

Her groundedness must also have been the key to William's heart: the greatest love story of the decade began among art books, coffee cups, and dining hall tables, and in typical British fashion, too. When the prince met the millionaire's daughter from Bucklebury at the University of St. Andrew's in 2001, she carried a £50 nylon Longchamp bag instead of designer pieces

and dressed as conservatively as her own mother, as is typical among the upper middle classes. It was in a wisp of a dress that Kate caught William's full attention, however. The athletic brunette took to the catwalk wearing just underwear and a bra underneath a transparent minidress for the Don't Walk charity fashion show in March 2002. Five years later, she set her first trend: she appeared in a £40 dress with a black-and-white fan design from Topshop on her twenty-fifth birthday. The affordable item of clothing was sold out within twenty-four hours. She pulled out all the fashion stops when the prince ended their relationship in 2007. "At the time I wasn't very happy about it, but actually it made me a stronger person," Kate confided in her official

Kate wore her Katherine Hooker coat with a fur hat to Cheltenham in 2006. She had it shortened to knee length in 2011.

<< On April 29, 2011, Kate entered Westminster Abbey in a wedding gown by Sarah Burton, the successor of the late designer Alexander McQueen. Sister Pippa carried the train.

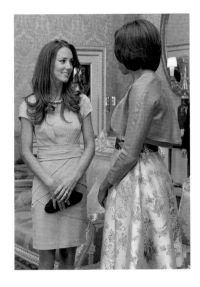

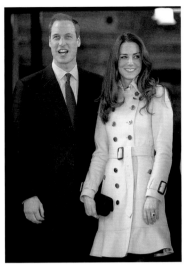

She's captivated the world with her signature mix of high and low fashion.

Vanity Fair

Kate's bestseller looks (clockwise): The duchess stole Michelle Obama's thunder in a camel-colored Shola dress (approx. £175); her Burberry trench coat was sold out within a day; Kate looked stunning in a white Peacock dress by Reiss at the races in Epsom and made nude-colored pumps by L. K. Bennett fashionable.

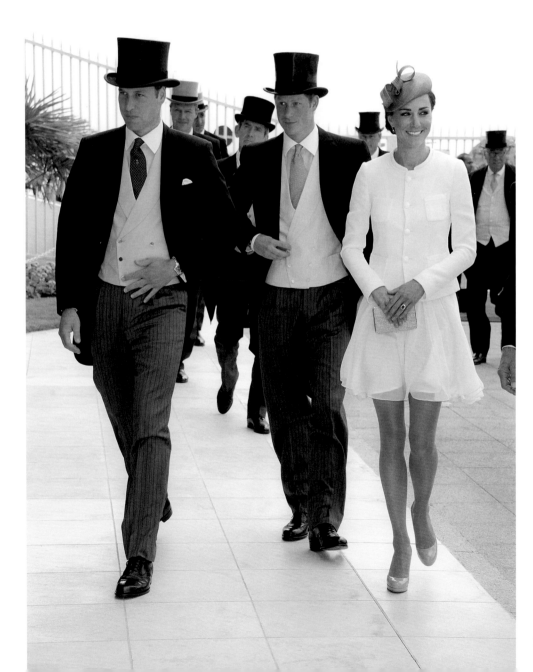

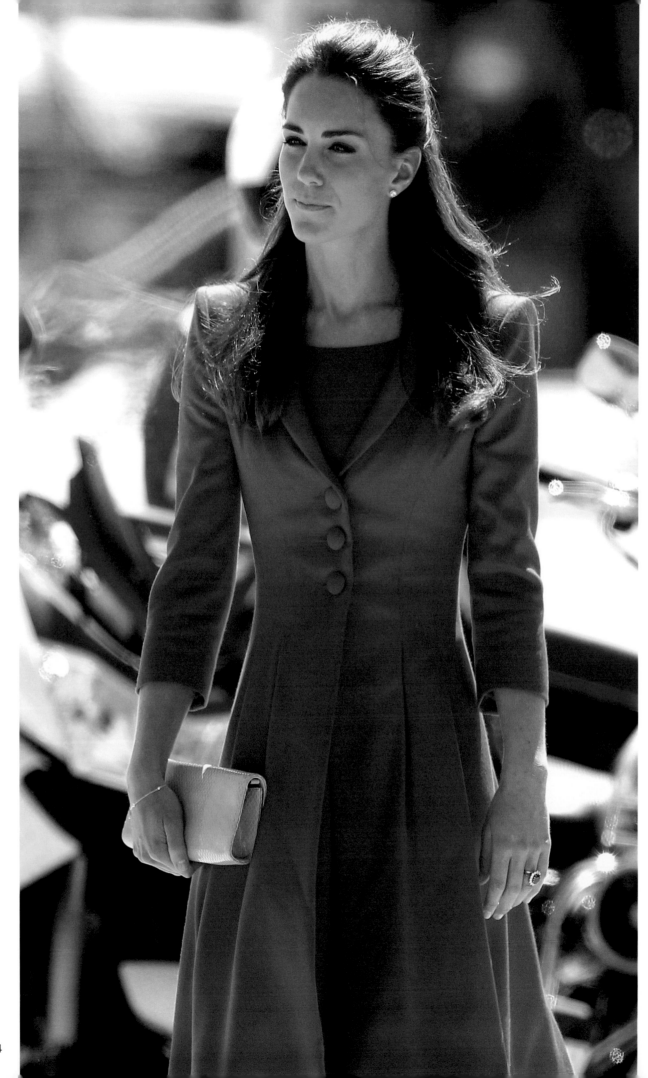

engagement interview. Her performances, too, were strong: the commoner pulled her fashion ace out of her cupboard, as Diana had with her retaliation couture. She flirted in the London nightclub Mahiki wearing an unusually short minidress by Lipsy and high boots. This was the first evening on which she wore a series of sexy pieces of clothing, as though to say: "See what you are missing?!" She worked on her athletic figure as part of the women's rowing team "The Sisterhood" and turned down an offer of £1.5 million for an interview. Kate's tenacity and discretion paid off: a few months later, she was spotted by William's side again.

Kate has now conquered the whole fashion world, not least with her looks. To the delight of British fashion designers, she, like Diana before her, has at last rejuvenated the chic of the English monarchy again, and acts as a walking advertisement for national labels such as Joseph and Temperley London. When she stepped up to the pancake tossing challenge with William in Belfast, demonstrating her domestic skills wearing a Burberry trench coat, she unleashed a stampede on the £650 coat. Within a day, the model with the double row of buttons and gathered hemline was sold out on the Internet. This was just one of Kate's countless fashion moments. After the honeymoon, she received U.S. first lady Michelle Obama at Buckingham Palace wearing a camel-color bandage dress by Reiss. After the first photographs of her look had gone around the globe, the company's website collapsed because of the demand.

Through her wedding, the "Queen of High Street Labels" has also discovered the glamorous world of Jenny Peckham and Jimmy Choo. In order to distract attention from her love of luxury, she grasps every opportunity to pull old clothes from her closet. After all, Kate is not just the "Queen of the High Street," but is also considered a role model for recycling looks. Having worn her mud-green tweed coat by Katherine Hooker with a Russian mink cap to the Cheltenham horse races in 2006, she had the piece shortened to knee length for a ship's christening five years later and added a fascinator as a fashionable update.

> 66 She is a lovely girl with a great sense of style. I love her choices. She's elegant and still knows how to have some fun. I'm a fan of her style. 99
>
> *Madonna*

"Princess of style": Kate honored the Irish Guards in a navy-blue coat dress by Alexander McQueen, and got the thumbs up for a black-and-white Zara dress at a wedding.

Right: She looked delightful in a lace dress by Erdem on a state visit to Canada.

Left: The duchess in a red coat dress by Catherine Walker, Diana's favorite designer.

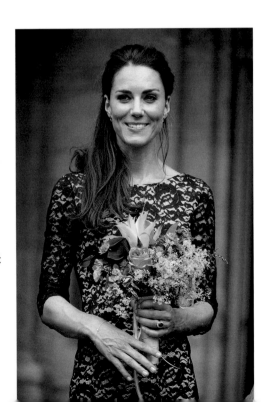

For weddings, she digs a recurring selection of frock coats out of her wardrobe, combining them with new accessories each time. Demonstrative down-to-earthness is, after all, as de rigueur as the famous stiff upper lip in the circles in which she moves. Kate bought the hat she wore to Zara Phillips's wedding, a flat, asymmetrical piece, from the London designer Gina Foster only ten days before the event. "She rang and asked to come in, then she tried a few on and we went from there," the milliner told the U.S. magazine *People*.

The fashionable duchess moves between two worlds. Although Kate often opts for high street fashion, she appears increasingly more often in couture. Since her wedding, she has supplemented her wardrobe with Sarah Burton designs. When she first visited the Irish Guards in Windsor with William, she made an impact with a dark blue military-style coat dress from the McQueen collection (see page 155). The outfit was perfectly in tune with the occasion: matching the little basket-shaped hat by Rachel Trevor-Morgan, Anya Hindmarch's Marano clutch, and a bracelet with her own Windsor monogram (C for Catherine), the duchess affixed the golden three-leaf shamrock brooch, a loan from the regiment, to the lapel. This was just one of a whole series of sophisticated, classy looks that catapulted her to the international best-dressed list of the U.S. magazine

Vanity Fair in 2011. The fashion bible's judgment: Kate had "a whirlwind of fashion successes."

No wonder: the duchess already turned her first state visit to Canada and California into a fashion cyclone, and the runway into a royal catwalk. "I'm not a clothes horse," she coolly declared before her royal trip, and let it be known that she would not require a stylist for her eleven-day tour. In addition to an entourage of six people, and more than forty dresses, the newlywed wife did not take a fashion advisor with her – although she did take her hairdresser James Pryce. The latter made sure that not a hair was out of place on "the Kate," her flowing mane with the ends curled inward, and contoured her eyes with black eyeliner.

On Canada Day, she wowed the nation with a Canadian look. The Duchess of Cambridge wore a little red hat with a maple leaf, the national symbol of Canada, with the white dress that is also to be seen on the engagement portraits. Many people considered the BAFTA gala in Los Angeles to be the high point of her fashion campaign, however. It was there that Kate enchanted the whole of Hollywood in a light lilac plissé gown by Alexander McQueen, turning even superstars like Nicole Kidman and Jennifer Lopez into excited fans. As queen, she will become in Great Britain the sixth Queen Catherine. In terms of fashion, she is already Kate the Great.

Canada look: The duchess surprised the people of Ottawa by wearing the country's national colors on Canada Day. She combined a little red hat with a maple leaf by Sylvia Flechter with her white Nannette dress, which she also wore for the official engagement portrait. Here, she holds a Fan clutch by Anya Hindmarch.

> **"When I look at Kate I see a changing of the guard in what is considered elegant. She likes to look easy but chic. I would liken her to Michelle Obama and Carla Bruni in that way."**
> *Michael Kors*

To die for (clockwise): At the BAFTA Awards in L.A., the Duchess of Cambridge stole the spotlight from the greatest Hollywood divas in her McQueen gown in delicate lilac. She cheered for her William at a polo match in Santa Barbara, wearing a dress by Jenny Peckham. The couple, wearing cowboy hats, was taken for a ride around Calgary (blouse with heart decorations: Alice by Temperley).

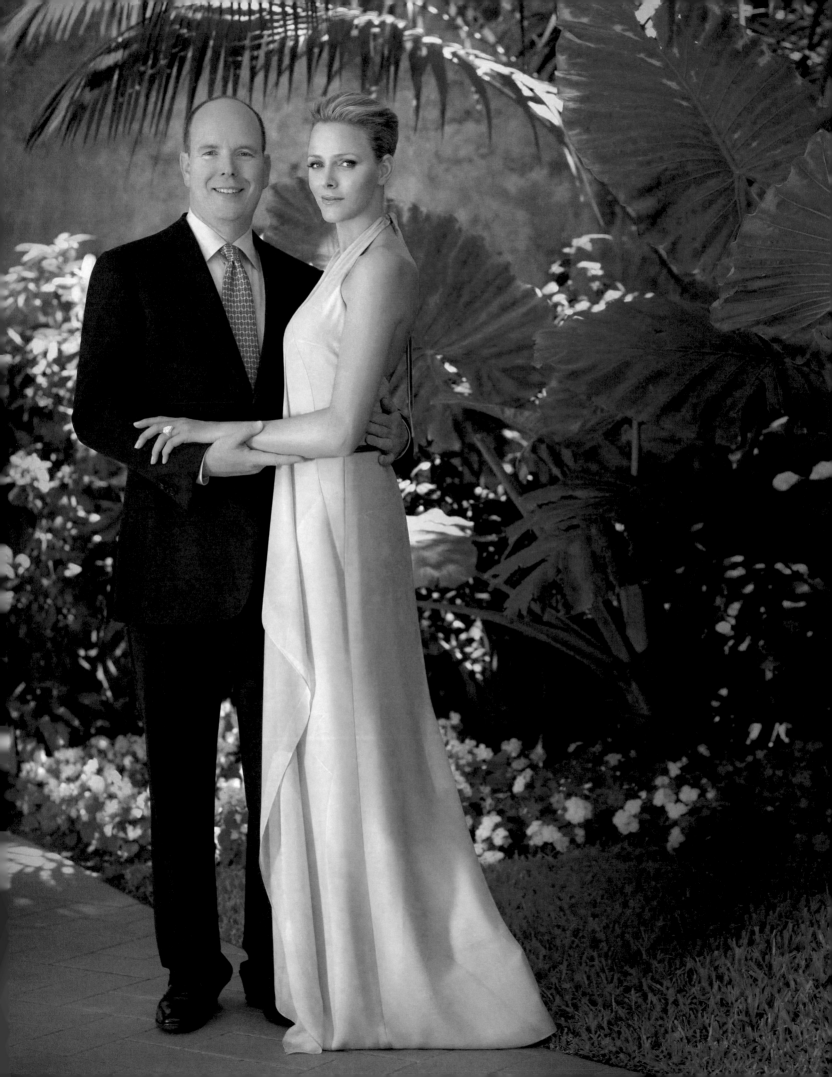

Charlène of Monaco
In the Footsteps of Gracia Patricia

With the wedding, a French grave accent was added to the e – a little line that hints at a crown. South Africa's "goldfish" Charlene Wittstock swapped her old life in Durban, 8,463 kilometers away, for a new name and everything that goes with it. As Princess of Monaco, she is now called Charlène, and that is not the only similarity with her deceased mother-in-law. The former Oscar winner Grace Kelly became known as Gracia Patricia after her wedding, and transformed the miniature state on the Côte d'Azur into a land of fashion. In addition to the husky-blue eyes, ice-blond hair, and even-featured face, Charlène shares Gracia Patricia's love of powder hues such

as champagne, and her love of subtle elegance. While Charlène used to pose by the poolside in a Speedo bathing suit and modeled for the swimsuit issue of *Sports Illustrated*, she now enchants all as a princess in off-the-shoulder gowns by Christian Dior and Terrence Bray, a South African designer.

Next to Kate, Charlène is the other girl for whom a fairytale came true in 2011. And, like her colleague, she is already being celebrated as a fashion icon. That's ironic, considering that the twenty-three-year-old first had to buy a going-out outfit before going on her first date with Albert – who was still the "Playboy Prince" at the time – in 2001 because she had brought only sports clothes

for the competition in Monte Carlo. They danced the night away and drank champagne in the back seat of his Rolls-Royce. Ten years passed between that evening and the fairytale wedding. Following their outing as a couple in 2006, the daughter of a businessman and a former professional diver handled the long wait with rigorous discipline. "One of the greatest challenges was to find my own style," she told the U.S. edition of *Vogue*. From the young age of twelve, her life had revolved around swimming pools, changing rooms, and hotel rooms, and she went on to train for the South African national team. With hindsight, Charlène would plan her fashion debut in Monaco better: "I did not care about fashion in the past. I played volleyball before the Red Cross Ball in 2006. I then borrowed a green dress from a friend, put my hair up, and painted my nails red. I looked like a Christmas tree."

Such faux pas are a thing of the past. Today, she asks the greatest designers in the world for suggestions and gets advice from the likes of the king of fashion, Karl Lagerfeld. While her sister-in-law Princess Caroline wears mainly Chanel, Charlène takes her cues from the plain designs of Italian maestro Giorgio Armani. The prince's girlfriend first appeared in one of Armani's dresses at the 2008 Olympics in Beijing. Since then, she has had a front row seat at the fashion shows of his haute-couture line Armani Privé. The designer himself is her greatest fan: "She is tall, slim, athletic, and simultaneously all grace and elegance. She has the ideal figure and posture to wear

On July 2, 2011, Charlène looked resplendent in a gown by Armani Privé. She wore an ice-blue blazer with a trouser skirt to the registry office ceremony (top).

Left: She opted for a jade-green Akris gown for the engagement photograph with Prince Albert. Its color is reminiscent of the dress worn to the Oscars by her mother-in-law Grace Kelly.

Charlène attended Kate's wedding in 2011 wearing a pearl-gray coat ensemble by Akris.

Below: A true fashionista, she sat in the front row of the 2009 Armani Privé show with the designer's niece, Roberta Armani.

Right: Albert brought up the rear as Charlène, like a true Hollywood star, walked gracefully across the gangway to the three-master *Signora del Vento* in a sea-blue satin dress and matching high heels.

> **" Charlène is blessed with an amazing body and spectacular shoulders, which is a fantastic base for any dress. "**
> *Roberta Armani*

great gowns." He created a monument to Charlène for her first official engagement on the National Day celebration in 2010: Albert's fiancée appeared in a golden polka-dot ensemble with a sophisticated peplum blazer.

Since her engagement to the wealthy prince in June 2010, the Swiss label Akris has been making headlines in Monaco with increasing frequency. The liaison between the princess and the Swiss institution in St. Gallen started in a boutique in Monte Carlo. This is where Charlène found her jade-green engagement dress of silk georgette; the gown shone in a color similar to the sea-blue Oscar dress worn by Grace Kelly. She was so enthralled by it that Charlène invited head designer Albert Kriemler to lunch in January. The designer helped the future princess to find her style. Kriemler's telephone rang in early April: Miss Wittstock wanted his clothing suggestions for Kate's royal wedding. She said, "I want to be British in my attitude, but not in my look." The designer made twenty sketches – all in a delicate pastel – for Charlène's appearance in Westminster Abbey alone. His client decided on a pearl-gray coat ensemble with a wide neck. The gloves were crocheted in the in-house atelier, and Kriemler even designed the cartwheel hat himself. He was not awarded the commission for her wedding gown, but dressed her for her debut as first lady: Charlène looked radiant in a corset gown of precious dupion silk at the Red Cross Ball in August 2011. In addition to the dress being one of a kind, the color – called azalee – was invented specially for the princess.

Her wedding look, too, was unique. For the registry office ceremony, the bride designed an ice-blue blazer with a fluttering trouser skirt together with Karl Lagerfeld, and she wore a majestic creation by Armani Privé in front of the altar. The ultra-plain gown with a boat neck underlined her slender figure. Armani decided on an off-the-shoulder top to draw attention to the "beautiful structure" of the ex-swimmer's shoulders. The five-meter-long train "à l'Adrienne" started at the turnover collar at the back. The gown's greatest decoration

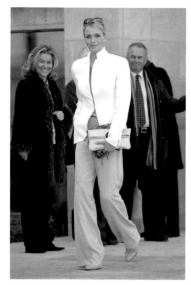

Akris looks: Charlène looked tough in a pantsuit, in Ireland; she was breathtaking in an azalea-colored gown and the Ocean tiara as a necklace at the 2011 Red Cross Ball; in Leeds, she made a great impression in champagne.

Right: The princess-to-be was resplendent in a golden polka-dot ensemble by Armani Privé with a hat by Philip Treacy on National Day 2010.

"à l'Adrienne" started at the turnover collar at the back. The gown's greatest decoration was hardly visible at first: 40,000 Swarovski crystals, 20,000 mother-of-pearl teardrops, and 30,000 stones in gold shades had been hand-stitched over the course of 700 hours. Charlène dispensed with virtually all jewelry and a tiara, however. Only her deep chignon was held by a diamond-studded lily hairpin, lent to her by her sister-in-law Princess Caroline, in the nape of her neck. Giorgio Armani himself had composed a cascading wedding bouquet of lilies of the valley, freesias, and orchids to match the narrow silhouette of her dress. Charlène changed into a white valance gown by Armani Privé before the banquet on the opera terraces. She looked resplendent, surrounded by ice statues of elephants and golden light. Her unusual headdress caused a particular stir: Charlène's hair was

adorned by Lorenz Bäumer's Diamond Spray tiara, a sort of fascinator with eleven tear-shaped diamonds, the largest of which weighs eight carats. It symbolizes the spray of the waves; after all, the native South African is a passionate surfer. For the wedding, Albert also gave her the forty-four carat Ocean tiara by Van Cleef & Arpels: waves of white gold with 883 diamonds, 359 sapphires, and 11 tear-shaped diamonds. These are not the only jewels to make reference to her former career as a swimmer. Even her pear-shaped engagement ring by the court jeweler Repossi is named for the Greek sea nymph Tethys. But leaving all the knick-knacks and thousands of sparkling stones aside, her husband Albert likes Charlène best au naturel: without makeup and with her hair tied back.

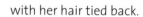

Victoria of Sweden
From Wallflower to Business Princess

Her job is the crown: Victoria is the future manager of a nation of nine million people. While the commoner princesses Mette-Marit, Mary & Co. entered the royal family only as a result of a love match, Victoria of Sweden is Europe's only "real" crown princess. The daughter of the king was born in the palace – and reflects this in her looks. Admittedly, there were a couple of faux pas at first. Instead of experimenting with miniskirts and her first makeup as a teenager, she constantly had to shake hands and act as a representative, next to her parents, from a young age – there is no room for fashion experiments at court. She enjoyed the perfect education in return. On her eighteenth birthday, Victoria was promoted to official representative for her father King Carl XVI Gustaf, and mastered her maiden speech despite reading and writing difficulties. No wonder that she used to go for outfits your aunt might wear, cardigans and geeky glasses – the people were supposed to talk about her message, not her clothes. In contrast to her chic sister Madeleine, Victoria used to admit openly to a lukewarm interest in fashion.

The crown princess long ago got rid of her mousy gray suits and knee-length granny skirts. When she fell for her great love Daniel Westling, color entered her wardrobe, too. Her story reads like a fairytale. When Victoria was no longer able to hide her anorexia from the media in 1998, her parents sent her to university in the United States. She registered under her family name "Bernadotte" at Yale University. "I was unable to reconcile the crown princess and Victoria," she now explains. Following her recovery and return to Stockholm in 2001, she showed up at Daniel Westling's exclusive fitness studio. The crown princess hired the boss himself as her private trainer – and invited him for dinner a few weeks later.

But the young man in the baseball cap and jeans did not look like the right match for a future queen at first. The crown princess had to fight for Daniel for years until, on February 24, 2009, the royal family finally announced the engagement. The look on Victoria's face spoke volumes: the beaming crown princess proudly held her three-carat diamond ring up to the cameras.

Journalists soon observed an astounding phenomenon: the closer the wedding date, the shorter Victoria's skirts became. Victoria discovered sexy clothes alongside her love for Daniel. A few weeks before the ceremony, she jetted to Paris with her stylist Tina Törnqvist to equip her wardrobe for the official engagements surrounding the wedding. Her fashion advisor introduced her to the luxurious world of Yves Saint Laurent and Lanvin. Victoria bought not only a knee-length couture dress in delicate lilac

Victoria wore a cupid's-bow hairpin to her wedding concert and was rewarded with admiring looks from her future husband – she was enchanting, dressed in a one-shoulder gown by Elie Saab Couture.

Right: The Swedish crown princess looked more beautiful than ever in her wedding gown by Pär Engsheden. Napoleon gave the cameo tiara to his wife as a gift in 1809.

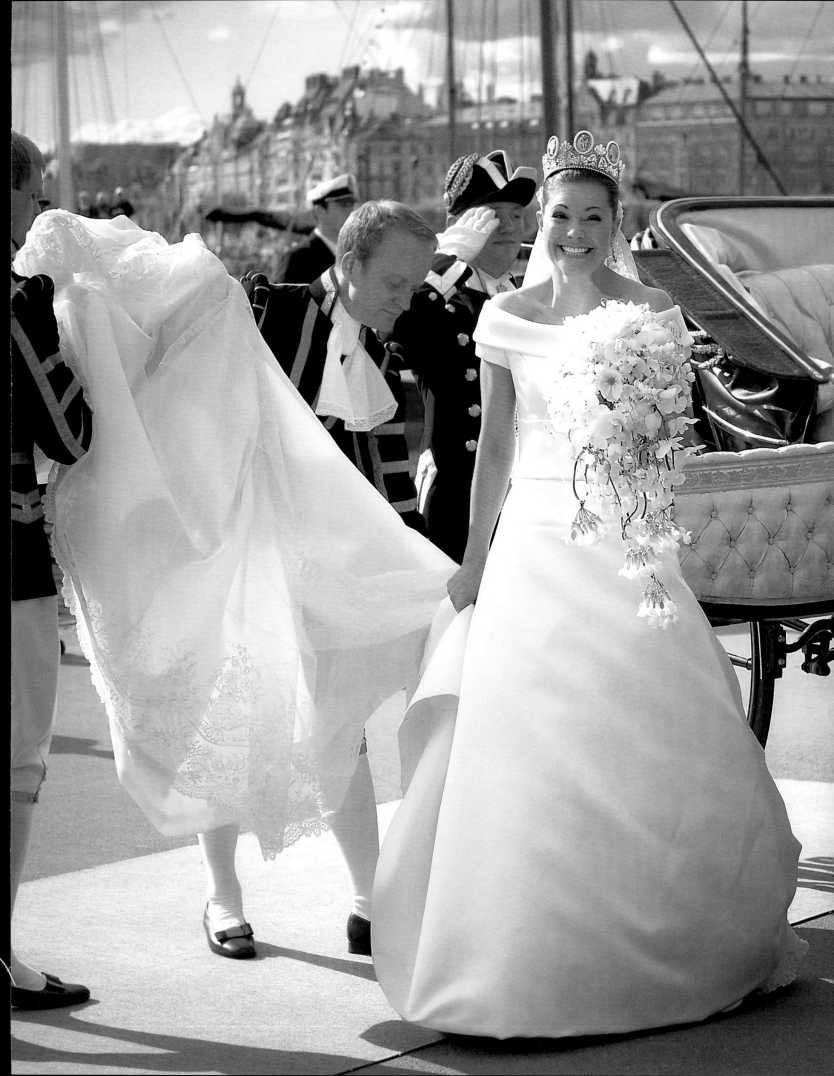

Sales skyrocketed after Victoria wore her 49 cream-colored coat by H&M.

Right: At the Polar Music Prize 2009, Sweden's Grammys, she catapulted herself into the limelight in a flower dress with cascading sleeves by Matthew Williamson.

for the reception at the Town Hall, but also a glittering one-shoulder gown in the color nude, from Elie Saab. With this look, Victoria enchanted the groom on the evening before the wedding, and had inserted a message of love into her hair: a hairpin in the shape of a cupid's arrow sparkled in her updo.

It was a symbol that might as well have been invented for Victoria: the love god's tool reappeared in her wedding tiara. When the crown princess stood at the altar of the Strokyrkan in Stockholm on June 19, 2010, exactly thirty-four years after her parents' wedding, she was wearing her mother's tiara of gold, pearls, and seven cameos – the central medallion depicts Amor and Psyche. The headdress has a long history: Emperor Napoleon gave this unusual piece of jewelry to his wife Joséphine in 1809. In contrast to Victoria's mother, Queen Silvia, who was wed in Dior in 1976 when she still had the surname of Sommerlath, the crown princess said "I do" in a cream-colored silk gown by her favorite Swedish designer, Pär Engsheden. As plain as the dress looked, it was equivalent to a little revolution: the model's turnover collar revealed the bride's shoulders and, in contravention of the tradition of European royal families, it had short sleeves. A broad sash, from which the five-meter-long train spilled out, drew attention to Victoria's waist. On her feet, she wore buckle pumps by Roger Vivier. Her bouquet was as simple as her gown: a white, tear-shaped arrangement of Swedish summer flowers, roses, lilies of the valley, and gardenias.

Victoria, like her little sister Madeleine, transformed herself into a Swedish fashion icon, combining luxury brands with young local labels. At a state visit to Paris, she even stole the limelight from Carla Bruni in a black-and-white etui dress by Escada. Since 2010, the crown princess has even discovered the world of the German luxury label for herself, in addition to the creations of Alberta Ferretti,

Diane von Fürstenberg, and Marni. Escada's head designer Daniel Wingate, an American with Swedish roots, knows Victoria's taste quite well: "No prints, no patterns, no pure black. And not too sexy," he revealed to the German magazine *Bunte*. Victoria chooses her clothes together with her stylist. She does not accept gifts, but is given a princess discount. At the same time, she presents herself as refreshingly normal: "She rarely makes special requests. Recently, for example, she wanted to have sleeves added to an off-the-shoulder dress. But her dressmakers in Sweden deal with smaller alterations," said Wingate.

But Victoria also presents herself as of the people, wearing inexpensive Swedish clothes. The owners of the fashion

Snake print from head to toe: The crown princess stepped out of a limousine in Berlin wearing a sexy Lanvin dress with matching pumps.

> 66 Her style has also taken off since she fell in love: her dresses have become a centimeter shorter, and her platform pumps have become vertigo inspiring. 99
> *Bunte*

> 66With her radiant smile, she is my personal supermodel.99
> *Head designer of Escada,*
> *Daniel Wingate*

Pure glamour: Victoria and Daniel at the Polar Music Prize 2010. The crown princess was resplendent in a metallic dress by Escada, Tribute platform sandals by Yves Saint Laurent, and jewelry by Lara Bohinc.

Right: On the evening before Kate's wedding, Victoria posed in a red Escada gown, her hair in a side bun.

conglomerate H&M are among her friends. But this is not the only reason for which she often wears their designs: these looks are popular with the Swedes because they are affordable. Her off-white, forty-nine-euro coat sold out almost immediately. Even her popular husband has started a fashion in Sweden: square-edged "Daniel" glasses. Many of their compatriots want to be a little bit like Victoria and Daniel. "You have given me my prince," Victoria said to her people in gratitude at her wedding. No wonder that she is the most popular representative of the royal family – she under-

stands her job, and in recent years has also mastered the fashionable side of it. The preconditions for her future role as queen are more than met. She will be the first female monarch of Sweden in three hundred years.

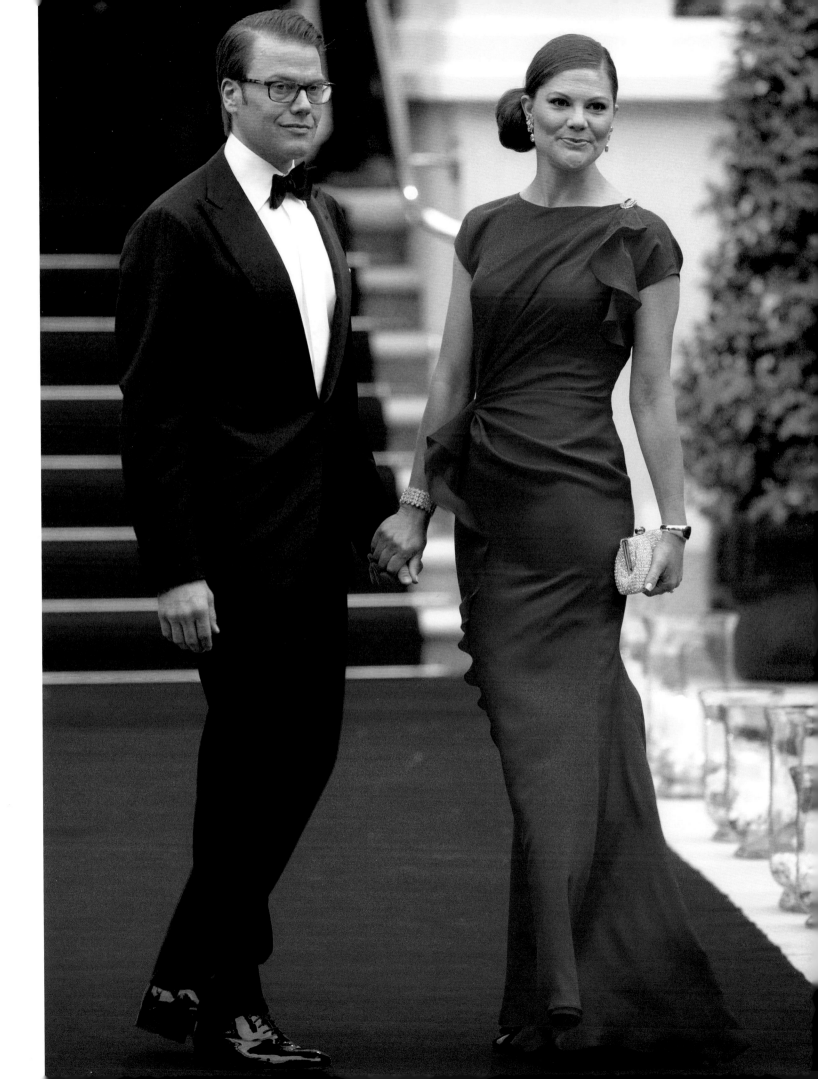

Small Crowns Glitter, Too…

When Prince Nikolaos said "I do" to his girlfriend Tatiana Blatnik on the miniature Greek island of Spetses in August 2010, his sister-in-law Marie-Chantal attended the church ceremony dressed in dusky pink. This suited her tanned skin and blond hair. She covered her shoulders with a folklore-style scarf. Her children were all dressed in white.

Marie-Chantal of Greece
The Dollar Princess

Powder tones: Marie-Chantal of Greece loves clothes in beige nuances, such as this romantic chiffon gown with a black skirt and rosé-bronze bodice by Valentino. Her appearance at Kate's pre-wedding dinner in London was even more understated: a flowing gown, all in nude.

She keeps up with the most expensive fashion trends – Marie-Chantal of Greece is a key player in the sporting discipline of haute couture. No wonder: the middle daughter of the American duty-free billionaire Robert Warren Miller sat in the front row at Paris fashion shows with Greek crown prince Pavlos even before they were married. She is one of a few hundred clients worldwide who can afford gowns that cost upward of thirty thousand euros, and she was already wearing Chanel when she met the prince of her dreams. At a party in New Orleans in 1992, she appeared wearing one of her mother's dark-blue ensembles, and looked (in her own words) "like a million bucks" in it. She was supposed to be engaged to the son of Greece's king Constantine II anyway, but it was love at first sight all the same. Three years later, and to her daddy's delight, Marie-Chantal (nickname: "MC") married into the royal family, which lives in exile to this day because the monarchy was abolished in Greece in 1974.

That did not stop royals from flocking to her wedding to the crown prince. More crowned heads were present at the Greek Orthodox church of St. Sophia in London than at the 1981 wedding of Prince Charles and Diana. And this despite the fact that Pavlos's "I do" was quite a sensation; long before Norway's Haakon, he was actually the first crown prince of his generation to marry a commoner. In addition to bringing a dowry of over two hundred million dollars into the marriage, his twenty-seven-year-old bride wore a fortune on her body on their wedding day: Marie-Chantal looked radiant in an ivory-colored couture gown by Valentino, made of handmade lace and embroidered silk and worth an estimated $225,000. Twenty-five seamstresses had worked on the dress for four months, using twelve different types of lace.

Her love of Valentino and Chanel remains to this day. The blond princess favors classic cuts and couture in shades of beige: "That is so discreet that I can wear the clothes several times." Marie-Chantal never had to learn to dress perfectly; good taste courses through her veins. Not only did the billionaire's daughter work for Pop Art artist Andy Warhol in New York City at the age of sixteen, but she was also one of the first to wear the fluttering hat creations of the Irishman Philip Treacy. Her accessories read like an ABC of luxury brands, and every fashionista envies her for her wardrobe. But amongst her Louboutins and Prada stilettos there is now a pair of wellington boots: Marie-Chantal, Pavlos, and their five children – all of whom were given names from Greek mythology – live in a stately home in the countryside of West Sussex, about an hour from London by car. She stores her couture clothes in six boxes in the attic there, and unpacks them again only for special occasions such as balls and royal weddings: "They are from a period of my life when I lived in New York in the nineties, and everything was much more glamorous. Now my world revolves around bringing up my children and looking after my husband." The dollar princess turns her fashion sense into money, too: under her given name, Marie-Chantal designs playful outfits for the jet set of tomorrow. Whether or not she has her own royal household, in terms of fashion she is queen.

❝ I borrowed a navy-blue Chanel couture suit from my mother and looked like a million bucks. ❞
Marie-Chantal about her first date with husband Pavlos

Right: Marie-Chantal and her husband are part of London's high society. She made an appearance in navy blue and Leo booties by Charlotte Olympia at the premiere of Madonna's film *W.E.*

Top: To Prince William's wedding, she wore Chanel Couture and a Philip Treacy hat.

Left: Marie-Chantal in a silver-gray satin gown with a waterfall neckline at the ARK Gala in 2011.

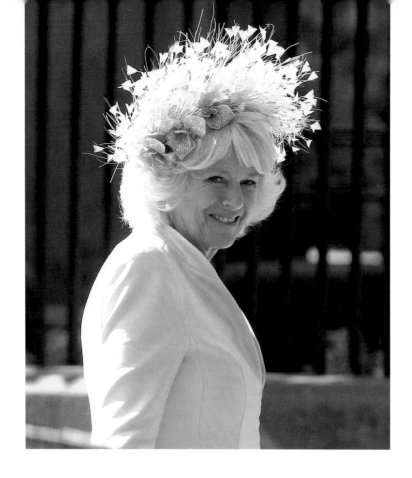

Right: Hat designer Philip Treacy conjured up a golden crown of feathers for the service of blessing in 2005.

Left: The duchess was cloaked in a meadow of flowers at Zara Phillips's wedding (hat: Philip Treacy). When she and Charles left the Windsor Guildhall after the civil ceremony, she looked radiant in pearly white, with a matching Philip Treacy hat.

Duchess Camilla
From "Yorkshire Pudding" to Lady with Style

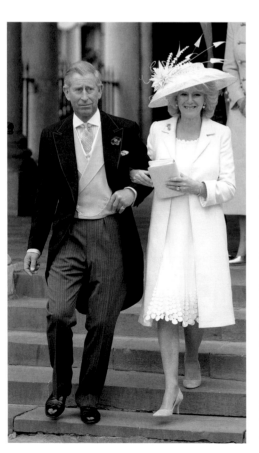

Her love for Prince Charles began in the early 1970s with the pickup line, "My great-grandmother was your great-greatgrandfather's mistress, so how about it?" After that, Camilla – like her ancestor Alice Keppel – made history as the crown prince's long-term affair. Diana angrily called her a "Rottweiler" – and the fashion media derided her as the "Lady of Tweed." Charles's married mistress had no sense of style while his wife radiated glamour. The feared fashion critic Richard Blackwell once even compared Camilla's attire of rubber boots, anorak, and riding pants to a collapsed Yorkshire pudding. Eventually, Camilla was seen as an honorary man – her favorite perfume was the smell of horses, her most beautiful accessory a shotgun. But before she could appear publicly as Charles's girlfriend, after her own divorce and Diana's death in 1997, she had to pass muster with the royal family.

Since then, Camilla has not left the house without pastel makeup and blond highlights by London's hairstylist to the stars Jo Hansford. She appeared at one of her first engagements at Charles's side in a rosé-colored glittering gown by Donatella Versace. The media had never before seen Camilla looking so glamorous! She had commissioned the design duo Antonia Robinson and Anna Valentine ("Robinson Valentine") with her new style. The two women gave her a new image: "Camilla was never the type for dark colors. Pastel colors, camel hair, cream, and white make her look younger. She has accepted that," said Anna Valentine in the newspaper *Evening Standard*. When it became known that they would dress Camilla for her wedding in April 2005, they closed their little showroom in the exclusive borough of Kensington, and blacked out the windows.

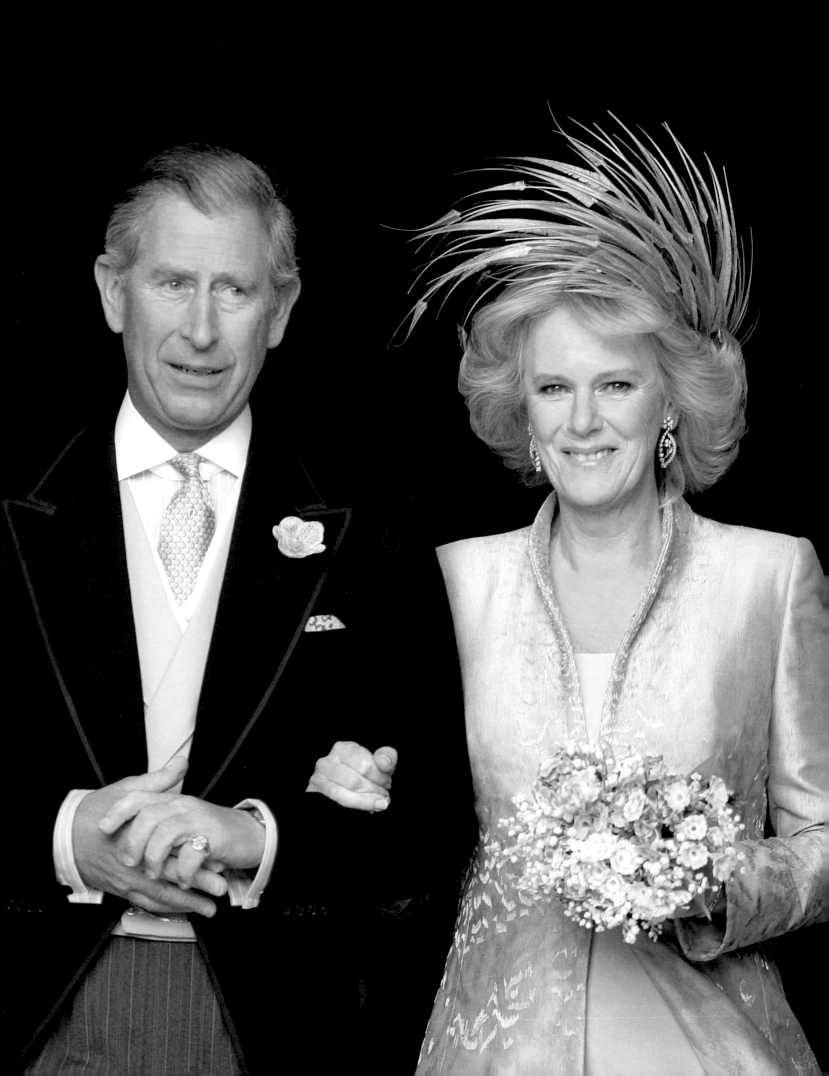

"The queen of pastel": Camilla opted for soft tones at the wedding of her stepson William. Her coat in light blue and rosé was created by the designer of her wedding outfit, Anna Valentine, who now works without her ex-colleague Antonia Robinson. The hat is by Philip Treacy.

Below: Charles leads his wife through the Botanical Gardens of Rio de Janeiro in a gentlemanly fashion. He is wearing a suit despite the heat.

> **I love dressing the Duchess… She gives us a lot of her own input, but is always very happy for us to suggest things. She likes something understated and well tailored with a nice detail.**
> *Anna Valentine*

The result was a success: the fifty-seven-year-old bride accented her greatest asset – her slim legs – at the registry office ceremony at the town hall of Windsor. After almost thirty-five years as Charles's mistress, Camilla, wearing a pearl white combination, became the Duchess of Cornwall. A knee-length chiffon dress, its seam decorated with oversized sequins, peaked out of her open silk coat. Camilla wore a large white Philip Treacy hat of French lace and feathers on her short, silver-blond hair. Even the suede leather pumps with five-centimeter heels had been made specially by the shoe designer Linda Kristin Bennett (L.K. Bennett). The bride walked to the altar in a floor-length porcelain-blue silk coat with gold embroidery and matching dress for the service in St. George's Chapel. A piece of jewelry belonging to Camilla's mother served as inspiration. The bride accessorized it with a gold feather crown with Swarovski stones by Philip Treacy. Her elegant appearance convinced even critical fashion insiders.

Charles certainly is Camilla's equal when it comes to fashion: the British heir to the throne spends quite a lot of money on clothes and grooming. Even in the summer heat, he will appear in a gray double-breasted suit or wear cashmere, and he owns nothing but tailor-made silk pajamas and suits by the Savile Row gentlemen's tailor Anderson & Sheppard, handmade shoes, and more than 300 ties. Charles gives only the most precious jewelry to his second wife: Camilla received the Queen Mother's sapphire and diamond ring, which Queen Victoria had worn when she was crowned Empress of India in 1877. This fact alone shows how much Charles loves Camilla: whenever there is an opportunity, he buys at auction jewelry that once belonged to her great-grandmother Alice Keppel, presents from King Edward VII to his famous mistress, including a fleur-de-lis brooch of black pearls. Camilla attached it to her lapel for the registry office wedding. If that isn't love, what is?

Umbrella chic: Camilla, Duchess of Cornwall, surrounded by Brazilian models in Manaus in 2009.

Below: The Prince of Wales and his wife arrive by carriage at the Ascot races in 2009. Charles, as usual, wears a top hat, and Camilla dons a pink Treacy hat with peonies. Her jewelry consists of a five-strand choker with an amethyst at its center.

Madeleine of Sweden
The Stylish Little Sister

Sweden's prettiest daughter Princess Madeleine (born in 1982) is in love with luxury: at the age of twenty, she was already shopping at Louis Vuitton and Gucci, and partying in Stockholm's most fashionable clubs. Whereas her dutiful sister Victoria, as crown princess, is a servant of the crown, little sister "Madde" was allowed to push the boundaries in her childhood and youth. She has always been quite a handful. As a four-year-old, the princess disregarded protocol by running toward the king, screaming "Daddy, there is a wasp on your shoulder!" Madeleine has grown up. As a young woman, she now tows the line – and in fashion, too. She knows what suits her and loves classic bags such as the Birkin Bag by Hermès and the Chanel 2.55. Madeleine made the Knot clutch by Bottega Veneta popular among princesses (virtually all of them wear one nowadays). She loves pastel-colored chiffon by Alberta Ferretti and

sexy satin dresses by Dolce & Gabbana. The tanned blond with the blue eyes celebrated her engagement to the lawyer Jonas Bergström in a nude-colored 1,200-euro dress by Fendi. When her fiancé's affair came to light, Madeleine annulled the engagement in April 2010 and fled to New York. Not only did she become a brunette in the Big Apple, but she also met her new love there. Professionally, she makes an impression in blazers and formal suits at events for her mother Silvia's charity organization (Childhood). The only faux pas in her fashion career: at her sister's wedding concert in June 2010, she walked the red carpet in a gray-white Empress Elisabeth gown by the Venezuelan designer Ángel Sánchez, looking almost as though she were the bride. Victoria must have let her off the hook, though – little sisters can, as everybody knows, get away with murder.

The redheaded princess: Beatrice with a half hat by Philip Treacy at the horse race in Ascot 2010. A year later, she sat in the front row at Elie Saab, wearing a tomato-red dress by Roland Mouret.

66 Princess Beatrice is Queen Victoria's great, great, great, great-granddaughter and looks like Queen Victoria. 99

Philip Treacy

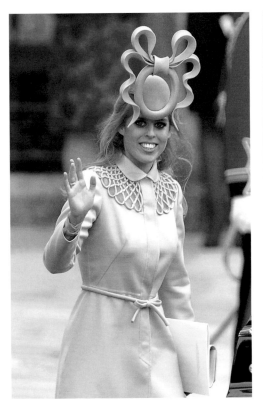

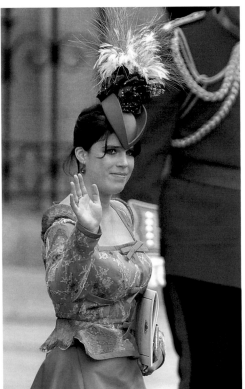

Beatrice & Eugenie of York
The "Hat Gate" Affair and Other Experiments

Above: At William's wedding, the media joked about Beatrice's "music-stand" hat by Philip Treacy and her coat dress by Valentino Couture. Her sister Eugenie, too, failed to please the fashion police with her blue Vivienne Westwood outfit (little hat by Philip Treacy).

No hat in history has ever been subjected to as many insults as the meat-colored headdress worn by Princess Beatrice: "deer antlers," "uterus," "toilet seat," "music stand," and "pretzel" are just a few among many. At William's wedding, half the world laughed about the shrill piece by star designer Philip Treacy. The queen's granddaughter became an Internet sensation against her will: her headdress was given its own page on Facebook, where tens of thousands of people made fun of it. The designer himself came to her rescue: "Princess Beatrice is Queen Victoria's great, great, great, great granddaughter and looks like Queen Victoria," he told the British weekly newspaper *The Observer*, "I thought of her as a beautiful, exotic, Victorian doll. I thought I was making a hat with a bow on it."

Whether it was because of the eccentric design, or whether hat and wearer simply didn't look good together, is another question. This much is certain: April 29, 2011 entered the princess's diary as "Black Friday"; others referred to the incident as "Hat Gate," a pun on the famous Watergate affair. But the twenty-two-year-old took advantage of the opportunity by selling the cult object at a charity auction. The designer piece changed hands for a record price of £81,101. Beatrice made it known that "I cannot believe the amazing response to the hat. It has its own personality."

Sarah Ferguson, however, was so horrified by the criticism of her oldest daughter that she engaged the services of stylist Charlie Anderson. The former head of fashion at the British *Tatler* magazine also dresses Hollywood stars like Emma Watson, Katie Holmes, and Anne Hathaway, and prescribed simple-yet-elegant outfits for Beatrice. For Elton John's White Tie and Tiara ball in June 2011, for example, the red-haired princess chose a nude-colored £73,000 gown by Elie Saab. Since then, Beatrice has eschewed unsuitable outfits. To the contrary: Beatrice enchants with her thoughtful looks, wears Ascot-worthy ensembles by Phillip Lim, figure-hugging etui dresses by Roland Mouret, and Issa's famous jersey dresses.

Beatrice is not the only fashion black sheep of the family, however; her younger sister Eugenie, too, has often made bad judgments, as she did at the Royal Ascot horse races of 2008. For the first time, her grandmother, Queen Elizabeth, had employed "fashion police" in the VIP area of the race track, and Eugenie failed to pass muster in a dress that was far too short. But she was only eighteen years old, and was given pass for being a teenager. At the wedding of her cousin William, the princess appeared in an unflattering outfit by Vivienne Westwood. She, too, appears to have taken the public's criticisms to heart, and has made more of an effort in terms of styling since then. To their defense: The two sisters are very young. Beatrice's hat performance remains unforgettable, however. On this subject, Philip Treacy said quite rightly that "in the future, we'll look back and think she looked wild."

WHAT DOES THE FUTURE HOLD?

The progeny is well taken care of – the youngest generation of royals is growing up slowly in Europe's palaces, as they are playfully prepared for their future roles. The children of future queens such as Letizia, Mette-Marit, and Máxima will bear a heavy inheritance: to secure their monarchies. While kings ruled in the past, nowadays they generally have very little influence on affairs of state. Instead, the women in particular have become the prettiest jewels in their kingdoms' crowns – and at the same time their most effective marketing instruments. In tough economic times, when the monarchy is no longer truly a necessity, they have to work ever harder for their countries. It is no coincidence that Mary of Denmark (see facing page) and her colleagues are involved with charitable work, and act as cheerleaders for the economy, tourism, and the fashion industry of their countries. These days, Europe's young royals are constantly in the limelight, acting as advertising executives for their kingdom, as well as model citizens. This is also how they justify their costly apanages: in order to finance their lives, the royal families are given a generous "manager's salary" by their people.

This makes it all the more important that the women show themselves to their best advantage at official engagements. With their glamorous looks, they are admired by many as though they were pop stars. About two billion television spectators watched the wedding of Prince William and millionaire's daughter Kate Middleton. No matter who the royal trendsetters of tomorrow are – aristocrats or commoners – one thing is certain: their looks will continue to play an important role. After all, in their everyday representative functions, they are on a sort of "royal catwalk."

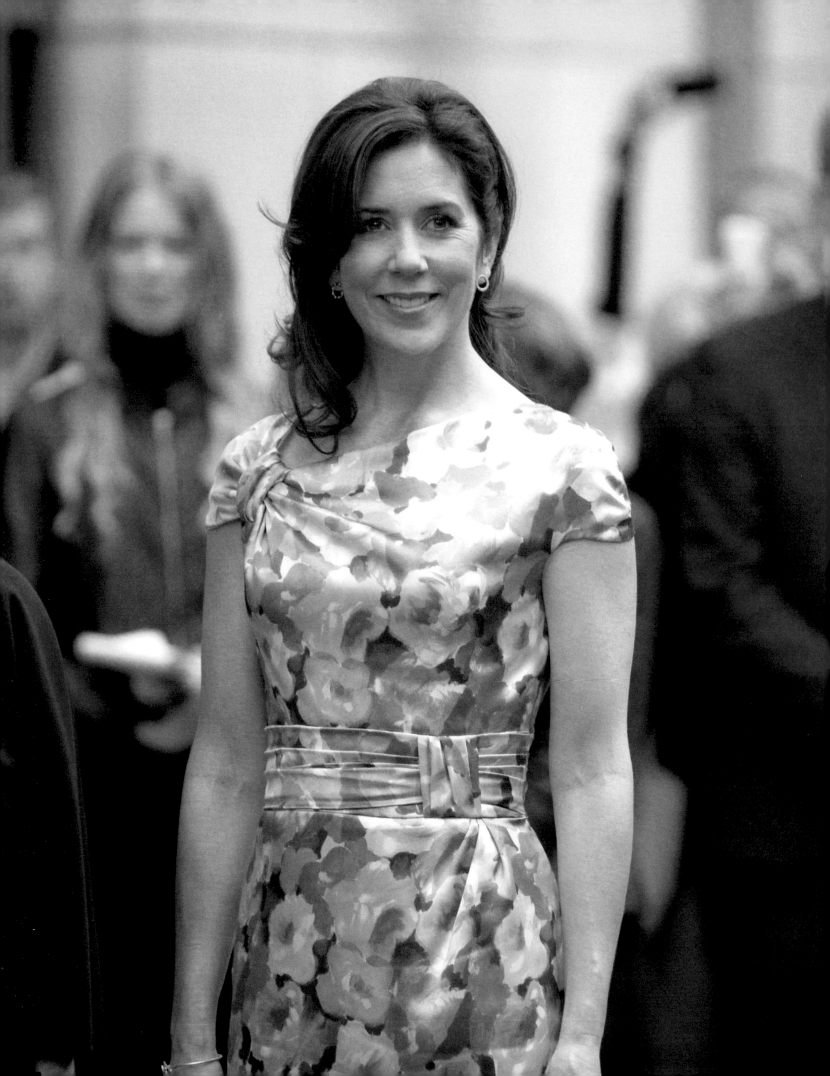

TIMELINE
Royal Trendsetters

Middle Ages until 1500, followed by modern age

1100	1200	1300	1400	1500

Twelfth and thirteenth century (1100–1299) The kings, noble ladies, and knights of France governed international fashion trends at court in Paris. While the influence of the latter waned during the fourteenth century, the rulers of France retained their power.

Thirteenth century In France and Italy, laws were passed to curb luxury among the aspiring middle classes, safeguarding the sartorial privileges of the nobility.

Fourteenth century Medieval status symbols: The length of their poulaines revealed the wearer's rank, from mid-fourteenth century until the end of the fifteenth century, and only the highest members of the aristocracy were allowed to wear red.

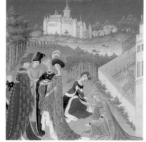

Fifteenth century The fashion-crazy dukes of Burgundy created quite a stir with their sumptuous looks.

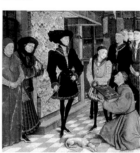

ca. 1450 When even the common people wore increasingly colorful clothes, Philip the Good, Duke of Burgundy (1396–1467), wanted to set himself apart and introduced the color black in fashion.

Sixteenth century (1500 to 1550) The "bourgeois" styles of the Italian Renaissance conquered the world of fashion.

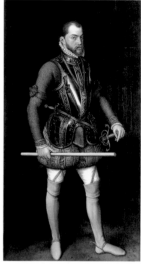

1556 On his accession to the throne, Philip II of Spain (1527–1598) introduced painful clothing dictates: women flattened their breasts with lead plates and even men wore corsets.

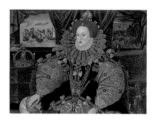

Unmarried Queen Elizabeth I of England (1533–1603) shored up her power with oversized collars and expansive hooped skirts.

1610–1715:
Baroque fashion

1715–1789:
Rococo fashion

1600 **1700** **1800** **1850** **1900**

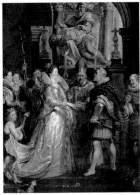

1600 At her wedding by proxy, the Italian Marie de' Medici (1575–1642) wore the first white wedding dress in history and imported the term "alla moda italiana" to France.

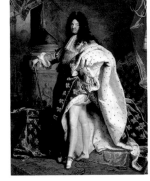

At the court of Versailles, the Sun King Louis XIV (1638–1715) wore the first red-soled pumps.

1672 Establishment of the first French fashion magazine (*Mercure galant*).

1685 Louis's mistress Duchess of Fontanges unleashed an unusual trend: women arranged their hair in towering structures up to sixty centimeters high on their heads.

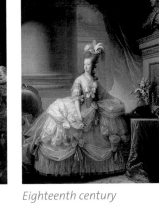

Eighteenth century
The fashion-crazy queen Marie Antoinette (1755–1793) set new fashion trends every week at the court of Versailles.

1772 Rose Bertin ("The Patricia Field of Rococo") became Marie Antoinette's "Minister of Fashion".

1789 The French Revolution put an end to the unfettered fashion dictatorship of the aristocracy. From then on, royals had to share their status as trendsetters with the grande bourgeoisie.

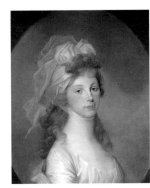

Louise of Mecklenburg-Strelitz (1776–1810) made the "nude look" fashionable – and men go out of their minds – with her light muslin dresses.

Nineteenth century
Corsets and hooped skirts made a comeback under the rule of France's empress consort Eugénie (1826–1920). She went on to ruffle feathers with above-the-ankle hemlines on dresses by Charles Frederick Worth, the first couturier in history.

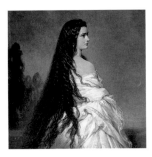

Elisabeth, Empress of Austria and Queen Consort of Hungary (1837–1898), was born and bred in Bavaria. With her model's measurements and floor-length hair, she became the first German supermodel in 1860 – more than a hundred years before Claudia Schiffer.

1856 Thanks to the invention of the "artificial crinoline," made of featherlight splints of steel, women's hooped skirts expanded to a width of two and a half meters.

1868 Charles Frederick Worth invented a new silhouette: he gathered the mounds of fabric together at the bottom to create what is known as a *tournure* (bustle).

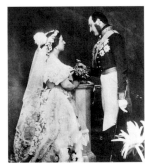

Queen Victoria (1819–1901) made the white wedding dress popular at her wedding to her much-loved husband in 1840. Following her husband's death in 1861, she wore nothing but black for almost forty years.

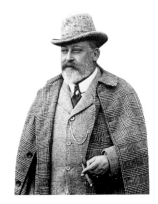

Victoria's eldest son, Edward VII (1841–1910), did more than just give his name to Prince of Wales check. He, long before Prince Charles, was known as the "eternal crown prince." Alice Keppel, the great grandmother of Camilla Mountbatten-Windsor, was Edward VII's long-time mistress.

1900 | 1950 | 1980 | 1990 | 2000

1936 Edward VIII (1894–1972) renounced the British throne for the love of the twice-divorced and shockingly stylish American Wallis Simpson (1896–1986), swapping royal titles for accolades as the "most stylish couple in the world."

1938 The mother of the present queen, Elizabeth Bowes-Lyon (1900–2002), ordered an entire wardrobe of clothes in white from Norman Hartnell for a state visit to Paris, and became a fashion icon.

Europe's longest-serving monarch, Elizabeth II (b. 1926), has been on the British throne since her coronation 1953. Her signature style: pastel colors, hats, and sensible pumps.

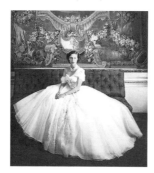

1951 The queen's little sister, Princess Margaret (1930–2002), enchanted those who saw her on her twenty-first birthday, wearing a voluminous ball gown by Christian Dior. Her only rival was Liz Taylor.

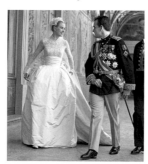

1956 Oscar winner Grace Kelly (1929–1982) married Prince Rainier and her cool elegance lent the tiny state of Monaco a new sense of glamour.

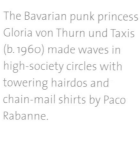

The Bavarian punk princess Gloria von Thurn und Taxis (b. 1960) made waves in high-society circles with towering hairdos and chain-mail shirts by Paco Rabanne.

Icon of the century Princess Diana (1961–1997) expressed her emotional state through her clothes and established her own style in 1995 – clean chic.

1987 American designer Calvin Klein bought Wallis Simpson's "eternity ring" at auction in Geneva, and named one of his most famous scents after it.

1999 A commoner by birth, Rania of Jordan (b. 1970, née Faisal Yasin) was the youngest queen in the world at her coronation. Her style: a daring mix of Western trends and Arab glamour – without a veil.

1995 The American billionaire's daughter Marie-Chantal (b. 1968, née Miller) married Greece's crown prince in exile. She was already a top player in the fashion world of haute couture before saying "I do."

2001 The Norwegian heir to the throne Haakon married the Oslo party girl Mette-Marit Tjessem Høiby (b. 1973). Both her life story and her style are straight out of a fairytale: the blond, Cinderella-like princess casts a spell on her subjects in pastel colors and flounces.

2002 Since her wedding to Crown Prince Willem-Alexander of the Netherlands, the native Argentinian Máxima (b. 1971, née Zorreguieta) has set a cheerful tone with bright colors and crazy hats.

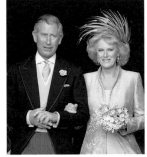

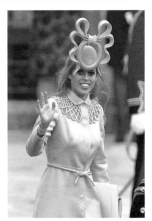

May 14, 2004 The Australian marketing specialist Mary (b. 1972, née Donaldson) brought tears of heartfelt emotion to the eyes of Danish crown prince Frederik as they stood at the altar. Her immaculate luxury looks are also to die for.

2005 After almost thirty-five years as his mistress, Camilla (b. 1947, née Shand) married Prince Charles. Since then, she has worn pastel outfits and fluttery hats by Philip Treacy instead of the rural style she loves so much.

Victoria (b. 1977) is the only "real" crown princess. When the daughter of the king of Sweden fell in love with her personal trainer, Daniel Westling, she swapped her conservative suits for glamour looks.

April 29, 2011 Kate (b. 1982, née Middleton) said "I do" in front of a television audience of about two billion people. Since then, William's young wife has taught us that royal glamour does not have to be expensive.

Victoria's little sister Princess Madeleine (b. 1982) is already considered Sweden's fashion icon, with her trendy accessories and classic looks.

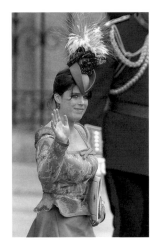

May 22, 2004 Upon her wedding, the news presenter Letizia Ortiz-Rocasolano (b. 1972) became Spain's future queen. She wears mini-skirts and platform pumps in response to the Palace's strict dress code.

The South African professional swimmer used to pose in a swimsuit by the poolside. Since her wedding to Prince Albert of Monaco in 2011, Charlène (b. 1977, née Wittstock) has become known for her timeless elegance.

The party princesses Beatrice and Eugenie of York (b. 1988 and 1990, respectively) caused a minor fashion scandal with their bizarre hats at William's wedding, and have since then made an effort to avoid "fashion mistakes" at official appearances.

INDEX

190

PHOTO CREDITS

The pictures in this book were graciously made available by the agencies, museums and collections mentioned in the credits, or have been taken from the Publisher's archive (t = top; c = center; b = bottom; l = left; r = right):

Frontispiece: Samir Hussein/GettyImages; p. 7: Kevin Davies; p. 12: George Gower (attributed), *Elizabeth I., The Armada Portrait*, c. 1588, Bridgeman Art Library/Getty Images; p. 14: *Konrad von Altstetten, Codex Manesse* (Cod. Pal. germ. 848, Bl. 249v), 1300-1340, Heidelberg, University Library; p. 15: *Alram von Gresten, Codex Manesse* (Cod. Pal. germ. 848, Bl. 311r), 1300-1340, Heidelberg, University Library; p. 16 t.: Rogier van der Weyden, *Jean Wauquelin, Philippe le Bon, Charles the Bold, Nicolas Rolin and Jean Chevrot*, Chronicle of Hennegau (ms. 9242, fol. 1r), 1448, Brussels, Bibliothèque royale de Belgique; p. 16 b.: Dedication image of *Les Faiz du Grant Alexandre* (ms. fr. 22457, fol. 1r.), 1469/70, Paris, Bibliotheque nationale de France; p. 17 t.: Rogier van der Weyden, *Phili the Good*, c. 1450, Musée des Beaux-Arts, Dijon; p. 17 b.: Limbourg brothers, Engagement scene from the *Très riches heures du Duc de Berry* (Month of April), c. 1413-1416, Musée Condé, Chantilly; p. 18: Sofonisba Anguissola, *Isabella Clara Eugenia*, 1599, Prado, Madrid/akg; p. 19: Anthonis Mor, *Philipp II. in armour*, c. 1557, San Lorenzo de El Escorial; p. 21: Elizabeth I., *Ditchley Portrait*, 1592, SuperStock/Getty Images; p. 22: English School, *The Kitchener Portrait of Queen Elizabeth I*, c. 1550, The Bridgeman Art Library/Getty Images; p. 23: English School, *Elizabeth I.*, 16th century, SuperStock/Getty Images; p. 24: Peter Paul Rubens, *Marie de' Medici cycle: The Wedding by Proxy of Marie de' Medici to King Henry IV, 5 October 1600*, 1621-25, Musée du Louvre, Paris, SuperStock/Getty Images; p. 25 t.: Scipione Pulzone, *Maria de' Medici*, 17th century, Palazzo Pitti (Galleria d'Arte Moderna), Florence, Bridgeman Art Library/Getty Images; p. 25 b.: Frans II Pourbus, *Maria de' Medici*, 1611-13, Musée du Louvre, Paris, Bridgeman Art Library/Getty Images; p. 26: Hyacinthe Rigaud, *Louis XIV of France*, 1701, Musée du Louvre, Paris, Universal Images Group/Getty Images; p. 27 t.: Detail of p. 26; p. 27 b.: French School, *Louis XIV of France*, after 1670, Palace of Versailles, Hulton Archive/Getty Images; p. 28 l.: Nicolas de Largillière, *Portrait of a nobleman*, private collection; p. 28 r.: *Mary II*, 1692, Hulton Archive/Getty Images; p. 29 b.: French School, *Madame de Ventadour with Louis XIV of France and his descendants*, 1710, Wallace Collection, London, © Wallace Collection, London/Bridgeman; p. 30: ullstein bild/The Granger Collection; p. 31 t.: *Miss French Lady Opera*, c. 1770, akg; p. 32: Elisabeth Vigee-Le Brun, *Marie Antoinette holding a rose*, 1783, Palace of Versailles, Bridgeman Art Library/Getty Images; p. 34: Jacques-Fabien Gautier d'Agoty, *Marie Antoinette*, 1775, Palace of Versailles, Hulton Archive/Imagno/Getty Images; p. 35: Elisabeth Vigee-Le Brun, *Portrait of Marie Antoinette*, 1778, Hulton Archive/Imagno/Getty Images; p. 36: Elisabeth Vigee-Le Brun, *Marie Antoinette en chemise*, 1783, Staatliche Museen zu Berlin - Preußischer Kulturbesitz, Gemäldegalerie, akg; p. 38: Josef Grassi, *Louise, Queen consort of Prussia*, 1802; p. 39: Henriette Félicité Tassaert (after Johann Friedrich August Tischbein), *Crown princess Louise*, after 1796, Archiv der Stiftung Preußische Schlösser und Gärten Berlin-Brandenburg; p. 40: Friedrich Georg Weitsch, *Frederickh William III. and Louise in Charlottenburg garden*, 1799, Archiv der Stiftung Preußische Schlösser und Gärten Berlin-Brandenburg; p. 41 t.: Jean Charles Tardieu, *The meeting of Queen Louise and Napoleon in Tislit on 6 July 1807*, 1808, Archiv der Stiftung Preußische Schlösser und Gärten Berlin-Brandenburg; p. 41 b.: Wilhelm Böttner, *Louise, Queen consort of Prussia*, 1799; p. 43: Franz Xaver Winterhalter, *Empress Eugénie*, 1855, Leemage/Universal Images Group/Getty Images; p. 44/45: Franz Xaver Winterhalter, *Empress Eugénie with her court ladies*, 1855, Apic/Hulton Archive/Getty Images; p. 46 t.: Henry Guttmann/Getty Images; p. 46 b.: Franz-Xaver Winterhalter, *Empress Eugénie*, ullstein bild/Heritage Images/The Print Collector; p. 47 t.: Roger Viollet Collection/Getty Images; p. 47 b.: London Stereoscopic Company/Hulton Archive/GettyImages; p. 48: Franz Xaver Winterhalter, *Empress Elisabeth of Austria*, 1865, Hofburg, Wien, Bridgeman Art Library/Getty Images; p. 49: E. Riegele (after Franz Xaver Winterhalter) *Empress Elisabeth at dawn*, 1923 (original 1864), Imagno/Hulton Archive/Getty images; p. 50: Photographer: Emil Rabending, Imagno/Hulton Archive/Getty Images; p. 51 t.: Hulton Archive/GettyImages; p. 51 b.: Franz Xaver Winterhalter, *Empress Elisabeth of Austria*, 1865, Kunsthistorisches Museum, Vienna, Imgano/Hulton Archive / Getty Images; p. 52 t.: ullstein bild/Roger-Viollet; p. 52 b.: Imagno/Hulton Archive/Getty images; p. 53 t.: August Mansfeld, *Empress Elisabeth visiting the Volkskueche*, 1876, Imagno/Hulton Archive/Getty images; p. 53 b.: Georg Raab, *Empress Elisabeth of Austria*, 1873, Roger Viollet/Getty Images; p. 54: Franz Xaver Winterhalter, *Queen Victoria*, 1842, Palace of Versailles, Imagno/Hulton Archive/Getty Images; p. 55: Franz-Xaver Winterhalter, *Queen Victoria*, 1847, The Royal Collection © 2011 Her Majesty Queen Elizabeth II/bridgeman; p. 56 t.: George Hayter, *The wedding of Queen Victoria*, 10 February 1840, 1840-42, The Royal Collection/bridgeman; p. 56 b.: Hulton Archive/Getty Images; p. 57: dpa picture alliance; p. 58 t.: Photo by W & D Downey/Hulton Archive/Getty Images; p. 58 c.: Hulton Archive/Getty Images; p. 58 b.: Roger Fenton/Hulton Archive/Getty Images; p. 59: Time & Life Pictures/Getty Images; p. 60: Hulton Archive/Getty Images; p. 62: Popperfoto/Getty Images; p. 63: Ivan Dmitri/Michael Ochs Archives/Getty Images; p. 64/65: © Bettmann/CORBIS; p. 66 t. and c.: Cartier; p. 67: Cecil Beaton © Condé Nast Archive/CORBIS; p. 68: Popperfoto/Getty Images; p. 69: Thomas D. McAvoy/Time & Life Pictures/Getty Images; p. 70: Grace Kelly during the shooting of *Rear Window*, 1954, Bud Fraker/John Kobal Foundation/Getty Images; p. 72 t.: Temple University Library, Urban Archives, Philadelphia; p. 72 b.: rexfea-

IMPRESSUM

For my parents, my brother Christian and my sister Pia

© Prestel Verlag, Munich · London · New York, 2012
© for illustrations see Photo Credits, page 191

Jacket (Front): Grace Kelly in a strapless gown with a sprig of flowers tucked into her bodice, Hollywood, March 1954. (Photo by Sharland/Time Life Pictures/Getty Images)
Jacket (Back): Left column (from top to bottom): Louis XIV (see p. 26), Princess Diana (see p. 107), Elizabeth I. (see page 12); right column top: Mette-Marit of Norway (see p. 120); right column bottom: Mary of Denmark (see p. 122); right: Duchess Catherine (see p. 154).

Prestel would like to thank

for their kind cooperation

Prestel Verlag, Munich
A member of Verlagsgruppe Random House GmbH

Prestel Verlag
Neumarkter Strasse 28
81673 Munich
Tel. +49 (0)89 4136-0
Fax +49 (0)89 4136-2335

www.prestel.de

Prestel Publishing Ltd.
4 Bloomsbury Place
London WC1A 2QA
Tel. +44 (0)20 7323-5004
Fax +44 (0)20 7636-8004

Prestel Publishing
900 Broadway, Suite 603
New York, NY 10003
Tel. +1 (212) 995-2720
Fax +1 (212) 995-2733

www.prestel.com

Library of Congress Control Number is available; British Library Cataloguing-in-Publication Data: a catalogue record for this book is available from the British Library; Deutsche Nationalbibliothek holds a record of this publication in the Deutsche Nationalbibliografie; detailed bibliographical data can be found under: http://dnb.d-nb.de

Prestel books are available worldwide. Please contact your nearest bookseller or one of the above addresses for information concerning your local distributor.

Translated from the German by: Jane Michael
Editorial direction: Claudia Stäuble
Assistance: Franziska Stegmann
Copyedited by: Jonathan Fox, Barcelona
Design and Layout: Joana Niemeyer, April
Production: Nele Krüger
Art direction: Cilly Klotz
Origination: Lanarepro
Printing and binding: TBB a.s.

Verlagsgruppe Random House FSC-DEU-0100
The FSC-certified paper Hello Fat Matt is produced by mill Condat, Le Lardin Saint-Lazare, France.

ISBN 978-3-7913-4635-9